KU-023-252

CONTENTS

PREFACE

Every effort has been made to make this new 'hand-book' as helpful as possible. Dates and details of the manufacturer's specialities and the firm's duration and address are given. In the case of the more important manufacturers the reader is informed of books giving fuller information and/or illustrations of typical specimens. A unique and helpful feature of this new work is the addition of guidance on the rarity of some marks and of the desirability of certain wares.

Appendix I contains over seven hundred initials or combinations of initials used by British potters or firms from 1775, giving in a concise manner the basic initials mark (which may occur in many varying and ornate forms), the name of the firm or partnership concerned and its working period.

Appendix II contains the names of over nine hundred Staffordshire potters of the period from 1786 to 1900. To these names, taken from contemporary directories, have been added their working periods. This feature will enable the collector to date many name or initial marks which occur on Staffordshire wares.

Appendix III should be of the greatest help to the trade, both in Britain and in America and Canada, as it shows which English ceramics are Duty Free under the recent American and Canadian law permitting the entry of articles made over one hundred years before the date of importation.

GEOFFREY A. GODDEN

14 Sompting Avenue
Worthing, Sussex
England

INTRODUCTION

The object of a ceramic trade mark is to enable at least the retailer to know the name of the manufacturer of the object, so that re-orders, etc., can be correctly addressed. In the case of the larger firms the mark also has publicity value and shows the buyer that the object was made by a long-established firm with a reputation to uphold; such clear name-marks as Minton, Wedgwood, Royal Crown Derby and Royal Worcester are typical examples.

To the collector the mark has greater importance, for not only can he trace the manufacturer of any marked object, but he can also ascertain the approximate date of manufacture and in several cases the exact year of production, particularly in the case of 19th and 20th century wares from the leading firms which employed private dating systems.

With the increasing use of ceramic marks in the 19th century, a large proportion of English pottery and porcelain can be accurately identified and often dated. With the many hundreds of different manufacturers' marks it is quite impossible to remember all the various devices, sets of initials, or the working periods of the firms concerned, hence the need for a concise pocket-book such as this, to give the collector basic information and to lead him to works giving detailed information and illustrations of typical examples. I know of no reproductions of post-1840 English ceramic marks, so that the hundreds of later marks give a reliable guide. In the few cases where pre-1840 marks are known to have been reproduced on forgeries, the reader is warned of this risk.

Ceramic marks are applied in four basic ways:

(a) *Incised* into the still soft clay during manufacture, in which case the mark will show a slight ploughed-up effect and have a free spontaneous appearance.*

(b) *Impressed* into the soft clay during manufacture, many name-marks such as 'Wedgwood' are produced in this way from metal or clay stamps or seals. These have a neat mechanical appearance.

* Photographs of typical incised and other basic mark forms are given in G. Godden's *Encyclopaedia of British Pottery and Porcelain Marks* (1964), Plates 1–8.

(c) *Painted* marks, usually name or initial marks, added over the glaze at the time of ornamentation, as were some stencilled marks.

(d) *Printed* marks transferred from engraved copper plates at the time of decoration. Most 19th-century marks are printed, often in blue under the glaze when the main design is also in underglaze blue.

Information on the method of applying each mark is given in this book, and the information can be of vital importance, for instance the early Chelsea triangle mark must be *incised* not impressed, as it can be on 19th-century fakes.

There are several general rules for dating ceramic marks, attention to which will avoid several common errors.

(1) Printed marks incorporating the Royal Arms are of 19th or 20th century date.

(2) Printed marks incorporating the name of the *pattern* are subsequent to 1810.

(3) Marks incorporating the word 'Limited', or the abbreviations 'Ltd', 'Ld', etc., denote a date after 1861, and most examples are much later.

(4) Incorporation of the words 'Trade Mark' in a mark denotes a date subsequent to the Act of 1862.

(5) Inclusion of the word 'Royal' in a firm's title or trade name suggests a date in the second half of the 19th century, if not a 20th-century dating.

(6) Inclusion of the abbreviation R^d N^o (for Registered Number) followed by numerals denotes a date subsequent to 1883 (see page 111).

(7) Inclusion of the word 'England' in marks denotes a date after 1891, although some manufacturers added the word slightly before this date. 'Made in England' denotes a 20th-century date.

(8) Inclusion of the words 'Bone China', 'English Bone China', etc., denotes a 20th-century date.

Very many 19th-century ceramic marks incorporate the Royal Arms. This basic device can help to date examples bearing such a mark, for the pre-Victorian version used prior to 1837 shows an inescutcheon or small shield in the centre of the main quartered arms. The post-1837 Victorian Arms have a simple quartered arms without the inescutcheon.

A high proportion of English pottery and porcelain was made in the district known as the 'Staffordshire Potteries' centred on the present city of Stoke-on-Trent. The 'Staffordshire Potteries' are basically made up of seven separate towns—Burslem, Cobridge, Fenton, Hanley (incorporating Shelton), Longton (also Lane End), Stoke and Tunstall. These towns will be found to be given in the addresses of many firms listed in the main part of this book. The initial letters of these towns—B, C, F,

H, L, S or T—will be found incorporated in several 19th-century initial marks:

$\dfrac{\text{H \& G}}{\text{B}}$ (Heath & Greatbatch of Burslem),

$\dfrac{\text{J \& G}}{\text{L}}$ (Jackson & Gosling of Longton), etc.

This book is arranged in alphabetical order of the manufacturer's or pottery's name. There is also an index where trade names, devices, initial marks, etc., are listed. A useful bibliography is given on pages 190–191, in order that the collector may find specialized books in a reference library, or order copies from a bookseller.

PICTORIAL GLOSSARY

BASALT

The basalt body was also known as 'Egyptian black'. The black body has a matt (unglazed) surface and was popular for teapots and teawares from the 1760's into the 19th century. Josiah Wedgwood improved the original body and termed it 'basalt' (c. 1773). Wedgwood also adapted it for the manufacture of classical formed vases, relief moulded plaques, etc. Very many 18th and early 19th century manufacturers produced 'basalt' or 'Egyptian black' wares and Wedgwood's still produce the body today.

BISQUE

'Bisque' or 'biscuit' porcelain is simply the once-fired body without the addition of glaze. Bisque figures and groups were popular on the Continent in the 18th century, and in England the Derby factory produced tasteful examples from c. 1770. It is noteworthy that such pieces were more expensive than the same model which had been glazed and coloured, because the bisque examples had to be perfect in every respect. Several early 19th century factories produced charming biscuit figures, groups and animals, until the new, creamy-coloured, Parian body became fashionable in the 1840's.

Victoria and Albert Museum. Crown copyright

BLUE AND WHITE

18th-century porcelain and pottery wares were often decorated in underglaze-blue (that is, blue applied on the bisque body before glazing). Such designs were very popular and often depicted an Oriental influence, as the designs were suggested by the popular Chinese porcelains imported into England at this period. 'Blue and White' can be most interesting and decorative, and examples from the Bow, Bristol, Caughley, Derby, Liverpool, Longton Hall, Lowestoft and Worcester factories are to be found.

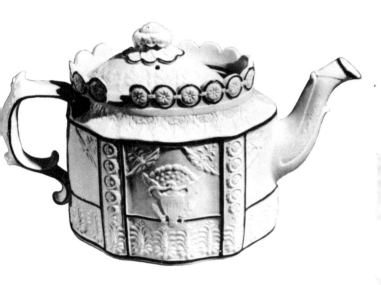

CASTLEFORD WARE

'Castleford' is largely a genetic term, covering a class of white, semi-porcelainous (slightly translucent) stoneware, with a slight glaze. Teapots with hinged or sliding cover (as illustrated), with blue enamel line borders, are typical, but such wares were by no means restricted to the Castleford factory in Yorkshire. Many potters of the 1800–20 period made these attractive wares.

CREAMWARE

Creamware is a cream-coloured earthenware, introduced c. 1740. It soon became the standard English pottery body, replacing the delft-type and salt-glazed wares. Josiah Wedgwood refined and perfected this body and used the name 'Queen's ware'. It is light in weight, pleasant to the touch and neat.

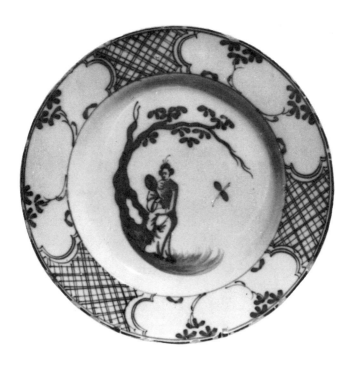

DELFT

Delft type wares have a clay-coloured body which has been coated with an opaque, whitish (oxide of tin) glaze. This glaze tends to chip at the edges, exposing the clay body (see illustration). The Delft technique was widely used on the Continent, and in England was made at London (Lambeth and Southwark), Bristol, Dublin, Glasgow, Limerick, Liverpool and Wincanton, from the 17th century into the 18th century, when it was outmoded by the new creamwares.

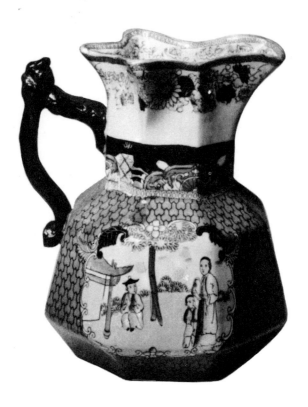

IRONSTONE

The Ironstone body was patented by Charles James Mason in 1813. As the name suggests, it was a strong, durable body. A fine range of useful wares were made—dinner services, sets of jugs, etc., often decorated with rich Chinese-styled designs. The name has been continued to the present day by Messrs Ashworths.

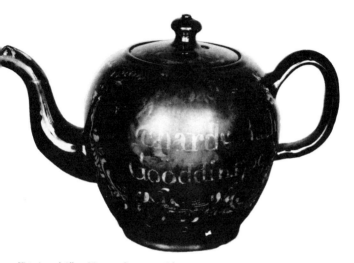

Victoria and Albert Museum. Crown copyright

JACKFIELD

'Jackfield' is largely a generic name
for a class of earthenware decorated
with a glossy black glaze. Tradi-
tionally this type of ware was made
at Jackfield, near Coalport in
Shropshire, but excavations and
other evidence suggest that such
pieces were also made in Stafford-
shire and at other ceramic centres,
in the 18th century.

JASPER

Jasper is a fine-grained, hard earthenware which can be stained to various tints. Josiah Wedgwood experimented with jasper bodies during the 1770's and his name is rightly connected with it, although many other potters emulated Wedgwood's celebrated jasper wares. The tinted body, often blue (but see Colour Plate XIV of the *Illustrated Encyclopaedia of British Pottery and Porcelain*), is normally set off with added white relief motifs.

LUSTRE

Lustre decorated earthenwares and porcelains come in many forms, the most common being the 'copper lustre' (produced from gold); this often completely covers the object. Silver lustre was also employed in the same manner. Other lustre effects were also employed, one type being built up by one or two washes of lustre forming the scenic or other motif. The so-called Sunderland lustre was splashed to give a distinctive effect. Lustre decoration is 19th century in period, although it has been *reproduced* in the 20th century.

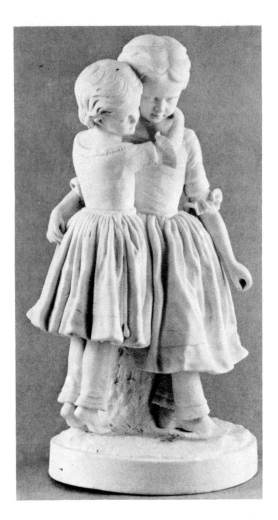

PARIAN

A creamy-white porcelainous body sometimes with a slight smear-glaze. Introduced in the early 1840's for the mass reproduction in miniature of famous marble statues, etc., hence the contemporary term 'statuary porcelain'. At first produced by Copeland, Minton and Wedgwood, and subsequently mass-produced by a host of small firms. The better pieces bear makers' marks. See Chapter VII of *Victorian Porcelain* (1961).

PÂTE-SUR-PÂTE

The most expensive form of ceramic decoration, in which the cameo-like effect is slowly built up layer by layer. M. L. Solon of Mintons (page 96) excelled in this technique and trained several followers. Other firms produced similar effects; see Chapter VIII of *Victorian Porcelain* (1961).

PORCELAIN

All porcelain is translucent (as opposed to opaque pottery), the translucency depending on the quality of the porcelain, the thickness of the piece and on the temperature at which it was fired; underfired porcelain is not very translucent. With the exception of Bristol, Plymouth, pre-1812 New Hall and pre-1820 Coalport porcelain, all English wares are soft paste as opposed to the glittery hardpaste Oriental and German porcelains.

POTTERY

Pottery is opaque. The general term covers various types: creamware, tin-glazed delft-type wares, ironstones, terra-cotta, etc.

PRINTING

Victoria and Albert Museum. Crown copyright

The first type of ceramic printing was over (or on) the glaze; this was practised at Worcester, London and Liverpool in the 1750's (see R. Hancock and Sadler). By the late 1760's printing in blue under the glaze had been introduced and was widely practised at Worcester, and later at Caughley and Lowestoft. The Staffordshire potters also decorated their earthenwares with such underglaze prints, the willow pattern being the best known and lasting example (see illustration). In the 1800–20 period porcelains as well as earthenwares were decorated with 'bat prints'. These were transferred from glue-bats, the subjects were engraved with fine dots rather than lines, and a delicate effect was produced.

Fitzwilliam Museum, Cambridge

REDWARES

As the name suggests, these are reddish-coloured earthenwares, normally without glaze. This type of ware is associated with the Elers Brothers (late 17th century), but several other potters produced similar wares well into the 18th century. The example illustrated has the name Joseph Edge and is dated 1760. The wares emulated the Oriental red teapots.

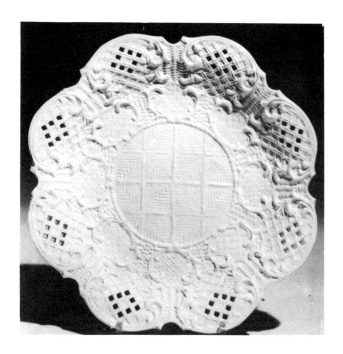

SALTGLAZE

Stonewares, both white (as illustrated) and clay coloured, were, in the first half of the 18th century, often glazed by throwing salt into the kiln during firing. The resulting glaze is hard but slightly pitted, like orange peel. Some firms, notably Doultons, produced saltglazed wares into the 19th century.

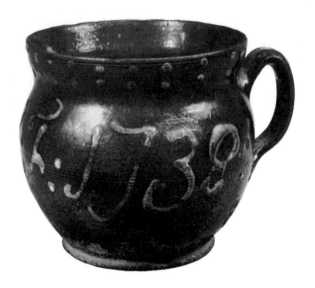

SLIP WARES

These wares get their name from the traditional method of decoration, in which 'slip' (clay, white or tinted, diluted to the consistency of cream) is trailed on to the earthenware. The technique is similar to that of decorating an iced cake; the result is primitive, but often charming. Names and dates (17th and early 18th century) occur.

STONEWARE

A compact, clay-colour, highly fired earthenware, often glazed with salt. Made in London (Fulham), Nottingham and at other centres from the 17th century onwards. The example illustrated is dated 1722.

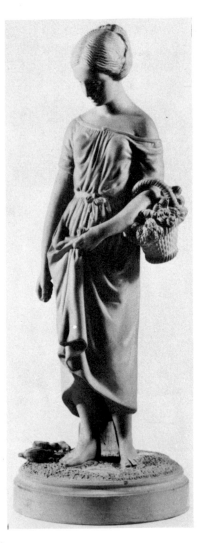

TERRA-COTTA

A reddish earthenware without glaze; although of great antiquity it was not revived by English potters before the 1840's (except for some 18th-century Wedgwood pieces). The example shown is a rare and attractive figure bearing the printed mark of the Watcombe Terra-cotta Clay Co. in South Devon, c. 1880.

BASALT Wedgwood plaque, $7\frac{1}{2}$ in. high, and Warburton covered sugar, c. 1800–10.

BISQUE Minton type figure, $7\frac{1}{2}$ in. high, c. 1820–30.

BLUE AND WHITE Early Worcester vase and cover, $15\frac{3}{8}$ in. high, c. 1765.
(Victoria and Albert Museum. Crown copyright.)

CASTLEFORD Castleford type teapot with sliding cover. American Arms relief motif, c. 1810–20.

CREAMWARE Marked 'Neale & Co', creamware ice-pail, c. 1778–88.

DELFT Typical English delft plate; chip to edge shows pottery body under white opaque glaze.

IRONSTONE Mason's Ironstone jug of typical shape and style of decoration, c. 1840.

JACKFIELD Black Jackfield type teapot inscribed and dated 1769 in gold.
(Victoria and Albert Museum. Crown copyright)

JASPER Marked Wedgwood blue jasper vase with applied white relief motifs, $10\frac{1}{2}$ in. high.

LUSTRE 'Silver' lustre earthenware coffee pot, c. 1825.
(Victoria and Albert Museum. Crown copyright)

PARIAN Mid-Victorian parian group, unmarked, 16 in. high, c. 1850.

PÂTE-SUR-PÂTE Minton Pâte-sur-Pâte vase by M. L. Solon, c. 1896.

PORCELAIN Marked Nantgarw dish shown against a light, illustrating the fine semi-translucent body.

PRINTING	Plate decorated with willow pattern in under-glaze blue, dated 1818. (Victoria and Albert Museum. Crown copyright)
REDWARE	A fine redware coffee pot incised name and date—Joseph Edge, 1760. $8\frac{3}{4}$ in. high. (Glaisher Coll., Fitzwilliam Museum, Cambridge)
SALTGLAZE	A typical moulded and pierced saltglaze dish, 9 in. diameter, c. 1765.
SLIPWARE	A simple Wrotham-type pot decorated with applied slip, 5 in. high. (Messrs Sotheby & Co.)
STONEWARE	A Fulham type tankard, inscribed 'This is to the proud memory of Queen Ann. Edward Venden 1722'. 8 in. high.
TERRA-COTTA	A Watcombe terra-cotta figure bearing the printed Kingfisher mark (see page 130), c. 1880.

Unless otherwise stated, the illustrations have been supplied by Messrs Godden of Worthing Ltd.

THE MARKS

A

RICHARD ABBEY

Engraver and printer at Liverpool.

R. ABBEY, SCULP.

Signature mark found on some printed designs engraved by Abbey, c. 1773–80. Signed examples are rare.

WILLIAM ABSOLON

Decorator of earthenwares at Yarmouth, Norfolk.

ABSOLON YARM.
No. 25

Painted marks occur c. 1784–1815. Reference to 'N.25' or 'No. 25' relates to the address in Market Row and denotes a date subsequent to 1790. Examples illustrated in Godden's *Illustrated Encyclopaedia of British Pottery and Porcelain*. For detailed information see *Transactions of the Engiish Ceramic Circle*, Vol. 5, Part 1. Signed examples of Absolon's decorations are rare.

WILLIAM ADAMS

Manufacturer of earthenwares, basalt, jasper, ironstone wares, etc., under various styles: 'W. Adams & Co.', 'W. Adams & Son', 'William Adams & Sons (Potters) Ltd', from 1769 to present day.

ADAMS
ADAMS & CO.

Early wares made before about 1780 would not seem to be marked. Impressed 'Adams' or 'Adams & Co.' marks occur on various wares from 1785.

Printed or impressed mark on fine blue printed earthenware made for European and American markets, c. 1804–40.

W. ADAMS & SONS
W. A. & S.

Various marks incorporating style 'W. Adams & Sons' or initials 'W. A. & S.', c. 1819–64.

Various printed and impressed marks incorporating style 'W. Adams & Co.' or initials 'W. A. & Co.' used c. 1893–1917. 'England' added under marks from 1891.

ADAMS
TUNSTALL

ADAMS
ESTBD 1657
TUNSTALL,
ENGLAND

Impressed marks on Wedgwood-type jasper wares, etc., c. 1896 +.

Printed mark on stoneware and 'ivory' wares, c. 1899 +.

Printed mark used for many years from 1914. For further information, see new 15th edition of *Chaffers*, pp. 54–7; *William Adams, an Old English Potter* by W. Turner (1904); Godden's *Illustrated Encyclopaedia of British Pottery and Porcelain*, Plates 8–11; and Chaffers' *New Keramic Gallery*, figs. 473–4.

SAMUEL ALCOCK & CO.
Manufacturers of porcelain, parian and earthenware at Cobridge and Burslem, Staffordshire, c. 1828–59.

SAML. ALCOCK & CO.
COBRIDGE

Various name-marks with place-name 'Cobridge' employed during 1828–53 period.

PUBLISHED BY
S. ALCOCK & CO.
BURSLEM

ALCOCK & CO.
HILL POTTERY
BURSLEM

Numerous name-marks with place-name 'Burslem' were employed during 1830–59 period. Other marks incorporate, or consist of, the initials 'S. A. & Co.'

ALCOCK'S
INDIAN IRONSTONE

Impressed marks on ironstone earthenwares, recently found on the factory site; one piece is dated 1839.

PATENT
SAMⁱALCOCK&CO.

For further information and illustrations, see Godden's *British Pottery and Porcelain 1780–1850* and the *Illustrated Encyclopaedia of British Pottery and Porcelain*, Plates 12–15.

CHARLES ALLERTON & SONS

Manufacturers of earthenwares and china, lustre decoration a speciality, c. 1859–1942.

Many marks occur with the name or initials of this firm. The printed marks reproduced cause confusion on account of the date incorporated in the marks; they were not used until the 20th century.

ASHBY POTTERS' GUILD

Manufacturers of earthenwares, often with decorative glaze effects, at Woodville, near Burton-on-Trent, from 1909 to 1922.

ASHBY
GUILD

Standard Ashby mark (in oval outline) and initial mark of proprietor Pascoe H. Tunnicliffe. Decorators' initial marks also occur (see revised 15th edition of *Chaffers*).

G. L. ASHWORTH & BROS (LTD)

Manufacturers of earthenwares at Hanley, c. 1861 to present day.

ASHWORTH

A. BROS

G. L. A. & BROS

Many different printed marks incorporate the name 'Ashworth(s)' or the initials given. c. 1861+. Messrs Ashworth possess the original Mason Ironstone designs and moulds and have produced 'Mason's Ironstone' to a considerable extent, sometimes re-using the Mason printed marks (see page 89). The Ashworth *impressed* name-mark may also occur on these Mason marked examples.

WILLIAM AULT

Manufacturer of earthenwares at Swadlincote, near Burton-on-Trent, Staffordshire, c. 1887–1923.

Standard printed mark, the initials 'A. P.' also occur, joined, c. 1887–1923.

AYNSLEY
LANE END

JOHN AYNSLEY

Engraver and printer at Lane End, Staffordshire, c. 1780–1809.
Name 'marks' occur incorporated in printed patterns found on good-quality creamwares of the 1780–1809 period; the christian name 'John' or initial 'J' is added to some marks. Examples are now rare.

B

WILLIAM BADDELEY

EASTWOOD

Manufacturer of earthenwares, often in Wedgwood style, at Eastwood, Hanley, c. 1802–22. Impressed mark, the place-name 'Eastwood'. Examples are now rarely found. See also new revised 15th edition of *Chaffers*, p. 72.

BAGGERLEY & BALL

B. & B.
L.

Manufacturers of earthenwares at St James' Place, Longton, Staffordshire, c. 1822–36. Printed marks incorporating these initials, c. 1822–36. A typical jug (with date 1823) is illustrated in Godden's *British Pottery and Porcelain 1780–1850*.

ALFRED BAGULEY

BAGULEY
ROCKINGHAM
WORKS

ROCKINGHAM
WORKS
BAGULEY
MEXBRO.

Decorator of porcelains at the former Rockingham Works, c. 1855–65, and at Mexborough, Yorkshire, c. 1865–91.
Rare painted or printed name-mark, often including the griffin crest found on Rockingham porcelains (see page 114), c. 1842–65. This form of mark was probably used by Isaac Baguley from 1842 to 1855 and was continued by Alfred.
Rare post-1865 mark with Mexborough (or 'Mexbro') address, c. 1865–91.
Some porcelains bearing this decorator's mark also bear the mark of the original manufacturer.

BAKER, BEVANS & IRWIN

BAKER BEVANS & IRWIN
SWANSEA

Manufacturers of earthenwares at the Glamorgan Pottery, Swansea, Wales, c. 1813–38.
Standard impressed name-mark, c. 1813–38.

B. B. & I.
B. B. & Co.
G. P. Co.

Several different printed marks incorporate the initials 'B. B. & I', 'B. B. & Co.' or G. P. Co. (for Glamorgan Pottery Co.), c. 1813–38.

W. L. BARON

Manufacturer of decorative earthenware at Barnstaple, Devon, c. 1899–1939. Formerly employed at C. H. Brannam's Pottery (see page 47).

W. L. BARON

BARON, BARNSTAPLE

Impressed or painted name-marks, c. 1899–1939.

BATHWELL & GOODFELLOW

Manufacturers of earthenwares at Burslem and Tunstall, c. 1818–23.

BATHWELL
GOODFELLOW

Rare impressed mark, c. 1818–23.

N.B. This firm is sometimes listed as **BOTH-WELL & GOODFELLOW** in error.

BELLEEK WORKS

Messrs David McBirney & Co. produced attractive parian, porcelain and earthenwares at Belleek, Co. Fermanagh, Ireland, from c. 1863. These wares have a characteristic iridescent glaze and shapes are often based on marine forms. The works still produce similar wares.

BELLEEK
Co. FERMANAGH

Impressed or relief moulded name-mark, c. 1863–90.

Standard printed mark, c. 1863–91. Post-1891 marks have a ribbon below this device with the wording 'Co. Fermanagh, Ireland', see below. For further information, see *Ceramic Art of Great Britain* by L. Jewitt (1883). Examples are included in the *Illustrated Encyclopaedia of British Pottery and Porcelain*, Plates 40–5.

JOHN BEVINGTON

Manufacturer of decorative (Dresden-style) porcelain at Hanley, c. 1872–92.

Blue painted mark, often on floral-encrusted porcelains or figures, c. 1872–92. Examples are illustrated in the *Illustrated Encyclopaedia of British Pottery and Porcelain* (1966), Plate 48.

E. B.

EDWARD BINGHAM

Manufacturer of pottery (in early style) at Castle Hedingham, Essex, c. 1864–1901.

Moulded relief mark on early-looking pottery (sometimes with incorrect dates). The signature mark also occurs incised, as do the initials 'E. B.'

See also new revised 15th edition of *Chaffers*, pp. 268–9. A typical specimen, with a photograph of Bingham, is included in Godden's *Illustrated Encyclopaedia of British Pottery and Porcelain*.

E. J. BIRCH

Manufacturer of Wedgwood-type earthenwares, basalt body, etc., at Shelton, c. 1796–1814.

Birch

E. I. B.

Impressed name or initial* marks, c. 1796–1814, somewhat rarely found today. Three typical specimens are illustrated in Godden's *Illustrated Encyclopaedia of British Pottery and Porcelain*.

BISHOP & STONIER

Manufacturers of porcelain and earthenwares at Hanley, c. 1891–1939.

Printed trade marks, often with trade name, 'BISTO'. 'ENGLAND' added to these basic marks on most examples.

Other marks of this firm included the name in full, c. 1891 + .

T. & R. BOOTE LTD

Manufacturers of earthenwares, ironstone, etc., at Burslem from 1842 to present day.†

* The initial 'J' is nearly always given as 'I' in 18th and early 19th century marks.

† From 1906 Messrs T. & R. Boote Ltd have concentrated on the manufacture of tiles.

T. & R. BOOTE

T. & R. B.

Early marks consist of (or incorporate) the firm's name or initials. The word 'England' was added to marks from 1891.

Standard printed mark, c. 1890–1906.

BOOTHS (LIMITED)

Manufacturers of earthenwares, at Tunstall, c. 1891–1948.

Blue printed or painted mark found on reproductions of 18th-century blue and white Worcester porcelain, c. 1905–20. Other marks used by this firm incorporate the name 'BOOTHS'.

N.B. Messrs Booths' reproductions are of opaque earthenwares, whereas the originals were in transparent porcelain.

CHARLES BOURNE

Manufacturer of porcelain at Fenton, c. 1807–1830.

Rare painted mark on high-grade decorative porcelain, c. 1807–30. This mark is often mistaken for a Coalport or Coalbrookdale mark. The number appearing below the initials relates to the pattern and therefore varies. The full name-mark, 'Charles Bourne', has been reported. Typical marked specimens are illustrated in Godden's *Illustrated Encyclopaedia of British Pottery and Porcelain*, Colour Plate I. See also *Collectors' Guide* magazine, May 1967.

J. BOURNE (& SON LTD)

Manufacturer of stoneware and earthenware at Belper and Denby, Derbyshire, from c. 1812 to present day.

BELPER & DENBY

BOURNE'S
POTTERIES
DERBYSHIRE

Early impressed name-mark on moulded ornamental bottles, etc., first half 19th century.

DENBY

Several 20th-century marks consist of, or include, the trade name 'DENBY'.

BOW PORCELAIN FACTORY (also known as 'New Canton', a name which occurs on rare inkwells)

This factory was established in the 1740's and with the Chelsea works (see page 51) ranks as the earliest British manufactory of transparent *porcelain*. Specimens, especially the early pre-1760 articles, are rare and desirable, but many pieces do not bear a factory mark. The factory closed c. 1776.

Examples of several early incised or impressed marks, c. 1750–60.

NUMERALS PAINTED
IN UNDERGLAZE
BLUE

Specimens decorated in underglaze blue often have workmen's numbers painted on the bottom (not on the inside of the footrim as on the similar Lowestoft porcelains). For this aspect of the factories' productions, see B. Watney's *English Blue and White Porcelain of the 18th Century* (1963).

Painted anchor and dagger mark normally found on post-1760 figures and groups. The marks also sometimes occur on French 'hard-paste' reproductions.

The impressed 'Tebo' mark is found on Bow (as well as other) porcelains (see page 125).

The blue crescent mark also occurs, as it does on Worcester, Caughley and Lowestoft porcelains. The Bow porcelain body (like that employed at Lowestoft) contains a high proportion of bone ash. Typical specimens can be seen at the Victoria and Albert Museum and at the British Museum in London.

For further details and illustrations, see British Museum *Catalogue of 1959 Exhibition of Bow Porcelain*; revised 15th edition of *Chaffers*, pp. 270–90; *The New Keramic Gallery*, figs. 524–5, 530–9, 541–4; Godden's *Illustrated Encyclopaedia of British Pottery and Porcelain*, Plates 66–71; also *English Porcelain 1745–1850* (1965) edited by R. J. Charleston.

G. F. BOWERS (& CO.)

G. F. BOWERS
TUNSTALL
POTTERIES

G. F. B.

Manufacturer of porcelain and pottery at Brownhills, Tunstall, c. 1842–68.
Impressed or printed name-mark. The initials 'G. F. B.' were incorporated in other marks, c. 1842–68.

ZACHARIAH BOYLE (& SONS)

Z. B.

Z. B. & S.

Manufacturers of earthenware at Stoke and Hanley, c. 1823–50.
Several printed marks occur incorporating these initials, c. 1823–50. '& S.' or '& Sons' added to basic initials from 1828.

WALTER BRADLEY & CO.

BRADLEY & CO.
COALPORT

Manufacturers of basalt and creamwares at Coalport, Shropshire, c. 1797–1803.
This rare impressed mark has hitherto been attributed to J. Bradley & Co., retailers, of London, but a recently discovered 'Walter Bradley & Co. . . . Coalport Pottery' advertisement dated April 1797 indicates the true meaning of this mark. Two marked basalt teapots, in the Victoria and Albert Museum, are shown in Godden's *Illustrated Encyclopaedia of British Pottery and Porcelain*, Plate 73.

E. BRAIN & CO. LTD

Manufacturers of porcelain at Foley Works, Fenton, 1903–63.
Early printed mark, c. 1903 +.

Printed mark, c. 1905. Note use of word 'FOLEY'* extensively used on many different marks to 1963, with the initials 'E. B. & Co.' or the name in full.

* Also used by WILEMAN & CO., c. 1892–1925 (see page 132).

C. H. BRANNAM LTD

Manufacturers of earthenwares at Barnstaple, Devon, c. 1879 to present day.

C. H. BRANNAM
BARUM

Incised signature mark in writing letters; many other impressed marks occur, incorporating the name 'BRANNAM' with the place-name 'BARNSTAPLE' or 'BARUM', c. 1879 +.

IVY BREADING

Modeller of fine-quality individual figures of 'Cries of London' type, at Fulham, London, in the 1920's.

I. BREADING
FULHAM. 1925

I. BREADING
1926
FULHAM POTTERY

Incised marks with varying dates found on Miss Breading's pottery, examples of which are rare, c. 1920 +.

BRIDGWOOD & CLARKE

Manufacturers of earthenwares at Churchyard Works, Burslem, c. 1857–64.

BRIDGWOOD
& CLARKE

B. & C.
BURSLEM

Several marks occur incorporating the initials 'B. & C.' or the firm's name in full, c. 1857–1864.

BRISTOL

BRISTOL or BRISTOLL

Very rare relief moulded marks found on sauce boats and figures, c. 1750. See the *Illustrated Encyclopaedia of British Pottery and Porcelain*, Plates 79–80.

The city of Bristol was one of the earliest centres of the British ceramic industry. Tin-glazed delft-type earthenwares were produced in the first half of the 18th century, but such wares are seldom marked. Various earthenwares were also produced and porcelain as early as c. 1750. *Hard*-paste porcelain was produced from c. 1770 to 1781. The marks on this porcelain are:

A painted cross or letter B, often with painter's or gilder's number added. Reproductions occur, mainly in a soft-paste body; these reproductions often have a date below the cross mark.

The crossed-swords mark (of the Dresden factory) occurs in underglaze blue on Bristol porcelain of the 1770–81 period, often with painters' or gilders' numerals added in overglaze enamel or in gold.

The impressed or moulded 'Tebo' mark also occurs on some Bristol porcelain, but see page 125.

Bristol porcelain is rare and desirable, except for pieces bearing simple floral patterns. Good examples can be seen in the Bristol City Art Gallery and Museum, and at the Victoria and Albert Museum in London.

For further information and illustrations, see *Bristol Porcelain* by F. Hurlbutt (1928); *Champion's Bristol Porcelain* by F. Severne Mackenna (1947); new revised 15th edition of *Chaffers*, pp. 228–44; and *Illustrated Encyclopaedia of British Pottery and Porcelain* by G. Godden (1966).

WILLIAM BROWNFIELD (& SONS)

Manufacturers of earthenwares and porcelain (the latter from 1871) at Cobridge, c. 1850–1891.

W. B.

W. B. & S.

W. B. & Son

Various printed, impressed or moulded marks incorporating these initials were used. '& S.' or '& Son' added from 1871. The name 'Brownfield' was also used.

BROWN-WESTHEAD, MOORE & CO.

Manufacturers of high-grade earthenwares and porcelain at Cauldon Place, Hanley, c. 1862–1904.

Various printed marks incorporating the initials 'B. W. M.' or 'B. W. M. & Co.' used 1862–1904. The name of the firm in full was also used.

C

CARTLEDGE JOHN ; Cobridge Staffordshire Potteries
Earthenware Figures
c 1800
"John Cartledge, at the Lodge in Plantation
Cowbridge 1800" This inscription on pair
earthenware figures

THOMAS & JOHN CAREY

Manufacturers of earthenwares, 'Saxon Stone' ware, etc., at Lane End, c. 1823*–42. Standard impressed name-mark, often with an anchor; several printed marks also occur incorporating the name 'Carey's'. Good-quality blue printed wares were made c. 1823*–42.

CAREY'S

CASTLEFORD. See D. DUNDERDALE & CO., page 67.

CAUGHLEY PORCELAIN WORKS, situated near Broseley in Shropshire. Good porcelain in the Worcester style was made by Thomas Turner from c. 1775 to 1799, when John Rose of the nearby Coalport factory took over the Caughley concern.

SALOPIAN Impressed 'Salopian' name-marks in upper or lower case letters, c. 1775–99.

 Blue painted or printed 'S' marks, often with a small cross or circle after, found on underglaze-blue decorated wares, c. 1775–c. 1795.

 Printed and painted 'C' marks relating to Caughley but this initial mark is sometimes mistaken for a crescent, c. 1775–95.

Blue printed crescent mark (also used as a mark on Worcester specimens). Found on blue *printed* examples, an open or unshaded crescent may occur on blue *painted* articles, c. 1775–95.

* The Thomas & John partnership dates from 1823, but John Carey was potting from 1813. The anchor device relates to the address: Anchor Works, Anchor Road.

 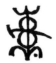

Numerals disguised as Chinese characters occur on blue printed porcelains traditionally attributed to Caughley, but recent research suggests that these are Worcester marks of the 1770–83 period. A recessed but relief moulded version of the Royal Arms is very rarely found under Caughley jugs of the cabbage-leaf type.

The later 1785–99 wares, often decorated with simple floral motifs, do not appear to have been marked.

For further information and illustrations, see new revised 15th edition of *Chaffers*, pp. 134–135; F. A. Barrett's *Caughley and Coalport Porcelain* (1951); and Godden's *Illustrated Encyclopaedia of British Pottery and Porcelain* (1966), Plates 95–102.

Recent excavations on the factory site have shed much fresh light on the productions, and a new reference book on Caughley porcelain is in preparation. A good selection of Caughley porcelain can be seen in the Victoria and Albert Museum.

CHAMBERLAIN (& CO.)

Manufacturers of porcelain at Worcester from c. 1788 to 1852.

Chamberlain's
Chamberlain's
Worcester
Warranted

Painted name-mark in writing letters often with place-name 'Worcester' or 'Worcester Warranted' added, also with pattern number on early wares, c. 1788–1810. On teapots the mark is inside the cover. Different spellings, even of 'Worcester', occur.

Crown device

A crown and/or the word 'Royal' added to name-marks from c. 1811 to c. 1840.

REGENT CHINA

New 'Regent' body introduced c. 1811 and description added to marks. The 'Regent' body was expensive and is rather rare.

Chamberlain's
Worcester
& 63, Piccadilly,
London.

Address of London retail shop added to name-marks from 1814 to mid 1816.

155 NEW BOND STREET

New London address added to marks from July 1816.

| CHAMBERLAIN & CO. | '& Co.' added to style and marks from c. 1840; new address 'No. 1. Coventry Street London' also occurs (c. 1840–5). |

| GRANITE CHINA W. C. & Co. | Rare impressed mark, on special heavy and durable porcelain, c. 1845–52. |

| CHAMBERLAINS WORCESTER | Impressed mark, c. 1846–50. |

Printed mark, c. 1850–2. Factory continued by Messrs Kerr & Binns (see page 138).

For further information and illustrations, see Godden's *Illustrated Encyclopaedia of British Pottery and Porcelain*.

CHELSEA PORCELAIN WORKS

Produced attractive porcelain—decorative figures, etc., as well as useful wares—from c. 1745 to 1769, when the Chelsea-Derby period commenced. Early Chelsea porcelain is rare and desirable.

Incised (not impressed) triangle mark on early wares, which were sometimes left undecorated. The place-name 'Chelsea' and a date occur on some very rare specimens with an incised triangle mark, c. 1745–50. All triangle marked examples are rare.

Very rare underglaze-blue crown and trident mark, c. 1748–50.

Rare *raised*, moulded mark of small size, called the 'raised anchor mark', c. 1749–52. Marked examples are rare and desirable. On some examples the anchor is picked out in red.

Photographic reproductions of the above four Chelsea marks are included in the *Illustrated Encyclopaedia of British Pottery and Porcelain*, Plates 115, 116, 122A and 126.

Small anchor painted in red—the 'red anchor mark' used c. 1752–6. In some cases numerals occur with the anchor device, as on the example reproduced. Red anchor period Chelsea porcelain is desirable.

Small anchor painted in gold—the 'gold anchor mark' used c. 1756–69. Many reproductions of gold anchor period Chelsea porcelain bear this mark, often painted larger than the original; *any anchor mark over a quarter of an inch in height should be treated with great suspicion.*

Most general reference books give at least a brief history of the factory and illustrate some specimens. Specialist books include F. S. Mackenna's *Chelsea Porcelain, the Triangle and Raised Anchor Wares* (1948), *Chelsea Porcelain, the Red Anchor Wares* (1951), and *Chelsea Porcelain, the Gold Anchor Period* (1952); also Arthur Lane's *English Porcelain Figures of the 18th Century* (1961), and *English Porcelain 1745–1850* (1965) edited by R. J. Charleston. A good selection of illustrations is included in Godden's *Illustrated Encyclopaedia of British Pottery and Porcelain* (1966), Plates 112–46.

CHELSEA-DERBY

William Duesbury, the proprietor of the Derby porcelain factory, purchased the Chelsea works in 1769. Porcelain continued to be made or decorated at the Chelsea factory until 1784 under Duesbury's direction.

The former Chelsea gold anchor mark was continued and two new marks were introduced, incorporating the Chelsea anchor and the Derby crown or initial 'D'. These 'Chelsea-Derby' marks are normally painted in gold. The decoration is tasteful and restrained (see Godden's *Illustrated Encyclopaedia of British Pottery and Porcelain*, Plates 147–52.

CHETHAM (& SON)

Manufacturer of earthenwares at Longton, c. 1810–35, succeeded Chetham & Woolley, see next entry.

CHETHAM

CHETHAM & SON

Impressed name-mark, c. 1810–18. '& SON' added to name-mark, c. 1818–34. Marked examples are rare.

CHETHAM & WOOLLEY
Manufacturers of earthenwares at Lane End, Longton, c. 1796 to November 1809, when Ann Chetham continued the works.

CHETHAM & WOOLLEY Impressed name-mark, 1796–1809. Marked examples are rare.

SMITH CHILD
Manufacturer of earthenwares at Tunstall, c. 1763–90. Early wares unmarked.

CHILD Rather rare impressed mark, c. 1780–90.

J. CLEMENTSON
Manufacturer of earthenwares at Phoenix Works, Shelton, Hanley, c. 1839–64.

J. C.

J. CLEMENTSON

Several printed marks occur with the initials 'J. C.' or the name 'J. Clementson'. The full mark occurs on examples dated 1839 as well as later examples. The works were continued by Clementson Brothers, c. 1865–1916; these later marks incorporate the name of the new firm.

JAMES & RALPH CLEWS
Manufacturers of earthenwares at Cobridge, c. 1818–34.

CLEWS
WARRANTED
STAFFORDSHIRE

Several different impressed or printed marks were used by the Clews, each including the name. Good-quality blue printed earthenware as well as 'Stone China' was made, much of which was for the American market, c. 1818–1834. Porcelain was made in the 1821–5 period, but this does not appear to have been marked.

CLOSE & CO.

Manufacturers of earthenwares at Church Street, Stoke, c. 1855–64.

T. CLOSE & CO.

Several impressed or printed marks occur with the name 'Close & Co.'; these often record the fact that the firm succeeded W. Adams & Sons, c. 1855–64.

COALPORT PORCELAIN WORKS

Established at Coalport, Shropshire, by John Rose late in the 18th century, early pre-1805 porcelains were unmarked and marks were rarely used before 1820. The early, pre-1820 Coalport wares have proved to be of a type of hard-paste porcelain.

COALBROOKDALE

Very rare early painted mark in red enamel (see *Illustrated Encyclopaedia of British Pottery and Porcelain*, Plates 158–9).

2

The impressed numeral '2' on plates helps to identify many fine Coalport services and single plates of the 1805–25 period.

Coalport.

Rare name or initial marks painted in underglaze blue, c. 1810–25. The decorative floral-encrusted porcelains often bear one of these marks.

C Dale Dale ℬ

C.B. DALE

Rare mark in underglaze blue found on blue printed willow-pattern type designs, c. 1810–1820.

Large printed mark introduced soon after 30th May 1820 on the award of the Society of Arts Gold Medal. Several variations of this mark occur (see *Encyclopaedia of British Pottery and Porcelain Marks*, p. 155), c. 1820–30.

 Printed mark, one of several incorporating the name 'John Rose & Co.' or 'J. Rose & Co.' Many printed marks also incorporate the initials 'J. R. & Co.' or 'I. R. & Co.', c. 1830–1850.

 Painted or gilt monogram mark, c. 1851–61.

 Painted or gilt 'ampersand' mark, c. 1861–1875; the name 'Coalport' rarely appears with this device.

COALPORT, A.D. 1750 Printed or painted mark, c. 1875–81.

 Standard printed mark from 1881 to c. 1939. 'England' added to mark, c. 1891; 'Made in England' replaced 'England' from about 1920.

 Example of post-war printed mark. The company moved from Coalport to Stoke in 1926 and continues at the present time.

Since the publication of F. A. Barrett's *Caughley and Coalport Porcelain* in 1951, much new information has been discovered and a new book is in preparation. Some newly discovered early Coalport porcelains are depicted in Godden's *Illustrated Encyclopaedia of British Pottery and Porcelain* (1966).

R. COCHRAN & CO.
Manufacturers of earthenwares at Glasgow, Scotland, c. 1846–1918.*

* Messrs COCHRAN & FLEMING worked the Britannia Pottery, Glasgow, from 1896 to c. 1920. The marks incorporate the firm's name or the initials 'C. & F.'

**R. COCHRAN & CO.
GLASGOW**

Basic name-mark incorporated in several different marks; the initials 'R. C. & Co.' were also used, c. 1846–1918.

COPELAND & GARRETT

Manufacturers of earthenwares, parian, fine porcelain, etc., at Stoke, 1833–47. Succeeding Messrs Spode (see page 119).

**C. & G.
COPELAND & GARRETT**

Several printed and impressed marks incorporate the name or initials of this partnership, c. 1833–47. Three typical marks are reproduced.

Messrs W. T. Copeland & Son continued from 1847 (see next entry).

W. T. COPELAND & SONS

Manufacturers of earthenwares, parian and fine porcelain at Stoke, 1847 to present day. Successors to Copeland & Garrett (see previous entry).

COPELAND

Standard impressed mark found on earthenware, porcelain and especially the parian figures and groups popularized by this firm, c. 1847+.

Rare printed mark, c. 1847–51.

Standard printed mark, c. 1851–85, a fancy version of the rare earlier mark (see above).

Four standard printed marks found on earthenwares, c. 1867–90; c. 1875–90; c. 1894–1910; c. 1891 into 20th century.

SPODE
COPELANDS CHINA
ENGLAND

Printed mark, sometimes in gold on fine porcelains, c. 1891 into 20th century.

Example of several post-war printed marks which incorporate the old name 'Spode'.

For further information and illustrations, see Arthur Hayden's *Spode and his Successors* . . . (1925) and Godden's *Illustrated Encyclopaedia of British Pottery and Porcelain*, Plates 175–85.

CORK & EDGE

Manufacturers of earthenwares at Burslem, c. 1846–60.

CORK & EDGE

C. & E.

Various printed marks were used incorporating the name 'Cork & Edge' (see example) or the initials 'C. & E.', c. 1846–60.

CROWN STAFFORDSHIRE PORCELAIN* CO. LTD

Manufacturers of high-grade porcelain at Fenton, c. 1889 to present day.*

* Firm retitled 'Crown Staffordshire *China* Co. Ltd' in 1948.

Three basic printed marks, c. 1889+. The name 'England' often added from 1891, also date of establishment 'A.D. 1801'.

Copies of early porcelains sometimes bear these marks.

JOSEPH CYPLES

Manufacturer of earthenwares at Lane End, c. 1784–95. Works continued by other members of the family until c. 1840.

I. CYPLES

Rather rare impressed mark, c. 1784–95. The Cyples name-mark without an initial probably relates to a later date.

D

JOHN DALE

Manufacturer of earthenware figures at Burslem, early in the 19th century.

I. DALE
BURSLEM

Very rare impressed mark found on the back of earthenware figures of the 1820–30 period. An example is included in Godden's *Illustrated Encyclopaedia of British Pottery and Porcelain*, Plate 187.

HENRY & RICHARD DANIEL (DANIEL & SONS)

Manufacturers of high-grade decorative porcelain and earthenwares at Stoke and Shelton, c. 1822–41.

DANIEL & SON

Very rare form of mark, c. 1822–6.

H. & R. DANIEL

Rare form of mark, written or printed, c. 1826–9.

Very rare printed mark, c. 1826–9.

H. DANIEL & SONS

Rare form of mark, c. 1829–41.

All Daniel porcelains are of very fine quality but are seldom marked.

DAVENPORT

Manufacturers (under various styles—W. Davenport & Co., etc.) of earthenwares, porcelain and glass at Longport, c. 1793–1887.

DAVENPORT

Standard early impressed marks on earthenwares. The earliest 'Davenport' mark is found in upper and lower case letters, c. 1793–1820. The last two numerals of the year of manufacture were sometimes added each side of the anchor, '42' for '1842', etc.

Standard printed mark found on 'Stone China' wares, c. 1805–20.

DAVENPORT

Very many printed wares of the 1815–50 period bear different printed marks incorporating the name 'Davenport' and often the name of the pattern.

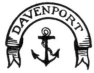

Overglaze printed mark on porcelains, c. 1815–30. Basic mark used later (c. 1840+) but then occurs in underglaze blue.

DAVENPORT
LONGPORT

Rare printed mark on early porcelains, prior to 1820; on some seemingly Davenport wares only the name 'LONGPORT' occurs.

DAVENPORT
LONGPORT
STAFFORDSHRE

Standard printed mark, c. 1870–87.

Examples of Davenport wares are shown in Godden's *Illustrated Encyclopaedia of British Pottery and Porcelain*, Plates 190–200.

WILLIAM DE MORGAN
Manufacturer of decorative earthenwares at Chelsea, Fulham, etc., c. 1872–1907 (decoration continued to 1911).

W. DE MORGAN

Several different marks incorporate the name 'DE MORGAN', sometimes with addresses: 'Merton Abbey', c. 1882–8; 'Sands End', c. 1888+.

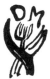

Initial mark, c. 1882. A circular mark also occurs with these initials and last two numerals of the year of production.

For further information and illustrations, see *Catalogue of Works by William De Morgan* (1921); *Victorian Porcelain* by H. Wakefield (1962); or *Illustrated Encyclopaedia of British Pottery and Porcelain*, Plates 209–10 and Colour Plate VI.

DERBY PORCELAIN WORKS

William Duesbury commenced the manufacture of porcelain at Derby, c. 1750, the original factory closed in 1848 (a small works continued in the same tradition, see Stevenson and Hancock, page 62) and a new company was formed in 1878, which now continues the tradition of Derby fine porcelain.

D Derby

Duesbury Period (examples are of good quality and desirable)
Very rare early incised marks, c. 1750–55. Most products prior to about 1770 were unmarked.

PAD MARK

Three 'pad marks' or dark patches occur on the bases of Derby figures, groups or vases. These were formed by the wads of clay placed under the bases to prevent the object sticking to the base of the saggar. A photograph of a typical pad-marked base is included in Godden's *Encyclopaedia of British Pottery and Porcelain Marks*, Plate 8, and in the companion *Illustrated Encyclopaedia of British Pottery and Porcelain*, Plate 214.

N

Incised initial, rarely found on flatware—plates, dishes, etc.—not to be confused with abbreviation of 'number' placed before the model number on the base of figures, etc., c. 1770–80.

Rather rare painted mark, normally in blue, c. 1770–82.

Standard post-1782 mark, *incised* under the bases of figures, groups, vases, etc.
Painted neatly and of small size, in puce, blue or black, c. 1782–1800.
Painted in red, often carelessly, c. 1800–25.

Painted mock-Dresden mark (similar Dresden-style marks are found on other wares), c. 1785–1825.

Bloor Period
Earliest painted or transferred (by the thumb) Bloor Derby mark, in red, c. 1820–40.

Painted or printed Bloor Derby marks, c. 1825–48.

The main factory closed in 1848, but a group of former employees started a new works at King Street, Derby. The following marks were employed, but are rare.

1849–59 1859–61 1849–63

Standard 'Stevenson & Hancock' mark (old basic mark with new initials 'S' and 'H' at the sides), 1861–1935.

A new company was formed in 1876. The prefix 'Royal' was granted in 1890.

Standard printed mark (without wording), c. 1876–89.

Standard printed mark, from January 1890, note wording 'Royal Crown Derby' added to former mark; the word 'England' was added to mark from 1891, and was replaced by 'Made in England' in about 1921.

N.B. Various devices were added below the last two standard marks; these show the year of decoration for any object from 1882 onwards. The key to this dating system is given in Godden's *Victorian Porcelain* (1961) and in *Encyclopaedia of British Pottery and Porcelain Marks* (1964), p. 204.

For further information and illustrations, see *The Old Derby China Factory* by J. Haslem (1876); *Crown Derby Porcelain* by F. Brayshaw Gilhespy (1954); *Derby Porcelain* by F. Brayshaw Gilhespy (1961); *Victorian Porcelain* by G. A. Godden (1961); *Royal Crown Derby China* by F. B. Gilhespy and D. Budd (1964); *English Porcelain 1745–1850* edited by R. J. Charleston (1965); and *Illustrated Encyclopaedia of British Pottery and Porcelain* by G. A. Godden (1966).
A good selection of Derby porcelain can be seen in the new Derby Museum and Art Gallery, and at the Victoria and Albert Museum in London.

DERBY POT WORKS
Situated at Cockpit Hill, Derby. The early experimental Derby porcelains may have been made at this works, but it is chiefly known for the rare earthenwares bearing printed designs, which are sometimes signed. The works closed, c. 1780.

POT WORKS IN DERBY
RADFORD Sc
DERBY POT WORKS

Very rare marks occurring in or near the printed design on cream-coloured earthenwares of the 1760's. Thomas Radford engraved designs for this pottery.

Two rare examples are shown in the *Illustrated Encyclopaedia of British Pottery and Porcelain*, Plates 238–9. See also new revised 15th edition of *Chaffers*, p. 188; Donald Towner's *English Cream-coloured Earthenware* and a paper by Mr Towner in the *Transactions of the English Ceramic Circle*, Vol. 6, Part 3 (1967), p. 254.

DOE & ROGERS

Decorators of porcelain at Worcester, c. 1820–40.

DOE & ROGERS
WORCESTER

Rare painted name-mark, sometimes with address '17 High St' added, c. 1820–40. Typical examples are illustrated in the *Illustrated Encyclopaedia of British Pottery and Porcelain*, Plate 241.

DON POTTERY

Various types of earthenwares produced by proprietors named Green and later, Barker, c. 1790–1893. Early wares are rare.

DON POTTERY
GREEN
DON POTTERY

Early basic name-marks, c. 1790–1834.

Impressed or printed crest mark, sometimes with name 'Green' added, c. 1820–34.

BARKER. DON
POTTERY

S. B. & S.

Various printed or impressed marks occur after 1834 with the name 'BARKER' or the initials 'S. B. & S.', c. 1834–93.

JAMES DONOVAN

Decorator of English earthenware and porcelain purchased 'in the white', c. 1770–1829. Rare painted (very rarely impressed on wares made to order) name-mark sometimes with place-name 'Dublin'. The original maker's mark sometimes occurs with this *decorator's* name, c. 1770–1829.

DONOVAN

DOULTON & CO. (LTD)

Manufacturers of stonewares and earthenwares at Lambeth, London, c. 1854–1956, and at Burslem, Staffordshire (where porcelains were also made), c. 1882 to present day.

DOULTON & WATTS
LAMBETH POTTERY
LONDON

Lambeth

Standard impressed mark of Doulton & Watts partnership, c. 1820–54.

DOULTON
LAMBETH

Standard impressed mark, c. 1854+. *Ornamental* wares date from about 1870; about this period an oval impressed mark incorporating these words with the date of production added.

Impressed mark, c. 1877–80.

Impressed or printed mark on *earthenware*, c. 1872+.

Standard impressed mark, c. 1880–1902. The word 'England' added below from 1891.

DOULTON
LAMBETH
ENGLAND

Impressed mark on small pieces, c. 1891–1956.

Five marks found on special bodies from c. 1881 into 20th century.

DOULTON
& SLATER'S
PATENT

Sample *incised* decorators' marks found on Doulton stonewares. Monograms of: Arthur B. Barlow, c. 1872–9; Hannah Barlow, c. 1872–1906; George Tinworth, c. 1867–1913. Other decorators' monograms are given in the new 15th edition of *Chaffers*, in Godden's *Encyclopaedia of British Pottery and Porcelain Marks* or in D. Eyles' *Royal Doulton 1815–1965*.

Standard impressed mark, c. 1902–22 and c. 1927–36, also used on wares made at Burslem.

Standard impressed mark (without earlier crown), c. 1922–56.

Burslem

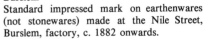

Standard impressed mark on earthenwares (not stonewares) made at the Nile Street, Burslem, factory, c. 1882 onwards.

Standard printed or impressed marks, c. 1882. Word 'England' added from 1891. Basic device also occurs with lion above crown from c. 1902 (see mark reproduced in Lambeth section). 'Made in England' added from c. 1930 to present day.

For further information and illustrations, see *Royal Doulton 1815–1965* by Desmond Eyles (1965) and *Illustrated Encyclopaedia of British Pottery and Porcelain* by G. Godden (1966).

For text, see also new revised edition of *Chaffers*.

DUCROZ & MILLIDGE

Retailer of porcelain and earthenware in London, c. 1835–54.

DUCROZ &
MILLIDGE

Various printed and painted marks incorporating or comprising the names of this partnership, c. 1835–54. In the past this firm has been included as a manufacturer in error.

JAMES DUDSON

Manufacturer of earthenwares at Hanley, c. 1838–88.*

JAMES DUDSON

DUDSON

Impressed name-marks on earthenwares, often in the Wedgwood style with white relief motifs (see *Illustrated Encyclopaedia of British Pottery and Porcelain*, Plate 254), c. 1860–88. Early pre-1860 wares do not seem to have been marked.

DAVID DUNDERDALE & CO.

Proprietors of the Castleford Pottery, Castleford, Yorkshire, where fine earthenwares, semi-porcelainous white-bodied teapots, etc., were made c. 1790–1820 (see page 17). Marked specimens are rare.

D. D. & Co.
CASTLEFORD
POTTERY

Rare impressed mark, the initials 'D. D. & Co.' may also occur, c. 1790–1820.

For two typical marked examples see Godden's *Illustrated Encyclopaedia of British Pottery and Porcelain*, Plates 256–7.

* Continued by J. T. Dudson (c. 1888–98) and by Dudson Bros (Ltd) from 1898 to the present day.

E

ECCLESHILL POTTERY, near Bradford, Yorkshire, c. 1836–67.

ECCLESHILL

Very rare impressed or incised name-mark on stonewares, c. 1835–67.

WOODHEAD,
DAVIDSON &
COOPER
ECCLESHILL
MANOR
POTTERY
YORKSHIRE

Very rare impressed mark, c. 1835–67.

EDGE, BARKER & CO.
Manufacturers of earthenwares at Fenton, c. 1835–6 (subsequently Edge, Barker & Barker).

E. B. & Co.

Several printed marks incorporate these initials, c. 1835–6.

ELKIN, KNIGHT & CO.
Manufacturers of earthenwares at Foley Potteries, Fenton, c. 1822–6.

ELKIN
KNIGHT & CO.

E. K. & Co.

Impressed name-mark; other printed marks incorporate the initials 'E. K. & Co.', c. 1822–6.

SIR EDMUND ELTON
Manufacturer of earthenware at Clevedon, Somerset, c. 1879–1930.

Elton

Incised or painted name-mark, c. 1879–1920. A cross was added to this basic mark on the death of Sir Edmund Elton, c. 1920–30.

F

THOMAS FELL (& CO.)

FELL

Manufacturers of earthenwares at St Peter's Pottery, Newcastle-upon-Tyne, c. 1817–90. Rare early impressed mark, c. 1817–30.

FELL & CO.

T. FELL & CO.

F. & Co.

T. F. & Co.

Standard post-1830 marks with '& Co.' added to name; the initials 'F. & Co.' or 'T. F. & Co.' also occur incorporated in printed marks.

Typical specimens of Fell pottery are included in the *Illustrated Encyclopaedia of British Pottery and Porcelain*, Plates 262–5.

FERRYBRIDGE POTTERY

Known as the KNOTTINGLEY POTTERY (Yorkshire) before 1804, it produced various earthenwares, c. 1792 to present day.

WEDGWOOD & CO.

Impressed name-mark, c. 1796–1801.

FERRYBRIDGE

Impressed place-name mark, c. 1804+.

TOMLINSON & CO.

Impressed name-mark, c. 1801–34 (also 1792–6).

Subsequent marks, often printed, incorporate the initials of various partnerships:

R. & T. or R. T. & Co. Reed & Taylor, c. 1843–50.

B. T. & S. Benjamin Taylor & Co., c. 1850–6.

L. W. or L. W. & S. Lewis Woolf (& Sons), c. 1856–83.

P. B. or P. Bros. Poulson Brothers, c. 1884–97.

S. B. Sefton & Brown, c. 1897–1919.

T. B. & S. T. Brown & Sons, c. 1919 to present day.

ENGLAND

CROWN DEVON

S. FIELDING & CO. (LTD)

Manufacturers of earthenware at Stoke, c. 1879 to present day.

Printed mark, two of several, incorporating initials 'S. F. & Co.' The name 'Fielding' also occurs. The trade name 'CROWN DEVON' has been extensively used in the 20th century.

FIFE
SEMI-CHINA

FIFE POTTERY, Sinclairtown, Fifeshire, Scotland, c. 1820–37: factory then continued by Robert Heron (& Son). see p. 77

Very rare painted mark on jug dated 1830 in the collection of Roger Warner of Burford, Oxfordshire.

EDWIN B. FISHLEY

Manufacturer of country-type earthenwares at Fremington, Devon, c. 1861–1906.

E. B. FISHLEY
FREMINGTON
N. DEVON

Rare incised mark found mainly on special presentation pieces, c. 1861–1906.
Several other members of the Fishley family have been traditional potters. Name-marks occasionally occur.

> George Fishley—late 18th to early 19th century.
> Edmund Fishley—c. 1839–61.
> Edwin Fishley—c. 1861–1906 (see above).
> William Fishley Holland—c. 1921 + (initial or name-marks used).
> George Fishley Holland—c. 1955 + (initial or name-marks used, often with the place-name 'DUNSTER').

G. F. H.
DUNSTER

THOMAS FLETCHER

Printer and engraver at Shelton, c. 1786–1810.

T. FLETCHER
SHELTON

Signature found close to printed subject, c. 1786–1810.

THOMAS FRADLEY

Part-time manufacturer of decorative earthen-wares at Stoke. Wares fired in Messrs Minton's kilns, c. 1875–85.

T. FRADLEY

T. F.

Rare impressed name or initial marks, c. 1875–85.

G

SAMUEL GINDER & CO.

Manufacturers of earthenwares at Lane Delph, Fenton, c. 1811–43.

Sample printed mark, incorporating name of firm, c. 1811–43.

THOMAS GODWIN

Manufacturer of earthenwares at Burslem, c. 1834–54.

T. G.

T. GODWIN

THOS. GODWIN

Several printed marks incorporating the initials 'T. G.' Other marks included Thomas Godwin's name in full, c. 1834–54.

Several other potters named Godwin worked in Staffordshire during the first half of the 19th century. See *Illustrated Encyclopaedia of British Pottery and Porcelain*, Plates 275–7.

W. H. GOSS (LTD)

Manufacturers of porcelain, parian and earthenwares at Falcon Pottery, Stoke, c. 1858–1944.

W. H. GOSS

Early impressed or printed marks incorporate the name or the initials 'W. H. G.', c. 1858+.

Printed crest mark. 'England' added after 1891.

GRAINGER PORCELAIN FACTORY, WORCESTER

Factory worked by Grainger, Wood & Co. (c. 1801–12), by Grainger, Lee & Co. (c. 1812–39) and by George Grainger (& Co.) (c. 1839–1902) when the firm was taken over by the Royal Worcester Porcelain Co. Fine porcelains were produced.

GRAINGER, WOOD & CO. WORCESTER	Very rare painted marks incorporating the name of partnership, c. 1801–12.
GRAINGER, LEE & CO. WORCESTER or NEW CHINA WORKS WORCESTER	Rare painted, impressed or printed marks incorporating name of partnership, c. 1812–39, or the description 'New China Works, Worcester'.
GRAINGER	Painted, printed or impressed marks incorporating George Grainger's name, c. 1839+.
GRAINGER & CO. WORCESTER	'& Co.' added to most marks from about 1850. Initial marks also occur.

G. G. W.

G. & Co.
W.

Printed mark, c. 1889–1902. An earlier version of the shield mark was used c. 1870–89, without the wording above or 'England' below.

Typical examples of Grainger porcelain are illustrated in the *Illustrated Encyclopaedia of British Pottery and Porcelain*, Plates 280–93.

WILLIAM GREATBATCH

Greatbatch

Modeller, potter and engraver, c. 1760–80. Rare printed signature incorporated in, or near, printed pattern on earthenwares. A mark occurs with the date 1778.

GUY GREEN

Green. Liverpool

Printer and engraver at Liverpool, formerly in partnership with John Sadler, c. 1770–99. Rare name-mark incorporated in or near printed design. Guy Green printed earthenwares for Wedgwood and many other manufacturers, c. 1770–99. See new revised 15th edition of *Chaffers*.

M. GREEN & CO.

Manufacturers of earthenware and porcelain at Minerva Works, Fenton, c. 1859–76. Subsequently T. A. & S. Green (see below).

Sample printed mark, c. 1859–76.

STEPHEN GREEN

STEPHEN GREEN

Manufacturer of stoneware at Imperial Pottery, Lambeth, London, c. 1820–58.
Incised or impressed name-mark, sometimes with address, on stoneware bottles, etc., c. 1820–58.

T. A. & S. GREEN

Manufacturers of porcelain at Minerva Works, Fenton, c. 1876–89. Firm re-titled 'Crown Staffordshire Porcelain Co.' from 1889 (see page 57).

Printed mark, c. 1876–89.

H

HACKWOOD (& CO.)
Manufacturers of earthenwares at Shelton (Hanley), c. 1807–55.

HACKWOOD

HACKWOOD & CO.

Impressed or printed name-marks 'Hackwood & Co.', c. 1807–27. Several potters named Hackwood were working in the first half of the 19th century—accurate dating is difficult.

JAMES HADLEY & SONS (LTD)
Manufacturers of earthenware and porcelain at Worcester, c. 1896–1905. James Hadley was formerly modeller to the Royal Worcester Porcelain Company; his signature may be found on some of their finest figures, groups, etc.

Printed mark, 1900–2 (monogram alone used 1896–7).

Printed mark, 1902–5.

Typical wares and an advertisement of 1899 are shown in the *Illustrated Encyclopaedia of British Pottery and Porcelain*, Plates 300–1.

JOHN HALL (& SONS)
Manufacturers of earthenware at Burslem, c. 1814–32.

I. HALL

I. HALL & SONS

Several printed or impressed marks occur incorporating the name 'I. HALL', c. 1814–22. '& Sons' added to name, c. 1822–32.
N.B. The initial 'J' was normally printed as 'I' in 18th and early 19th century marks.

RALPH HALL (& CO.) or (& SON)

Manufacturers of earthenwares at Tunstall, c. 1822–48.

R. HALL

R. HALL & CO.

R. H. & Co.

Several different marks incorporating the name 'R. HALL' occur c. 1822–41 ('R. HALL & SON' occurs c. 1836). 'R. HALL & CO.' used in marks, c. 1841–8.

ROBERT HANCOCK

Engraver at Battersea, Bow and Worcester, c. 1755–65.

R Hancock fecit

RH Worcester

RHf

Rare signature and monogram marks found incorporated in the printed design on (mainly Worcester) porcelains, c. 1755–65.

For further information and illustrations, see *The Life and Work of Robert Hancock* (1948) by C. Cook.

THOMAS HARLEY

Manufacturer of earthenwares at Lane End, c. 1802–8.

HARLEY

T. HARLEY. LANE END

Rare impressed name-mark; the printed name is found near the added printed decoration, c. 1802–8.

GEORGE HARRISON

Manufacturer of earthenwares at Fenton, c. 1790–1804.

G. HARRISON

Rare impressed name-mark, c. 1790–1804.

JOSHUA HEATH

Manufacturer of earthenwares at Hanley, c. 1770–1800.

I. H.

HEATH

Impressed initial mark found on late 18th-century creamware, often decorated in underglaze blue. The impressed name-mark 'HEATH' also occurs, but several potters bore this name.

CHARLES HEATHCOTE & CO.

Manufacturers of earthenwares at Lane End, c. 1818–24.

C. HEATHCOTE & CO.

Printed mark incorporating name of firm, c. 1818–24.

HERCULANEUM POTTERY
Worked by various proprietors. This Liverpool pottery produced high-grade earthenwares and porcelain, c. 1793–1841.

HERCULANEUM — Early impressed name-mark, *very* rarely found on porcelain, c. 1793–1820.

Two printed or impressed marks, c. 1796–1822.

HERCULANEUM POTTERY — *Full* name-mark normally impressed c. 1822–1833.

For further information, see new revised 15th edition of *Chaffers*.

ROBERT HERON (& SON)
Manufacturer of earthenwares. Took over the Fife Pottery, Sinclairtown, Scotland, by September 1837 (see page 70).

R. H. F. P. — Printed mark occurs incorporating these initials, c. 1837–60.

R. H. & S.

ROBERT HERON & SON — Printed mark incorporating these initials or name in full occur from c. 1850 to 1929.

WEMYSS — Trade name 'Wemyss' or 'Wemyss Ware' on decorative, freely decorated earthenwares, c. 1880 into 20th century.

Printed mark, c. 1920–9. The decorative 'Wemyss' wares often also bear the mark of Goode's, the London retailers.

WILLIAM HEWSON
Retailer of pottery and porcelain trading from 86 Aldgate, London, from 1780's to December 1813.

HEWSON

HEWSON, ALDGATE
WARRANTED

Rare name-mark, sometimes with address, found on wares sold by this retailer, c. 1780–1813.

HICKS & MEIGH
Manufacturers of earthenwares, 'Stone China', etc., at Shelton in the Staffordshire Potteries, c. 1804–22. Subsequently Messrs Hicks, Meigh & Johnson (see next entry).

HICKS & MEIGH

Very rare impressed or printed name-mark, c. 1804–22.

Printed Royal Arms mark found on fine-quality Hicks & Meigh's 'Stone China', c. 1804–22.

N.B. The number under the basic mark varies.

HICKS, MEIGH & JOHNSON
Manufacturers of 'Stone China' and other earthenwares at Shelton. Successors to Messrs Hicks & Meigh (see above), c. 1822–35.

H. M. J.

H. M. & J.

H. M. & I.

Rare impressed or printed initial marks (the names in full also occur c. 1822–35).

Three printed marks found on fine and colourful earthenwares, c. 1822–35.

HILDITCH & SON
Manufacturers of porcelain and earthenware at Lane End, c. 1822–30.

Two rather rare printed marks which occur on porcelain and earthenwares, c. 1822–30. Slight variations occur.

SAMUEL HOLLINS
Manufacturer of high-grade earthenwares, often in Wedgwood type with figure relief motif, at Shelton, c. 1784–1813.

S. HOLLINS

Standard impressed mark on earthenwares, c. 1784–1813. Typical examples are shown in the *Illustrated Encyclopaedia of British Pottery and Porcelain*, Plates 313–16.

THOMAS & JOHN HOLLINS
Manufacturers of earthenwares at Hanley, c. 1795–1820.

T. & J. HOLLINS

Standard impressed mark, rather rare, c. 1795–1820.

HULL POTTERY
Good earthenwares were produced at The Bell Vue Pottery, Hull, under the proprietorship of William Bell, c. 1826–41.

BELLE VUE

BELLE VUE POTTERY
HULL

Printed or impressed marks were used incorporating the name 'Belle Vue' and two bells, c. 1826–41. Pottery was made earlier but does not appear to have been marked. Specimens are rarely found.

For further information, see new revised 15th edition of *Chaffers*.

J

REUBEN JOHNSON

Manufacturer of earthenwares at Hanley, c. 1817–23. Works continued by his widow Phoebe until c. 1838.

Standard printed mark in outline border; different descriptions occur below this device— 'Stone China', etc., c. 1817–38.

JOHNSON
HANLEY

JOSEPH JOHNSON

Engraver at Liverpool, late 18th century.

J. JOHNSON

Rare signature mark incorporated in or near printed designs.

A. B. JONES & SONS (LTD)

Manufacturers of porcelain and earthenware at Longton, c. 1900 to present day.

Three typical printed marks incorporating trade name 'Grafton China' (or 'Royal Grafton China') or the initials 'A. B. J. & Sons'.

A. G. HARLEY JONES

Manufacturers of decorative earthenwares at 'Royal Vienna Art Pottery', Fenton, c. 1907–1934.

Printed mark found on inexpensive but ornate earthenware vases, etc.

Other marks incorporate the initials 'HJ' (joined) or 'A. G. H. J.', c. 1907–34.

GEORGE JONES (& SONS LTD)

Manufacturers of decorative earthenwares and majolica-style wares, c. 1861–1951. Porcelain produced in 20th century.

Basic printed or impressed mark, c. 1874–1924. Monogram only (without crescent device) used c. 1861–73. The word 'crescent' added below, c. 1924–51.

Typical Victorian specimens are reproduced in the *Illustrated Encyclopaedia of British Pottery and Porcelain*, Plates 326–8.

K

ANTHONY & ENOCH KEELING
Manufacturers of earthenware (and *very* rare
porcelain) at Tunstall, c. 1795–1811.

A. & E. KEELING

Very rare painted or impressed mark, c.
1795–1811.

KEELING, TOFT & CO.
Manufacturers of earthenwares, basalt, etc.,
at Hanley, c. 1804–26. Partnership also titled
KEELING & TOFT.

KEELING, TOFT & CO.

Rare impressed mark, c. 1804–26.

JOSEPH KISHERE
Manufacturer of stoneware at Mortlake,
London, c. 1800–43.

KISHERE

KISHERE
MORTLAKE

Three basic impressed or incised marks, c.
1800–43.

I. K.

Typical examples from the Victoria and Albert
Museum are shown in the *Illustrated Encyclo-
paedia of British Pottery and Porcelain*, Plate
331. See also J. F. Blacker's *The A.B.C. of
English Salt-glaze Stone-ware* (1922).

KENT

William Kent (Porcelains) Ltd,
Auckland Sr. Burslem Staffordsh
Potteries. formerly WILLIAM KENT
Earthen ware
Printed marks 1944-62 (as on Swa
Production earthenwaves (ornament
ceased Dec. 31, 1962.
W.B.K. mould initial marks on
modern earthenware figures etc. ma
from 19ᵗʰ Century master moulds
Minrono 1963.
This firm continues to produce electrica
porcelains.

L

LAKIN & POOLE

LAKIN & POOLE

Manufacturers of earthenwares, basalts, etc., at Burslem, c. 1791–5.

Standard but rather rare impressed mark, c. 1791–5.

The mark 'POOLE, LAKIN & CO.' has also been recorded.

LEACH POTTERY

Established by Bernard Leach, C.B.E., at St Ives, Cornwall, in 1921. At this famous pottery a number of talented studio potters have been trained and have helped to extend the Leach Pottery tradition for fine craftsmanship and good design.

Basic Leach Pottery impressed seal, c. 1921 to present day.

The monogram or sign of individual potters often occurs with this mark.

Basic initial mark used by Bernard Leach; several variations occur, all incorporating the initials B. L.

For further information and illustrations, see *The Work of the Modern Potter in England* by M. Rose (1955) and *Bernard Leach, a Potter's Work* (1967).

LEEDS POTTERY

This famous Yorkshire pottery produced a wide range of earthenwares, creamware, basalt, etc., under various proprietorships from c. 1758 to c. 1878. The early pre-c. 1775 wares appear to have been unmarked.

LEEDS POTTERY

Standard impressed mark in upper or lower case letters, c. 1775–1800 +: this style of mark is sometimes stamped twice, one at right angles to the other. The two marks are also

HARLEY GREENS & CO. LEEDS POTTERY

found on late 19th-century and on early 20th-century copies of Leeds pierced creamwares. Impressed mark giving name of proprietors, c. 1781–1820.

For further information on Leeds wares, see *English Cream-Coloured Earthenware* by D. C. Towner (1957) and *The Leeds Pottery* by D. C. Towner (1963). Typical examples are also shown in Godden's *Illustrated Encyclopaedia of British Pottery and Porcelain* (1966), Plates 334–48.

LIVERPOOL

This was one of the centres of the pottery trade in the 18th and early part of the 19th centuries. Tin-glazed delft-type pottery as well as cream-coloured earthenwares and porcelain were produced by several manufacturers but, as a general rule, the Liverpool wares are unmarked.

John Sadler and the firm of Sadler & Green printed earthenwares and porcelain made by other manufacturers from c. 1756, and signatures occur on some of these printed motifs (see page 116).

The marks of the important HERCULANEUM factory are given on page 77.

HP

A painted 'H P' monogram mark occurs on some rare late 18th-century Liverpool porcelain, but the significance of this device is uncertain. Teawares bearing this mark are shown as Plate 351 of the *Illustrated Encyclopaedia of British Pottery and Porcelain*. For further information on the varied Liverpool wares, see *History of the Art of Pottery in Liverpool* by J. Mayer (1882); *Liverpool and her Potters* by H. Boswell Lancaster (1936); *English Delftware* by F. H. Garner (1948); *Liverpool Porcelain: 18th Century* by Dr Knowles Boney (1957); *English Blue and White Porcelain* by Dr B. Watney (1963); *English Porcelain 1745–1850*, edited by R. J. Charleston (1965).

LLANELLY. See SOUTH WALES POTTERY.

JOHN LLOYD

Manufacturer of earthenware and porcelain figures at Shelton, c. 1834–50. From 1850 to 1852 John's wife, Rebecca, continued the works.

LLOYD
SHELTON

Rare impressed mark on figures and animal models, c. 1834–52.

Typical examples are illustrated in the *Illustrated Encyclopaedia of British Pottery and Porcelain*, Plates 352–4.

LOCKE & CO. (LTD)

Manufacturers of porcelain at Worcester, c. 1895–1904.

Basic printed mark, c. 1895–1900.

Printed mark, c. 1900–4.

An advertisement photograph of typical, 1899, wares is shown in the *Illustrated Encyclopaedia of British Pottery and Porcelain*, Plate 355.

JOHN LOCKETT

Manufacturer of earthenwares, jaspers, etc., at Lane End, c. 1821–58.

J. LOCKETT

Rather rare impressed mark, c. 1821–58.
Potters with similar styles and marks include:

J. LOCKETT & CO., c. 1812+.
J. LOCKETT & SONS, c. 1828–35.
J. & G. LOCKETT, c. 1802–5.

LOCKETT & HULME

Manufacturers of earthenwares at Lane End, c. 1822–6.

OPAQUE CHINA
L. & H.
L.E.

Printed mark incorporating initials, c. 1822–6.

**LONGTON HALL PORCELAIN FAC-
TORY,** situated at Longton Hall, Stafford-
shire. This small factory produced rather
crudely modelled porcelains, c. 1749–60.
Specimens are rare and costly.

Rare hand-painted marks in underglaze blue—
slight variations occur. These marks seem only
to occur on early specimens, c. 1749–55, and
most Longton Hall porcelain is unmarked.

For further information and illustrations of
key pieces, see *Longton Hall Porcelain* by
B. Watney (1957); *English Blue and White
Porcelain* by B. Watney (1963); *English Por-
lain 1745–1850*, edited by R. J. Charleston
(1965); and the *Illustrated Encyclopaedia of
British Pottery and Porcelain*, Plates 357–9.

LOVATT & LOVATT*

Manufacturers of stonewares and earthen-
wares at Langley Mill, near Nottingham, c.
1895 to present day.*

Sample impressed or printed marks found on
post-1900 wares, mostly of a utilitarian
nature. Other marks occur with the name
'Lovatt' or the trade name 'LANGLEY';
marks from 1931 feature a windmill.

* Firm retitled 'Lovatts Pottery Ltd' in 1931 and
'Langley Pottery Ltd' in 1967.

LOWESBY POTTERY, Leicestershire.
Earthenwares manufactured c. 1835–40.

Rare impressed mark, c. 1835–40.

LOWESTOFT PORCELAIN FACTORY

Charming porcelains painted in underglaze
blue were made at this small factory at
Lowestoft, Suffolk. Overglaze enamel colours
were used from c. 1774, but the blue and
white specimens outnumber the later coloured
pieces. The body is soft paste containing bone
ash—it is similar to that used at the Bow
factory. Most products are of a useful nature
—teawares, etc.—rather than ornamental.

Rare early Lowestoft porcelains often bear
the painter's number in underglaze blue on the
inside of the footrim, c. 1760–75. Numbers
3 and 5 are relatively common.

Copies of the blue Worcester crescent mark
(open or with cross lines as drawn, on printed
patterns) and the Dresden crossed-swords
mark were used c. 1775–90.

A TRIFLE FROM
LOWESTOFT

The post-1774 enamelled porcelains are not
marked, although some rare examples bear
the inscription 'A Trifle from Lowestoft'.
Hard-paste reproductions of these 'Trifle'
pieces were made on the Continent.

For further information, see new revised 15th
edition of *Chaffers*; B. Watney's *English Blue
and White Porcelain of the 18th Century*
(1963); or Godden's *Illustrated Encyclopaedia
of British Pottery and Porcelain*, Plates 360–
363. It should be noted that the pieces illus-
trated in Chaffers' *New Keramic Gallery*, figs.
588–91, are Chinese *not* English.

M

MACHIN & CO.
Manufacturers (or decorators) of porcelain at Burslem, c. 1812–22.

MACHIN & CO.
BURSLEM

Very rare painted, or printed, name-mark, c. 1812–22.

JAMES MACINTYRE & CO.
Manufacturers of earthenware at Burslem, c. 1860 to present day.

MACINTYRE

Several early impressed or printed marks occur incorporating the name with or without the initial 'J'. '& Co.' added to name-marks from 1867.

Post-1894 printed mark with word 'Limited' or 'Ltd' added. Since 1928 only electrical wares have been produced.

An 1888 advertisement showing typical wares is reproduced in the *Illustrated Encyclopaedia of British Pottery and Porcelain*, Plate 365.

MARTIN BROTHERS
The first of the 'Studio Potters' working together making individually designed stonewares at Fulham and Southall, London, c. 1873–1914.

Incised or stamped signature mark with address 'FULHAM', 1873–4.

R. W. MARTIN
LONDON

Incised mark with address 'LONDON', c. 1874–8.

SOUTHALL

Various incised or stamped signature marks with address 'SOUTHALL', c. 1878–9.

LONDON & SOUTHALL

Signature marks with double address 'LONDON & SOUTHALL' date from 1879.

BROS

BROTHERS

From 1882 'BROS' or 'BROTHERS' added to standard signature 'R. W. MARTIN'.

Most Martin Brothers stoneware bears the incised date near the signature mark.

Contemporary photographs of the Martin Brothers are included with illustrations of typical wares in Godden's *Illustrated Encyclopaedia of British Pottery and Porcelain*, Plates 374–8. See also *Catalogue of the Martinware in the Collection of F. J. Nettlefold* by C. R. Beard (1936).

MARTIN, SHAW & COPE

Manufacturers of earthenwares and porcelain at Lane End, c. 1814–24.

MARTIN, SHAW & COPE

Rather rare printed name-mark occurring with or without the description 'Improved china', c. 1815–24.

MASON

A family of potters trading under various styles (see below) at Lane Delph and Fenton from c. 1800 to c. 1854. Charles James Mason patented the famous 'PATENT IRONSTONE CHINA' in 1813.

Miles Mason

M. MASON

Standard impressed mark on porcelain made by Miles Mason, c. 1800–13. Specimens are rather rare.

Printed mark on blue printed porcelain of willow-pattern type c. 1800–13.

G. M. & C. J. Mason

PATENT IRONSTONE CHINA

Impressed mark in various forms with or without the name 'MASON'S', c. 1813+.

Standard printed mark on Mason Ironstone wares from c. 1815. Very many variations of this mark occur and some have been used by Messrs Ashworths, the present owners of many of the original Mason models and patterns.

**FENTON
STONE WORKS**

Printed mark in box outline, c. 1825–40.

G. & C. J. M.

Several printed marks were used in the 1813–1829 period incorporating the initials 'G. & C. J. M.' or the fuller style 'G. M. & C. J. Mason'.

C. J. Mason & Co.

C. J. MASON & CO.

C, J. M. & Co.

Many marks were used in the 1829–45 period, incorporating the new style 'C. J. Mason & Co.' or the initials 'C. J. M. & Co.' From 1845 to 1848 and from c. 1851 to 1854 Charles Mason traded on his own (without the '& Co.'); the former standard printed 'Mason's Patent Ironstone China' mark was much used.

The Mason patterns, moulds, etc., passed through several firms to Messrs G. L. Ashworth & Bros in 1861 and this firm still produces Mason-style wares.

For further information and illustrations, see *The Masons of Lane Delph* by T. G. Haggar (1952) and the *Illustrated Encyclopaedia of British Pottery and Porcelain*, Plates 379–88. A new book is in course of preparation under the provisional title 'Mason's Patent Ironstone China'.

MAW & CO.

Manufacturers of tiles and earthenwares at Jackfield, Shropshire, c. 1850 +.

Standard impressed or moulded name-marks. 'Art Pottery' vases, etc., made from c. 1875. A good selection of Maw wares may be seen in the Shrewsbury Museum.

MAW

MAW & CO.

ELIJAH MAYER (& SON)

Manufacturers of earthenwares, basalt, etc., at Hanley, c. 1785–1804 and 1805–34.

E. Mayer

E. Mayer & Son

Standard impressed mark, c. 1785–1804. '& Son' added to mark, c. 1805–34. Typical marked specimens are illustrated in the *Illustrated Encyclopaedia of British Pottery and Porcelain*.

THOMAS MAYER

Manufacturer of earthenwares at Stoke, c. 1826–35 (and at Longport, c. 1836–8).

T. MAYER

MAYER. STOKE

Standard impressed name-marks, c. 1826–35. Various printed marks were also used incorporating these names. Mayer's blue printed earthenwares were of good quality and he enjoyed a large export trade.

T. J. & J. MAYER

Manufacturers of earthenwares, parian wares and porcelain at the Dale Hall Pottery, Burslem, c. 1843–55.

Several different printed marks were employed incorporating this title, c. 1843–55.

MAYER & NEWBOLD

Manufacturers of earthenware and porcelain at Lane End, c. 1817–33.

MAYR. & NEWBd.

Rare painted mark on porcelains, c. 1817–33.

The names may also occur in full or the initials 'M. & N.' occur on some marks used on earthenwares.

CHARLES MEIGH (& SON)

Charles Meigh succeeded his father, Job (see next entry), at the Old Hall Pottery, Hanley, in 1835. From 1850 to 1851 he was in partnership under the style 'CHARLES MEIGH, SON & PANKHURST', but from 1851 to March 1861 he traded under the style 'CHARLES MEIGH & SON' and subsequently the 'OLD HALL EARTHENWARE CO. LTD'.

CHARLES MEIGH

C. M.

Many printed, impressed or moulded marks were used incorporating the initials 'C. M.' or the name in full, c. 1835–49.

C. M. S. & P.

These initials were incorporated in marks, c. 1850–1.

C. MEIGH & SON

C. M. & S.

Many marks from 1851 to March 1861 incorporate the initials 'C. M. & S.' or the name in full.

Impressed or printed mark; slight variations occur with different wording according to the body—'Indian Stone China', etc., c. 1835–1861.

For further information on this important firm see Jewitt's *Ceramic Art of Great Britain* (1878 and 1883) and Godden's *British Pottery and Porcelain 1780–1850*. Examples are also reproduced in the *Illustrated Encyclopaedia of British Pottery and Porcelain*, Plates 394–5.

JOB MEIGH (& SON)

Manufacturer of earthenwares at Old Hall Pottery, Hanley, c. 1805–34.

MEIGH

Standard impressed mark, c. 1805–34. From 1812 '& Son' added to firm's style:

J. M. & S.

several printed marks occur incorporating the initials 'J. M. & S.' but these initials also relate to J. Meir & Son.

JOHN MEIR & SON

Manufacturers of earthenwares at Tunstall, c. 1837–97. Formerly John Meir (c. 1812–36).

J. MEIR & SON

J. M. & SON

J. M. & S.

Several different impressed or printed marks occur consisting of, or incorporating, these names or initials, c. 1837–97. A typical printed mark is reproduced. This Tunstall firm produced a good range of printed earthenwares, much of which was exported.

N.B. The initial 'I' sometimes replaces the 'J', so that marks read 'I. MEIR & SON'. 'I. M. & SON' or 'I. M. & S.'

MIDDLESBROUGH POTTERY CO. at Middlesbrough, Yorkshire.

Creamwares and general earthenwares were produced c. 1834–44 and from 1844 to 1852 by the MIDDLESBROUGH *EARTHENWARE* CO.

MIDDLESBRO
POTTERY CO.

M. P. Co.

Several different marks incorporate the name or initials (often with an anchor) of this firm, c. 1834–44.

M. E. & Co.

The initials 'M. E. & Co.' used 1844–52.

MINTON

Important manufactures of porcelain and various types of earthenware, under several different partnerships, as listed, 1793 to present day.

The early earthenwares and pre-1805 porcelains were apparently unmarked.

Painted mark on porcelain normally in over-glaze blue enamel, found with or without differing pattern number, c. 1805–16, mark rather rare.

The Dresden crossed-swords mark occurs in underglaze blue on a class of floral-encrusted Minton porcelain of the 1820's, formerly attributed to the Coalport factory. See the *Illustrated Encyclopaedia of British Pottery and Porcelain*, Colour Plate VIII.

Several printed marks of the 1820's and 1830's incorporate the initial 'M'.

Many printed marks of the MINTON & BOYLE period (c. 1836–41) incorporate the initials 'M. & B.'

Many different marks of the 1841–73 period incorporate or comprise the initials 'M. & Co.'

M. & H.

Many different printed marks of the MINTON & HOLLINS period (c. 1845–68) incorporate the initials 'M. & H.'

B. B.
NEW STONE

Impressed mark on earthenwares, c. 1830–1860.

Incised mark found on Minton parian figures and groups, c. 1845–60.

Painted or printed ermine device found on fine Minton porcelains, c. 1850–70. A similar incised mark occurs on parian and other figures from about 1845.

MINTON

The name 'Minton' occurs incorporated in many printed marks from 1851 onwards. The basic impressed mark from 1862 to 1872 was the word 'MINTON', an 'S' was added from 1873 so that the post-1873 basic mark was 'MINTONS'.

MINTONS

Standard printed mark, c. 1863–72.

Revised basic printed mark with crown above, c. 1873–1912. The word 'England' added from 1891.

Basic printed mark, c. 1912–50, often with 'Made in England' added below.

New printed trade mark, 1951 to present day.

TABLE OF YEAR CYPHERS FOUND IMPRESSED IN THE BODY OF MINTON WARES, SHOWING THE DATE OF PRODUCTION

Messrs Mintons have employed very many talented and famous ceramic artists and designers, several of whom were permitted to sign their work. Lists of these artists are given in the new revised 15th edition of *Chaffers* and in *Victorian Porcelain* by G. Godden (1961). The most famous artist/designer was M. L. Solon, whose form of signature is reproduced, and occurs on the valuable cameo-like Pâte-sur-Pâte wares.

L. Solon
or
M. L. Solon

Apart from the two above-mentioned works, further information and illustrations will be found in the *Illustrated Encyclopaedia of British Pottery and Porcelain* (1966), Plates 399–424. A new detailed reference book on the early pre-1851 Minton wares is in preparation entitled *Minton Pottery and Porcelain of the First Period, 1793–1850*.

JAMES MIST

Retailer at 82 Fleet Street, London. Porcelains, Turner-type-stonewares and earthenwares sold by this dealer bear his name, c. 1809–15. The following rather rare marks occur.

MIST	TURNER	J. MIST
	MIST, SOLE AGENT	82 FLEET STREET
		LONDON

W. MOORCROFT (LTD)

Manufacturers of earthenwares, normally decorated with bold floral designs, at Burslem, c. 1913 to present day.

MOORCROFT BURSLEM.

Standard impressed mark, c. 1915 +.

Modern wares have the wording 'Made in England'.

Signature trade mark, registered in 1919; the initials 'W. M.' occur on some examples. Walter Moorcroft succeeded his father in 1945.

MOORE BROS

Manufacturers of decorative porcelains at Longton, c. 1872–1905, continued by Bernard Moore, c. 1905–15, who produced fine glaze-effects on porcelain and earthenwares.

MOORE

MOORE BROS

Standard impressed marks, c. 1872–1905.

The word 'England' also occurs from 1891.

Standard printed mark, c. 1880–1902. With the word 'England' from 1891.

ENGLAND

Rather rare printed mark, c. 1902–5.

BERNARD MOORE

Painted or stencilled name-mark on Bernard Moore's Chinese-styled glaze-effects, c. 1905–1915. An initial monogram also occurs.

SAMUEL MOORE & CO.

Manufacturers of earthenwares at the Wear Pottery, Southwick, Co. Durham, c. 1803–1874.

Moore & Co.

MOORE & CO.
SOUTHWICK

S. MOORE & CO.

S. M. & Co.

Several different impressed or printed marks incorporate, or consist of, the name or initials of this firm, c. 1803–74.

FRANCIS MORLEY (& CO.)

Manufacturers of earthenwares including 'Mason's Patent Ironstone China' at Shelton, c. 1845–58, succeeded by MORLEY & ASHWORTH, c. 1859–61.

F. M.

F. M. & Co.

F. MORLEY & CO.

F. MORLEY & Cº.

Many different printed marks were used incorporating these initials or the name, c. 1845–58.

MORLEY & ASHWORTH

M. & A.

The new partnership issued various marks incorporating or comprising the joint names or the initials 'M. & A.', c. 1859–61. This partnership was succeeded by G. L. Ashworth & Bros (see page 39).

JOHN MOSELEY

MOSELEY

Manufacturer of earthenwares, basalts, etc., at
Cobridge and Burslem, c. 1811–22.
Rare impressed name-mark, c. 1811–22.

N

NANTGARW PORCELAIN WORKS

Situated at Nantgarw, Glamorgan, Wales, where fine-quality, highly translucent, mellow porcelain was made c. 1813–14 and 1817–1822.*

NANTGARW
NANT GARW
C. W.

Standard *impressed* marks, which are often difficult to see, unless the porcelain is held to a light (see page 26). The name occurs with, or without, a hyphen.

Painted name-mark in writing letters which should be viewed with great caution, as this overglaze mark is often added to Coalport and other porcelains. Nantgarw porcelain is rare and desirable.

For further information and illustrations, see *The Pottery and Porcelain of Swansea and Nantgarw* by E. M. Nance (1942), or W. D. John's *Nantgarw Porcelain* (1948).

JAMES NEALE & CO.

Manufacturers of high-grade, Wedgwood-type earthenwares—creamware, basalt, jasper, etc. —at Hanley, c. 1776–84. Several partnerships precede and succeed this firm (see p. 100).

NEALE & PALMER

Rare impressed mark used by this partnership, c. 1769–76.

Rare circular impressed or moulded mark on Wedgwood-type black basalt vases, etc., c. 1776–8.

* The exact date for the closure of this factory is open to some doubt.

Neale & Co.	Standard impressed mark, c. 1778–84 + .* Note addition of '& Co.'
Neale & Wilson	Rare 'Neale & Wilson' impressed mark, c. 1784–95.
Neale & Bailey	Rare impressed or printed mark, c. 1790–1814.

Typical Neale wares are shown in Godden's *Illustrated Encyclopaedia of British Pottery and Porcelain*, Plates 434–9.

NEW HALL PORCELAIN WORKS

Worked by several partners at Shelton from c. 1781 to 1835. The early pre-1812 products are a type of hard-paste porcelain; from 1812 to 1835 the, then, standard English bone china was made.

The early porcelains do NOT bear a factory mark, but the pattern number is *boldly* painted on teapots, creamers, etc. (not on cups and saucers). This pattern number was painted in larger-sized numerals than on other wares. Teawares formed the main output of the works; typical teaware shapes and patterns are shown in Plates 441–2 and 443 of the *Illustrated Encyclopaedia of British Pottery and Porcelain*.

Painted decorator's (?) sign, found on some otherwise unmarked New Hall porcelain of the 1800–15 period.

WARBURTON'S PATENT

Rare painted mark found on New Hall (hard-paste) porcelains, printed with gold, c. 1810–1812.

New Hall

Rather rare printed mark occasionally used on New Hall bone-china wares, c. 1812–25.

N. H.

A raised pad incorporating the initials 'N. H.' found on jugs are believed to be late New Hall examples, c. 1825–35.

For further information and illustrations, see *New Hall Porcelain* by G. E. Stringer (1949) and *English Porcelain 1745–1850* edited by R. J. Charleston (1965).

* It is probable that this mark was continued through 'Neale & Wilson' and 'Neale & Bailey', so that its use continued to c. 1814.

THOMAS NICHOLSON & CO.

T. N. & Co.

Manufacturers of earthenwares at Castleford, Yorkshire, c. 1854–71.
The initials 'T. N. & Co.' occur, incorporated in several printed marks, c. 1854–71.

NOTTINGHAM

Nottm. 1703

Made at Nottingham
yᵉ 17ᵗʰ day of
August A.D. 1771

Examples of incised marks sometimes found in writing letters on Nottingham stonewares.

A class of metallic-looking, brown-coloured stoneware was made in this city in the 18th and 19th centuries. Some rare specimens bear the name of the maker incised or the place-name Nottingham. Typical key pieces are included in the *Illustrated Encyclopaedia of British Pottery and Porcelain*, Plates 447–51, but not all stonewares of Nottingham type were necessarily made in that city, it is largely a generic term.

O

OLDFIELD & CO.

Manufacturers of earthenware at Brampton,
Derbyshire, c. 1838–88.

OLDFIELD & CO.
MAKERS

Rare impressed or moulded mark, c. 1838+.

OLD HALL EARTHENWARE CO. LTD

This company (the first limited liability company in the Staffordshire Potteries) succeeded
Charles Meigh (see page 91), c. 1861 to July
1886, when the OLD HALL PORCELAIN
WORKS LTD continued to 1902.

Printed or moulded mark, c. 1861–86. Other
marks incorporate the initials 'O. H. E. C.' or
'O. H. E. C. (L)'.

Printed trade mark first registered in 1885,
continued to 1902. 'England' added from
1891.

P

H. PALMER

HUMPHREY PALMER
Manufacturer of Wedgwood-type earthenwares at Church Works, Hanley, c. 1760–78.

Rare impressed mark, c. 1760–78; the name 'PALMER' also occurs impressed.

GWENDOLEN PARNELL
Modeller of theatrical and character figure in earthenware at Chelsea, c. 1916–36.

CHELSEA
CHEYNE

Incised mark with date of production July 1918+.

G. P.

Incised initials with drawing of a rabbit, used by Miss Parnell as a personal mark, c. 1916–1936.

PATTERSON & CO.

PATTERSON & CO.

Manufacturers of earthenwares at Sheriff Hill Pottery, Newcastle-upon-Tyne, c. 1830–1904. Several printed or impressed marks occur incorporating, or comprising, the name 'Patterson & Co.', c. 1830+.

EDWARD PHILLIPS
Manufacturer of earthenware at Cannon Street, Shelton, c. 1855–62.

EDWARD PHILLIPS
SHELTON,
STAFFORDSHIRE

Rare impressed or printed name-mark, c. 1855–62.

EDWARD & GEORGE PHILLIPS
Manufacturers of earthenwares at Longport, c. 1822–34.

PHILLIPS, LONGPORT

E. & G. PHILLIPS
LONGPORT

Several marks of the 1822–34 period incorporate the name 'Phillips' and the place-name 'Longport'. Good-quality blue printed earthenwares were made.

PILKINGTON'S 'ROYAL LANCASTRIAN' POTTERY

Messrs Pilkington's Tile & Pottery Co. Ltd commenced the manufacture of ornamental wares—vases, etc.—in about 1897. Until March 1938 decorative lustre effects were produced, often with individual motifs designed by leading artists and designers.

Standard impressed mark, c. 1904–14. Roman numerals found below this mark show the year of production, 'VII' for 1907, etc.

Standard impressed mark, c. 1914–35. The words 'England' or 'Made in England' also occur.

The stencilled marks of the various designers and artists are also found on Pilkington's wares; the key to these is given in the *Encyclopaedia of British Pottery and Porcelain Marks* (1964). For further information, see A. Lomax's *Royal Lancastrian Pottery* (1957).

PINDER, BOURNE & CO.

Manufacturers of earthenwares at Nile Street, Burslem, c. 1862–82. Works taken over and continued by Doulton & Co.

P. B. & Co.

PINDER, BOURNE & CO.

Several printed marks incorporate the name or initials of this firm, c. 1862–82. The initials 'P. B. & H.' were used by the firm of PINDER, BOURNE & HOPE, which preceded Pinder, Bourne & Co., c. 1851–62.

PINXTON PORCELAIN FACTORY

Established by John Coke and William Billingsley at Pinxton, Derbyshire, in 1796 and continued by others to c. 1813.

Most Pinxton porcelain is unmarked and bears a close likeness, in body, form and styles of decoration, to the contemporary Derby porcelain. Examples are relatively rare and desirable.

Very rare painted or gilt name-mark in writing letters, c. 1796–1805.

The painted initial 'P' rarely occurs, sometimes preceding the pattern number, different numbers occurring on each pattern. See the *Illustrated Encyclopaedia of British Pottery and Porcelain*, Plates 454 and 454A.

Painted crescent and star mark, attributed to Pinxton. A very rare double variety of this mark has been recorded.

For further information and illustrations, see *The Pinxton China Factory* by C. L. Exley (1963); *English Porcelain 1745–1850* edited by R. J. Charleston (1965); and the *Illustrated Encyclopaedia of British Pottery and Porcelain* (1966).

BENJAMIN PLANT

Manufacturer of earthenwares at Lane End, c. 1780–1820 (approximate dates only).

B. PLANT
LANE END

Very rare incised name-mark in writing letters, occurring on a teapot, dated 1814, reproduced in the *Illustrated Encyclopaedia of British Pottery and Porcelain*, Plate 459.

R. H. & S. L. PLANT (LTD)

Manufacturers of porcelain at Tuscan Works, Longton, c. 1898 to present day.

Printed mark, one of several including the initials 'R. H. & S. L. P.' with marks incorporating the trade name 'TUSCAN'; modern marks also incorporate the name 'ROYAL TUSCAN'.

PLYMOUTH PORCELAIN FACTORY

Hard-paste porcelain made under William Cookworthy's proprietorship at Plymouth, Devon, c. 1768–70. Examples are rare and desirable.

Mr.
Wm. Cookworthy's
Factory. Plymouth.
1770.

Very rare or unique inscription mark, in writing letters, on a sauce boat in the Plymouth Museum and Art Gallery. Included in the *Illustrated Encyclopaedia of British Pottery and Porcelain*, Plate 463.

Standard, but rare, painted mark in underglaze blue or overglaze enamel, c. 1768–70. Reproductions of Plymouth porcelain also bear this mark.

For further information and illustrations, see *Cookworthy's Plymouth and Bristol Porcelain* by F. Severne Mackenna (1946); *English Blue and White Porcelain* by B. Watney (1963); *English Porcelain 1745–1850* edited by R. J. Charleston (1965); and the *Illustrated Encyclopaedia of British Pottery and Porcelain* by G. Godden (1966).

POOLE POTTERY

Manufactured by Messrs Carter, Stabler & Adams (Ltd)* at Poole, Dorset, from 1921 to present day.

Standard impressed or printed name-mark, with or without border lines, c. 1921 +. A variation with the firm's name above also occurs, with 'Ltd' after 1925.

Printed trade mark, c. 1950–6.

Revised trade mark, 1956 +. The words 'oven tableware' appear with this standard mark on oven wares. The words 'Poole Studio' appear with the dolphin sign on special wares from 1963.

* The old title was changed to Poole Pottery Ltd in 1963.

POUNTNEY & ALLIES

Manufacturers of earthenwares at Temple Backs, Bristol, c. 1815–35. Works continued by POUNTNEY & GOLDNEY, c. 1836–49, and then by POUNTNEY & CO. (LTD) to the present day.

POUNTNEY
&
GOLDNEY

P. & Co.

POUNTNEY & CO.

Bristol
Founded 1652
England

Impressed mark, c. 1815–35. Other marks comprise or incorporate the initials 'P. & A.' or 'P. & A.'
B. P.

Impressed or printed marks incorporating or comprising these names, c. 1836–49. The title 'BRISTOL POTTERY' was also used.

Post-1849 marks—of many types—incorporate the initials 'P. & Co.' or the name in full. 'Ltd' added from c. 1889. Many modern marks incorporate the word 'BRISTOL' as the example reproduced.

F. & R. PRATT

Manufacturers of earthenwares at Fenton, c. 1818, continued into 20th century.

F. & R. P.

F. & R. P. & Co.

Several different printed marks occur, incorporating these initials, c. 1818–50. '& Co.' added c. 1840.

PRATT

FENTON.

Printed marks occurring, rather rarely, on the colour-printed earthenwares of pot-lid type, for which this firm is famous.

For further information and illustrations, see *The Pictorial Pot Lid Book* by H. G. Clarke (1955 and other editions); *Antique China and Glass under £5* by G. A. Godden (1966); also the *Illustrated Encyclopaedia of British Pottery and Porcelain*, Colour Plate X and Plates 470–1.

WILLIAM PRATT

Manufacturer of earthenwares at Lane Delph, c. 1780–99.

A class of moulded jugs, etc., with raised and coloured figures has always been called Pratt; in fact very few examples bear a mark and it would seem that the so-called Pratt ware was made by several potters.

PRATT

Rare *impressed* or *moulded* mark, on jugs, etc., typical examples of which are shown in the *Illustrated Encyclopaedia of British Pottery and Porcelain*, Plates 468–9.

R

WILLIAM RATCLIFFE
Manufacturer of earthenwares and porcelains at Hanley, c. 1831–40.

Printed mark, the initial 'R' also occurs over the name 'HACKWOOD', c. 1831–40.

J. REED
Manufacturer of earthenware at Rock Pottery, Mexborough, Yorkshire, c. 1839–73.

REED

Impressed mark, c. 1839 +.

R. & T.

The initials 'R. & T.' relate to Messrs Reed & Taylor of the Ferrybridge and Rock Potteries, c. 1820–56.

REGISTRATION MARKS
From 1842 to 1883 a diamond-shaped device occurs on a wide range of ceramics, the shape or added pattern of which was registered at the Patent Office. By the use of the key below, the date, month and year in which the design was registered can be ascertained. From 1884 progressive numbers were employed and occur on wares, preceded by 'Rd No' (see guide reproduced on page 111).

TABLE OF REGISTRATION MARKS 1843–1883

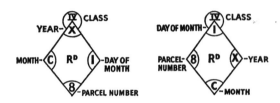

Above are the two patterns of Design Registration Marks that were in current use between the years 1842 and 1883. Keys to 'year' and 'month' code-letters are given below.

The left-hand diamond was used during the years 1842 to 1867. A change was made in 1868, when the right-hand diamond was adopted.

INDEX TO YEAR AND MONTH LETTERS

YEARS

1842–67		1868–83	
Year Letter at Top		*Year Letter at Right*	
A = 1845	N = 1864	A = 1871	L = 1882
B = 1858	O = 1862	C = 1870	P = 1877
C = 1844	P = 1851	D = 1878	S = 1875
D = 1852	Q = 1866	E = 1881	U = 1874
E = 1855	R = 1861	F = 1873	V = 1876
F = 1847	S = 1849	H = 1869	W = (1–6 March)
G = 1863	T = 1867	I = 1872	1878
H = 1843	U = 1848	J = 1880	X = 1868
I = 1846	V = 1850	K = 1883	Y = 1879
J = 1854	W = 1865		
K = 1857	X = 1842		
L = 1856	Y = 1853		
M = 1859	Z = 1860		

MONTHS (BOTH PERIODS)

A = December	G = February	M = June
B = October	H = April	R = August (and
C or O = January	I = July	1–19 September
D = September	K = November (and	1857)
E = May	December 1860)	W = March

TABLE OF DESIGN REGISTRATION NUMBERS, FOUND ON WARES FROM 1884

Rd. No.	1	registered in January 1884
Rd. No.	19754	registered in January 1885
Rd. No.	40480	registered in January 1886
Rd. No.	64520	registered in January 1887
Rd. No.	90483	registered in January 1888
Rd. No.	116648	registered in January 1889
Rd. No.	141273	registered in January 1890
Rd. No.	163767	registered in January 1891
Rd. No.	185713	registered in January 1892
Rd. No.	205240	registered in January 1893
Rd. No.	224720	registered in January 1894
Rd. No.	246975	registered in January 1895
Rd. No.	268392	registered in January 1896
Rd. No.	291241	registered in January 1897
Rd. No.	311658	registered in January 1898
Rd. No.	331707	registered in January 1899
Rd. No.	351202	registered in January 1900
Rd. No.	368154	registered in January 1901
Rd. No.	385500*	registered in January 1902
Rd. No.	402500*	registered in January 1903
Rd. No.	420000*	registered in January 1904
Rd. No.	447000*	registered in January 1905
Rd. No.	471000*	registered in January 1906
Rd. No.	494000*	registered in January 1907
Rd. No.	519500*	registered in January 1908
Rd. No.	550000*	registered in January 1909

Approximate numbers only.

JOB RIDGWAY (& SONS)

Manufacturer of earthenwares and porcelain at Cauldon Place, Shelton, c. 1802–13. Continued by Job's two sons, JOHN & WILLIAM RIDGWAY, c. 1814–30.

Most early Ridgway wares are unmarked.

I. RIDGWAY

Rare early impressed name-mark with bee-hive below, found on earthenwares, c. 1802–1808.

RIDGWAY & SONS

Rare impressed mark found on porcelains, c. 1808–13, note addition of '& Sons'.

J. & W. RIDGWAY

J. & W. R.

J. W. R.

From 1814 to 1830 Job Ridgway's two sons, John and William, traded in partnership at the Cauldon Place Works. Many printed or impressed marks were used incorporating the name or initials 'J. & W. Ridgway', 'J. & W. R.', 'J. W. R.'

In 1830 the two brothers separated, John continued the Cauldon Place Works to 1855 (see next entry), and William Ridgway worked the Bell Works (and other factories) at Shelton.

JOHN RIDGWAY (& CO.)

Manufacturer of fine porcelain and earthenwares at Cauldon Place, Shelton, c. 1830–1855, in succession to J. & W. RIDGWAY.

J. R.

I. R.

JOHN RIDGWAY

Several printed marks occur incorporating the initials 'J. R.' (or 'I. R.') or the name 'John Ridgway', c. 1830–41. The basic mark is the Royal Arms with the initials worked in the ribbon under; two specimen marks are reproduced.

J. R. & Co.

Similar initial or name marks with the addition of '& Co.' occur, c. 1841–55.

John Ridgway & Co. was succeeded by JOHN RIDGWAY, BATES & CO., c. 1856–1858, then BATES, BROWN-WESTHEAD, MOORE & CO., c. 1859–61, then BROWN-WESTHEAD, MOORE & CO., c. 1862–1904; initial and name marks were used by these different firms.

A selection of Ridgway wares is included in the *Illustrated Encyclopaedia of British Pottery and Porcelain*, Plates 476–82.

WILLIAM RIDGWAY (& CO.)

Manufacturers of earthenwares of various types at Bell Works, Shelton, and Church Works, Hanley, c. 1830–54. Also traded under other styles.

W. R.

W. RIDGWAY

Several printed or impressed marks, incorporating these initials or the name, c. 1830–4.

W. R. & Co.

W. RIDGWAY & CO.

Several printed or impressed marks occur from c. 1834 to 1854; note the addition of '& Co.'

From c. 1838 to 1848 the firm of WILLIAM RIDGWAY, SON & CO. worked the Church Works and the Cobden Works (c. 1841–6); the initials were incorporated in several printed marks.

W. R. S. & Co.

The name also occurs in full in some instances.

RIDGWAY, MORLEY, WEAR & CO.

Manufacturers of earthenwares at Shelton, c. 1836–42. Partnership succeeded Messrs Hicks, Meigh & Johnson and was followed by Ridgway & Morley, c. 1842–5.

R. M. W. & Co.

Several different printed marks occur incorporating these initials or the name in full, c. 1836–42.

Several different printed marks occur incorporating the initials 'R. & M.' or the name of the firm in full, c. 1842–5.

Ridgway & Morley

JOHN & RICHARD RILEY

Manufacturers of earthenwares and porcelain at Burslem, c. 1802–28.

Riley

Impressed mark, c. 1802–28.

Several different printed marks were used incorporating the name 'RILEY' or 'RILEY'S'.

ROBINSON & LEADBEATER (LTD)

Manufacturers of parian figures, etc., at Stoke, c. 1864–1924.

Impressed initial mark, found on the back of the base of parian and china figures and groups, c. 1885+. A selection of Robinson & Leadbeater's figures of 1896 are featured in the *Illustrated Encyclopaedia of British Pottery and Porcelain*, Plate 489.

Printed mark, c. 1905–24; note addition of word 'England' and abbreviation 'Ld'.

ROCKINGHAM WORKS

Situated on the Earl Fitzwilliam's Rockingham estate, near Swinton in Yorkshire. From 1806 to 1842 the works were managed by the Bramelds. A wide range of earthenwares were produced; also fine porcelains from 1826.

B

BRAMELD

BRAMELD & CO.

Several printed, impressed and moulded marks were used on earthenwares from 1806, incorporating the initial 'B' or the name 'Brameld' (often with crosses on numerals, after the name).

CI . CL b . C CL .

Painted, printed or gilt marks (of unknown significance) of small size, found on Rockingham porcelains, c. 1826–40.

Printed griffin mark (the crest of Earl Fitzwilliam) in *red* (or rarely in underglaze blue), c. 1826–30. The mark occurs *impressed* on some figures. After 1830 the basic mark occurs printed in puce; different wording appears under the crest: 'Royal Rock(ingham) Works' and/or 'China Manufacturers to the King'. The wording 'Manufacturers to the Queen' probably denotes wares decorated by Alfred Baguley after the closure of the factory in 1842. Reproduction Rockingham porcelain bears faked marks.

For further information and illustrations, see *The Rockingham Pottery* by A. A. Eaglestone and T. A. Lockett (1964); *Rockingham Ornamental Porcelain* by D. G. Rice (1965);

English Porcelain 1745–1850 edited by R. J. Charleston (1965); and the *Illustrated Encyclopaedia of British Pottery and Porcelain* by G. Godden (1966), Plates 490–8. A fine collection of Rockingham wares is housed in the Rotherham Museum.

JOHN & GEORGE ROGERS

Manufacturers of earthenware at Dale Hall, Longport, c. 1784–1814. The firm was continued by JOHN ROGERS & SON, c. 1814–1836.

ROGERS

Impressed name-mark, c. 1784–1814; this mark *may* have been continued until 1836.

THOMAS ROTHWELL

Engraver and printer of earthenwares and probably porcelain and enamels at Liverpool, Staffordshire Potteries, Birmingham and Swansea.

T. Rothwell, Delin et Sculp.

T. Rothwell, Sculp.

Rothwell, Sculp.

T. R. S.

Rare signature marks found incorporated in printed designs on creamwares seemingly of the 1760–70 period. See a paper by E. N. Stretton in the *Transactions of the English Ceramic Circle*, Vol. 6, Part 3, 1967, p. 249. It should be noted that the initials 'T. R. S.' could equally well relate to 'Thomas [or T] Radford, Sculp.' (see page 63).

'RUSKIN' POTTERY

Manufacturers of earthenwares under the proprietorship of W. Howson Taylor, at Smethwick, near Birmingham, from 1898 to July 1935.

TAYLOR

Early impressed name-mark, c. 1898 +.

Painted or incised marks, c. 1898 +.

RUSKIN

RUSKIN POTTERY

Several impressed or printed marks incorporating the name 'RUSKIN', in various forms; the name 'W. HOWSON TAYLOR' also occurs. The wording 'Made in England' added to most marks from c. 1920.

S

JOHN SADLER
Engraver and printer of earthenwares and
porcelains at Liverpool, c. 1756–70.

J. SADLER, LIVERPOOL Several different signature marks in writing
letters occur near the printed design on wares
decorated by Sadler, c. 1756. Sadler was in
partnership with Guy Green, trading as
SADLER & GREEN, until Sadler's retire-
ment, c. 1770. Guy Green then continued to
c. 1799 (see page 73). Typical printed wares
are included in the *Illustrated Encyclopaedia
of British Pottery and Porcelain*, Plates 503–5.

CHARLES SALT
Manufacturer of earthenware busts, etc., at
Hanley, c. 1837–64.

C. SALT
HANLEY

Very rare incised mark, reported on earthen-
ware bust of Wesley. Potters of this name at
Hanley are recorded in rates of 1837–8 and
1846–64. 'Salt' marks without an initial are
believed to relate to RALPH SALT (see next
entry).

RALPH SALT
Manufacturer of earthenware figures, etc., at
Hanley, c. 1820–46.

SALT

Rather rare impressed mark found on the
back of the base of figures, etc., c. 1820–46.
Typical examples are included in the *Illus-
trated Encyclopaedia of British Pottery and
Porcelain*.

SCOTT BROTHERS
Manufacturers of earthenwares at Portobello,
near Edinburgh, Scotland, c. 1786–96.

SCOTT
P. B.

Very rare impressed mark, c. 1786–96. The
initials 'P. B.' relate to Portobello.

SCOTT BROTHERS

Impressed mark formerly attributed to the Portobello Pottery, but as the marked wares are of 19th-century date, this mark would seem to relate to the SCOTT BROTHERS of the *SOUTHWICK POTTERY* at Sunderland, c. 1838–54.

Examples are included in the *Illustrated Encyclopaedia of British Pottery and Porcelain*, Plate 511.

SEACOMBE POTTERY

Established in 1851 on the Cheshire side of the Mersey, opposite Liverpool, by John Goodwin (formerly of the Crown Pottery, Longton, in the Staffordshire Potteries). The first kiln was fired in June 1852: a contemporary report mentions blue printed earthenwares and stone ware (ironstone?) as well as good-quality parian, but, by October 1871, the works had closed.

Rare printed marks incorporating the names 'J. Goodwin' or 'Goodwin & Co.' with the address 'Seacombe Pottery, Liverpool', c. 1852–71. The impressed mark 'Goodwin & Co.' may also relate to this pottery and period.

The information on this factory and the tracings of the hitherto unpublished marks have been very kindly supplied by Mr Alan Smith, Keeper of Ceramics and Applied Art, City of Liverpool Museum.

THOMAS SHARPE

Manufacturer of stonewares and earthenwares at Swadlincote, Derbyshire, c. 1821–1838, continued by SHARPE BROTHERS & CO., c. 1838–95.

SHARPE
MANUFACTURER
SWADLINCOTE

Impressed name-mark, c. 1821+.

JOHN SHORTHOSE

Manufacturer of earthenwares at Hanley, c. 1807–23. There is an overlap of dates in rate records, etc., between John Shorthose and the SHORTHOSE & HEATH partnership, also with SHORTHOSE & CO.

SHORTHOSE & HEATH	Rather rare impressed mark, c. 1795–1815.*
SHORTHOSE	Rather rare impressed mark, c. 1807–23.*
SHORTHOSE & CO.	Rather rare impressed mark, c. 1817.*

SILVERHILL POTTERY
Established c. 1838 at St Leonards, Sussex, for the production of utilitarian earthenwares. John Pelling took over in 1851; production ceased in 1886.

J. PELLING
SILVERHILL POTTERY
Very rare mark on pottery jug (dated 1877) in the Hastings Museum, c. 1851–86.

THOMAS SNEYD
Manufacturer of earthenwares at Shelton, c. 1846–7.

T. SNEYD
HANLEY
Impressed mark, c. 1846–7.

SOUTH WALES POTTERY
Earthenwares produced at Llanelly, Wales, under various proprietors as listed, c. 1839–1927: W. CHAMBERS & CO., c. 1839–54; COOMBS & HOLLAND, c. 1854–8, continued by HOLLAND & GUEST and GUEST & DEWSBURY.

SOUTH WALES POTTERY
W. CHAMBERS
S. W. P.
Sample mark, one of several impressed or printed incorporating the name 'W. CHAMBERS', c. 1839–54. Other marks incorporate the initials 'S. W. P.' or the name 'South Wales Pottery' in full, with the place-name 'LLANELLY'.

SOWTER & CO.
Manufacturers of earthenwares at Mexborough, Yorkshire, c. 1795–1804.

SOWTERS & CO.
MEXBRO;
Rare impressed marks, c. 1795–1804.

S. & Co.

S. & o.C
A moulded teapot with the impressed mark 'S. & o.C' is illustrated in the *Illustrated Encyclopaedia of British Pottery and Porcelain*, Plate 529. The mark is believed to be a misplaced version of 'S. & Co.'

* Dates approximate only.

JOSIAH SPODE

Manufacturer, with his sons, of fine-quality earthenwares and porcelains, at Stoke, c. 1770 to April 1833, when Messrs Copeland & Garrett succeeded (see page 56).

Spode

Rare early impressed mark in upper and lower case letters, c. 1780–90.

SPODE or Spode

Standard name-marks, impressed, printed or written, c. 1790+.

Impressed device, normally on porcelains, c. 1800–20.

SPODE & COPELAND

SPODE, SON & COPELAND

Rare marks incorporating trading title of Spode's London retail shop, c. 1797 to c. 1820.

Printed mark on 'Stone China', c. 1805–30.

Two typical printed marks, incorporating the names of special bodies, c. 1805–33.

Printed mark on fine porcelains, c. 1815–30. Slight variations occur, one with the date 1821.

For further information and illustrations, see *Spode and his Successors* by A. Hayden (1925) and the *Illustrated Encyclopaedia of British Pottery and Porcelain* (1966).

ST ANTHONY'S POTTERY

Earthenwares were manufactured at this Newcastle-upon-Tyne pottery under various proprietors from c. 1780 to 1878.

ST ANTHONY'S

Rare impressed mark, c. 1780–1820.

SEWELL
ST ANTHONY'S Rather rare impressed marks incorporating
SEWELL the name 'SEWELL', c. 1804–28.

SEWELL & DONKIN Printed or impressed mark, c. 1828–52.

SEWELL & CO. The name 'SEWELLS & DONKIN' may
also occur. 'SEWELL & CO.' was used, c.
1852–78.

DANIEL STEEL
Manufacturer of earthenwares, jasper, etc., at
Burslem, c. 1790–1824.
STEEL Rather rare impressed name-mark, sometimes
with the place-name 'Burslem', c. 1790–1824.

ANDREW STEVENSON
Manufacturer of earthenware at Cobridge, c.
1813–30.

STEVENSON

Impressed mark sometimes preceded by the
initial 'A', c. 1813–30.

Impressed mark, slight variations occur, c.
1813–30.

Impressed mark, believed to have been used
by Andrew rather than Ralph Stevenson,
c. 1813–30.

might be mark
Stevenson, Greenock,

RALPH STEVENSON
Manufacturer of earthenwares at Cobridge,
c. 1810–32, and continued by RALPH
STEVENSON & SON, c. 1832–35.

R. S. Several blue printed or impressed marks occur,
incorporating the initials 'R. S.' or the name,
R. STEVENSON c. 1810–32.

STEVENSON
(crown device)
STAFFORDSHIRE Impressed mark, c. 1810–32, the wording
often slightly curved.

R. S. & S.
R. STEVENSON & SON

Several printed or impressed marks occur, incorporating the initials 'R. S. & S.' or the name in full, c. 1832–5.

The Stevensons produced a good range of blue printed earthenwares, much of which was made especially for the American market.

STEVENSON & WILLIAMS
Manufacturers of earthenwares at Cobridge, c. 1825.

STEVENSON
&
WILLIAMS
COBRIDGE
STAFFORDSHIRE

Rare ornate printed mark occurs incorporating these names, c. 1825. A similar mark also occurs with the name 'STEVENSON ALCOCK & WILLIAMS'.

STOCKTON POTTERY (or 'STAFFORD POTTERY')
A wide range of earthenwares was made at this Yorkshire pottery under various managements (as listed below), from c. 1825.

William Smith (& Co.), c. 1825–55

W. S. & Co.

W. SMITH & CO.

W. S. & Co.
QUEEN'S WARE
STOCKTON

Many printed or impressed marks incorporate the initials 'W. S. & Co.', often with the place-name 'STOCKTON'. The word 'WEDGWOOD' or 'WEDGEWOOD' was also incorporated before 1848 and sometimes the description 'Queen's Ware'. The mark reproduced is a typical example.

George Skinner & Co., c. 1855–70

G. S. & Co.

Several printed or impressed marks incorporate these initials, c. 1855–70.

Skinner & Walker, c. 1870–80

S. & W.

Several printed or impressed marks incorporate these initials, often with the place-name 'STOCKTON' and the description of the body, 'PEARL WARE', etc., c. 1870–80.

JOSEPH STUBBS
Manufacturer of earthenwares at Dale Hall, Longport, c. 1822–35.

Impressed mark, impressed or printed marks also occur with the name in full, with the place-name 'Longport', c. 1822–35.

Good-quality blue printed earthenwares were made, much of which was exported to America.

SUNDERLAND POTTERIES

The potteries at Sunderland are associated with a type of 'splash lustre', typical examples of which are included in the *Illustrated Encyclopaedia of British Pottery and Porcelain*, Plate 558. Several different potteries were working in the Sunderland area, and many pieces are unmarked. The marks met with include:

'DAWSON'; 'I. DAWSON'; 'J. DAWSON'; 'DAWSON & CO.'

These name-marks relate to the Ford and South Hylton Potteries, c. 1799–1864.

'J. PHILLIPS'; 'PHILLIPS & CO.'; 'DIXON, AUSTIN & CO.'; 'DIXON & CO.'; 'DIXON, PHILLIPS & CO.'

These name-marks, sometimes incorporated in printed designs, relate to the 'Sunderland' or 'Garrison' Pottery, c. 1807–65.

'MOORE & CO.'; 'S. MOORE & CO.'; 'S. M. & CO.'

These marks relate to Moore's Wear Pottery (see page 97),

'A. SCOTT'; 'A. SCOTT & CO.'; 'SCOTT & SONS'; 'SCOTT BROS.'

These name-marks (and the relevant initials) relate to Scott's Southwick Pottery, c. 1800–1897.

Further details of the various Sunderland Potteries are contained in the new revised 15th edition of *Chaffers* and in an interesting booklet, *The Potteries of Sunderland and District*, published by the Sunderland Libraries and Museum Committee. Illustrations of typical examples will also be found in the *Illustrated Encyclopaedia of British Pottery and Porcelain*.

SWANSEA

Pottery as well as fine porcelain (c. 1814–22) was produced at Swansea in Wales under the management of various firms. Swansea earthenwares before the 1780's were not marked.

SWANSEA

CAMBRIAN

CAMBRIAN POTTERY

Three early impressed or painted marks found on earthenwares; the 'Cambrian Pottery' mark is rare, c. 1783–c. 1810.

DILLWYN & CO.

DILLWYN
SWANSEA

IMPROVED
STONE WARE
DILLWYN
& CO.

Three basic 'DILLWYN' marks (on pottery) incorporating the name of this proprietor. Several different printed marks incorporate this name or the initial 'D' or 'D. & Co.', c. 1811–17 and 1824–50.

SWANSEA

Basic name-mark on fine translucent *porcelain*, impressed, printed over the glaze, or painted, c. 1814–22. Reproductions also bear this name-mark. A variation has crossed tridents below the word 'Swansea'; this mark is normally impressed into the porcelain.

Swansea porcelain is attractive, rare and desirable.

BEVINGTON & CO.
SWANSEA

Rare impressed or painted mark, c. 1817–24.

EVANS & GLASSON
SWANSEA

Several different printed or impressed marks of the 1850–62 period incorporate the names 'Evans & Glasson', found on earthenwares only.

D. J. EVANS & CO.

Many different printed or impressed marks of the 1862–70 period incorporate or comprise the name 'D. J. Evans & Co.', found on earthenwares only.

For further details and illustrations, see E. Morton Nance's *The Pottery & Porcelain of Swansea and Nantgarw* (1942); W. D. John's *Swansea Porcelain* (1957); and the *Illustrated Encyclopaedia of British Pottery and Porcelain* (1966).

SWILLINGTON BRIDGE POTTERY

Blue printed earthenwares as well as iron-stone china, basalt and banded earthenwares were made at this little-known Yorkshire pottery, as has been proved by recent excavations (carried out by Mr Christopher Gilbert), c. 1820–50.

Impressed mark found on excavated Swillington Bridge fragments. A similar mark was used by W. Ridgway & Co., with the initials 'W. R. & Co.' below the word 'china', c. 1820–50.

Blue printed mark found on ironstone china fragments, c. 1820+.

T

'TEBO' (Thibauld)

The name given to a modeller or 'repairer' who used the impressed mark 'To' or, rarely, 'T'.

T o

This impressed (or relief moulded) mark is found on various 18th-century English porcelains: Bow porcelain, c. 1750–60; Worcester porcelain, c. 1760–9; Plymouth porcelain, c. 1769–70; Bristol porcelain, c. 1770–3. The mark is also found (very rarely) on Caughley porcelain, and correspondence shows that this modeller also worked for Wedgwoods, c. 1774. Three examples are included in the *Illustrated Encyclopaedia of British Pottery and Porcelain*.

JOSEPH THOMPSON

Manufacturer of earthenwares and stonewares at the Wooden Box (or Hartshorne) Pottery, near Ashby de la Zouch, Derbyshire, c. 1818–56.

JOSEPH THOMPSON
WOODEN BOX
POTTERY
DERBYSHIRE

Impressed and printed marks occur (often in circular form) with the name 'JOSEPH' or 'J. THOMPSON', c. 1818–56. After 1856 the title 'THOMPSON BROS' was used.

TOFT

Rare 17th-century earthenware dishes are found with the names of members of the Toft family (sometimes with a date) written on the front surface in 'slip'. The slipware dishes have a primitive charm and are rare and desirable; the slip technique is similar to that employed in decorating a cake with icing sugar.

CORNELIUS TOFT

JAMES TOFT
1695

RALPH TOFT
1677

THOMAS TOFT
(with dates ranging from
1671 to 1689)

Typical specimens are included in the *Illustrated Encyclopaedia of British Pottery and Porcelain*, Plates 577–9. Other 'slip wares' are shown in Plate 519.

TOFT & AUSTIN

Engravers of copper plates, used to decorate Stockton earthenwares, c. 1840–50.

Toft & Austin Sc.

Rare signature mark incorporated in printed designs on William Smith & Co.'s Stockton pottery. A pair of marked plaques are dated 1846.

JOHN TURNER

Manufacturer of earthenwares—creamwares, basalt, jasper, porcelain, etc.—at Lane End, c. 1762–c. 1806. Very early wares apparently unmarked.

TURNER

Standard impressed mark, c. 1770+. Very rarely found on porcelain.

From 1784 the Prince of Wales' feather plumes may appear with the standard name-mark.

TURNER & CO.

Standard impressed mark, c. 1780–6 and 1803–6, but the single name 'TURNER' also used at these periods.

TURNER'S PATENT

Rather rare written mark on special body patented in January 1800; used to c. 1805.

For further information and illustrations, see B. Hillier's *The Turners of Lane End* (1965) and the *Illustrated Encyclopaedia of British Pottery and Porcelain*, Plates 582–8.

J. TWIGG (& CO.)

Manufacturer of earthenwares at Newhill Pottery (c. 1822–66) and Kilnhurst Old Pottery (c. 1839–81) near Swinton, Yorkshire.

TWIGG

TWIGG
NEW HILL

Rather rare impressed marks, c. 1822+. The 'Newhill' mark predates 1866.

U

UNWIN, HOLMES & WORTHINGTON
Manufacturers of earthenware at Hanley, c. 1865–8.

UNWIN, HOLMES
& WORTHINGTON

U. H. & W.

Several printed or impressed marks incorporating the names of this partnership, or the initials 'U. H. & W.', c. 1865–8. This partnership was succeeded by Unwin & Holmes, c. 1868–77.

V

VEDGWOOD

Misleading, mock-Wedgwood, mark found impressed on earthenwares of the 1830–60 period. Mark probably used by several manufacturers, including Carr & Patton (Newcastle-on-Tyne) c. 1838–47, and William Smith & Co. (Stockton-on-Tees) c. 1825–55.

JEAN VOYEZ

Modeller whose signature mark is found on several earthenware jugs, etc., c. 1768–c. 1790.

J. VOYEZ

I. VOZEZ

Rare, impressed or moulded, name-marks, c. 1768–90.

For further information, see the *Transactions of the English Ceramic Circle*, Vol. 5. Part 1, a paper by Mr R. J. Charleston. Typical examples are included in the *Illustrated Encyclopaedia of British Pottery and Porcelain*, Plates 18, 271 and 590.

CHARLES VYSE

Modeller of earthenware figures and groups in the 1920's and 1930's and Chinese glaze-effect wares to 1963.

C. V.

VYSE
or
C. VYSE
or
CHARLES VYSE

Painted or incised initials, c. 1919–63, often with place-name 'CHELSEA'.

Several different name-marks occur with the place-name 'CHELSEA' and often the year of production.

W

RICHARD WALKER

Engraver and printer on earthenwares at Liverpool, c. 1790–1818.

R. Walker, Sculpt.

Very rare signature mark incorporated in the printed design on Liverpool earthenwares, c. 1790–1818.

EDWARD WALLEY

Manufacturer of earthenwares at Cobridge, c. 1845–56.

E. WALLEY
or
EDWARD
WALLEY

Several impressed or printed marks incorporate or comprise these names, sometimes with the place-name 'COBRIDGE', c. 1845–1856.

JOHN WALTON

Manufacturer of earthenware figures and groups at Burslem, c. 1818–35.

WALTON

Moulded or impressed name-mark found on the back of figures, etc., c. 1818–35.

Typical examples are shown in the *Illustrated Encyclopaedia of British Pottery and Porcelain*, Plates 591–2.

JOHN WARBURTON

Manufacturer of earthenwares at Cobridge, c. 1802–25.

WARBURTON

Standard impressed name found on rare creamware, basalt, etc., 1802–25.

Other potters named Warburton are recorded. John Warburton, Newcastle-upon-Tyne, c. 1750–95. Peter Warburton, Cobridge, c. 1802–12. Peter & Francis Warburton, Cobridge, c. 1795 to March 1802.

P. & F. W.

P. W.

The impressed initial mark 'P. & F. W.' probably relates to this partnership and 'P. W.' to Peter Warburton of Cobridge, but these initial marks are very rare.

WATCOMBE POTTERY CO.

Manufacturers of ornamental terra-cotta wares at Watcombe, South Devon, c. 1867–1901, continued as ROYAL ALLER VALE & WATCOMBE POTTERY CO., c. 1901–62. Basic impressed marks incorporate the word 'Watcombe' with or without the place-name 'TORQUAY', c. 1867–1901.

WATCOMBE

Printed mark, c. 1875–1901 (see page 32).

Further information is contained in Jewitt's *Ceramic Art of Great Britain* (1883).

WEDGWOOD & CO. (LTD)

Manufacturers of earthenwares at Tunstall, c. 1860–1965, then retitled 'ENOCH WEDGWOOD (TUNSTALL) LTD'.

N.B. The marks and wares of this firm are often mistaken for those of Josiah Wedgwood & Sons—who used the simple word 'WEDGWOOD', not 'WEDGWOOD & CO.' or 'WEDGWOOD & CO. LTD'.

WEDGWOOD & CO.

Standard name-mark, found incorporated in several printed marks, or used alone impressed, c. 1860–1900. 'Ltd' added from about 1900. Impressed mark also found on wares of the 1790–1801 period (see page 69).

Printed mark, one of several incorporating the name 'WEDGWOOD & CO.'; note '& CO.', which distinguishes these marks from those of Josiah Wedgwood & Sons, c. 1860+.

JOSIAH WEDGWOOD (& SONS LTD)

Celebrated manufacturers of earthenwares and porcelain at Burslem, Etruria and Barlaston, Staffordshire, c. 1759 to present day.

wedgwood

WEDGWOOD

Basic impressed name-mark on earthenwares, c. 1759+. Early specimens show individually impressed upper and lower case letters; subsequently all letters are of the same style, *sans serif* type from c. 1929. The word 'ENGLAND' should be added from 1891 or 'MADE IN ENGLAND' from c. 1910.

| WEDGWOOD & BENTLEY | Four impressed 'WEDGWOOD & BENTLEY' marks found on ornamental basalt, jasper and marbled wares, c. 1769–80. Examples are rare. The desirable circular mark has in recent years been added to unmarked objects; these fake marks are relatively soft and can consequently be marked by a pin, knife, etc. |

W. & B.

| WEDGWOOD | *Printed* name-mark on rare *porcelains*, c. 1812–22. |

| WEDGWOOD ETRURIA | Impressed mark with place-name 'ETRURIA', c. 1840–5. |

From 1860 Wedgwood creamwares, etc., bear impressed letters which show the month and year that a specimen was potted. The table below shows the year letters and relevant dates. The year letter is normally the last of the set of three.

WEDGWOOD'S IMPRESSED YEAR LETTERS

Occurring in sets of three (from 1860), the *last* shows the year of manufacture

O = 1860	U = 1866	Z = 1871	E = 1876	J = 1881
P = 1861	V = 1867	A = 1872	F = 1877	K = 1882
Q = 1862	W = 1868	B = 1873	G = 1878	L = 1883
R = 1863	X = 1869	C = 1874	H = 1879	M = 1884
S = 1864	Y = 1870	D = 1875	I = 1880	N = 1885
T = 1865				

O = 1886			
P = 1887		A = 1898	
Q = 1888		B = 1899	
R = 1889	From 1886 to 1897 the	C = 1900	From 1898 to 1906 the
S = 1890	earlier (1860–71) letters	D = 1901	letters used from 1872 to
T = 1891*	are repeated.	E = 1902	1880 re-occur, but
U = 1892		F = 1903	'ENGLAND' should also
V = 1893	* From 1891 'ENGLAND'	G = 1904	appear.
W = 1894	should occur on specimens.	H = 1905	
X = 1895		I = 1906	
Y = 1896			
Z = 1897			

From 1907 the sequence was continued, but a '3' replaces the first letter. From 1924 a '4' replaces the '3'. After 1930 the month is numbered in sequence and the last two numbers of the year are given, i.e. 1A 32 = January 1932, 'A' being the workman's mark.

EMILE LESSORE

Typical signature marks found on the Wedgwood earthenwares painted by the celebrated French artist Emile Lessore, c. 1858–76. Examples of this artist's work are shown in Colour Plate XV of the *Illustrated Encyclopaedia of British Pottery and Porcelain*.

WEDGWOOD

Basic printed mark on *porcelain*, c. 1878+. The words 'ENGLAND' or 'MADE IN ENGLAND' were added after 1891 and after about 1910. The description 'BONE CHINA' also appears.

WEDGWOOD

Basic impressed name-mark in *sans serif* type, from 1929.

OF ETRURIA
WEDGWOOD
& MADE IN ENGLAND
BARLASTON

Standard printed mark from c. 1940.

A wide selection of Wedgwood wares are included in the *Illustrated Encyclopaedia of British Pottery and Porcelain*, Plates 599–624. Many books give good information on this famous firm, recent examples include *Wedgwood* by W. Mankowitz (1953, reissued 1966); *The Story of Wedgwood* by A. Kelly (1962); *Wedgwood A.B.C. but not middle E* by H. Buten (1964); and *Decorative Wedgwood in Architecture and Furniture* by A. Kelly (1965). See also the new revised 15th edition of *Chaffers*.

N.B. True Wedgwood marks do NOT include a middle 'E' (as Wedgewood), any initial before the name, or '& Co.' added after the simple mark 'WEDGWOOD'.

WILEMAN & CO.

Manufacturers of china and earthenware at Foley Works, Fenton, c. 1892–1925. Subsequently SHELLEY POTTERIES LTD, retitled SHELLEY CHINA LTD in 1965.

Printed mark, c. 1892, note trade name 'FOLEY'.

Trade Mark
Late Foley
SHELLEY
ENGLAND.
c. 1911+

Printed trade mark, one of several incorporating the trade name 'SHELLEY', c. 1911+.

ROBERT WILSON

Manufacturer of earthenwares at the Church Works, Hanley, c. 1795–1801, works continued by David Wilson (& Sons) to c. 1818. Standard impressed mark, c. 1795–1818.

WILSON

Examples of Wilson's earthenwares are included in the *Illustrated Encyclopaedia of British Pottery and Porcelain*, Plates 626–7.

WILSON & PROUDMAN

Manufacturers of earthenwares at Coleorton Pottery, Ashby de la Zouch, Leicestershire, c. 1835–42.

WILSON & PROUDMAN Rare impressed mark, c. 1835–42.

WILTSHAW & ROBINSON (LTD)

Manufacturers of earthenware and china at Carlton Works, Stoke, c. 1890–1957, retitled CARLTON WARE LTD in January 1958. Three sample printed marks, of which several occur incorporating the initials 'W. & R.' or the trade name 'CARLTON WARE', c. 1890+.

WINCANTON

Tin-glazed delft-type wares made by Nathaniel Ireson at Wincanton, Somerset, c. 1735–50.

133

Wincanton 1738 IRESON	Rare place-name marks or inscriptions occur, sometimes with the year of production. The name Ireson is very rare, c. 1735–50. Fragments from the pottery site and rare marked examples are included in the *Illustrated Encyclopaedia of British Pottery and Porcelain*, Plates 628–9.

WOLFE & HAMILTON
Manufacturers of earthenwares at Church Street, Stoke, c. 1800–11. Works continued by Thomas Wolfe, c. 1811–18.*

WOLFE & HAMILTON	Rare impressed or painted name-mark, c. 1800–11.
WOLFE	Rather rare impressed mark, c. 1811–18.

WOOD & CALDWELL
Manufacturers of earthenwares at Burslem, c. 1790 to July 1818, preceded by Enoch Wood and succeeded by Enoch Wood & Sons (see following entries).

WOOD & CALDWELL	Standard impressed mark, c. 1790–1818, rather rare. Typical marked figures are included in the *Illustrated Encyclopaedia of British Pottery and Porcelain*, Plates 635–6.

ENOCH WOOD (& SONS)
Celebrated modeller and manufacturer of earthenwares at Burslem, c. 1784–90. In partnership under the style 'Wood & Caldwell' from c. 1790 to 1818 (see previous entry). Traded as ENOCH WOOD & SONS from July 1818 to 1846.

E. W. E. WOOD	Rather rare impressed initial or name marks found on fine creamwares, basalt, jasper, etc., c. 1790–1818.

* Thomas Wolfe also potted on his own before the Wolfe & Hamilton partnership, so that this mark could have been used c. 1784–97.

JOHN WESLEY, M.A.
DIED MAR. 2, 1791.
ENOCH WOOD, SCULP.
BURSLEM

Typical impressed inscription mark found on the back of busts, modelled by Enoch Wood. John Wesley's bust was one of this modeller's most celebrated works; copies were made by other potters.

Standard impressed mark of the 1818–46 period with the new-style 'ENOCH [or 'E'] WOOD & SONS'. Fine blue printed earthenwares were made especially for the American market.

E. W. & S.

E. & E. W.

E. WOOD & SONS

Several printed marks of the 1818–46 period incorporate these initials, as on the sample printed mark reproduced below, or the name in full.

For further information and illustrations, see *The Wood Family of Burslem* by F. Falkner (1912); *British Pottery & Porcelain 1780–1850* by G. Godden (1963); and the *Illustrated Encyclopaedia of British Pottery and Porcelain* (1966), Plates 630–4 and 637–8.

RALPH WOOD
Celebrated manufacturer of earthenware figures, etc., at Burslem, mid-18th century. Three generations of Ralph Woods made similar models: Ralph Wood I, 1715–72; Ralph Wood II, 1748–95; Ralph Wood III, 1781–1801.

R. WOOD

Typical but rare impressed marks found on desirable figures, etc., from about 1765.

78
Ra Wood,
Burslem

The model number sometimes occurs with the name, also the place-name 'BURSLEM'.

For further information and illustrations, see *The Wood Family of Burslem* by F. Falkner (1912) and *Astbury, Whieldon & Ralph Wood Figures and Toby Jugs* by R. K. Price (1922). Typical examples are also shown in the *Illustrated Encyclopaedia of British Pottery and Porcelain*, Plates 639–43.

WORCESTER PORCELAIN FACTORY

Established in 1751 by Dr John Wall and partners, after acquiring the Bristol works of Benjamin Lund. Worcester porcelain is justly celebrated for its charm and quality. The glaze is perfect, not discoloured or crazed; some early wares were decorated with overglaze prints (see Robert Hancock, page 76) and with attractive underglaze-blue designs. Specimens are desirable.

Many early specimens decorated in underglaze blue bear various workmen's signs on the base or under the handle; four typical marks are reproduced. Porcelains bearing these devices would date c. 1751–65.

The first standard Worcester mark is the blue crescent device, filled in (or with crosshatching) on printed designs, open (outlines only) crescent on hand-painted examples, c. 1755–83. An open crescent in red (or other overglaze enamel colour) as well as a gold crescent rarely occurs on specimens believed to have been decorated outside the factory.

Blue painted or printed examples sometimes bear the rather rare 'W' mark which occurs in various differing forms, c. 1760–80.

Many different fancy Oriental-style marks also occur painted in underglaze blue, often on colourful Japanese-type patterns, c. 1760–1775.

Two typical examples of the 'square' or 'seal' mark found painted by hand in underglaze blue on Worcester porcelains, often in conjunction with colourful 'scale blue' patterns. Many variations occur, c. 1755–75. Reproductions can bear 'square' marks.

Two examples of the Worcester version of the Dresden crossed-swords mark, found on overglaze printed specimens as well as ornate and colourful designs.

Printed numeral marks, disguised with Oriental-styled flourishes, formerly attributed to the Caughley factory. Recent (1967) research suggests that these are Worcester marks, c. 1770–83.

The first or 'Dr Wall' period of Worcester porcelain came to an end in September 1783. The factory, moulds, etc., were purchased by Thomas Flight and the works were continued under various partnerships, using different marks, as listed:

Flight Period, 1783–92

Early standard crescent mark continued but now very small, c. 1783–92.

Rather rare blue mark, c. 1783–8.

Rather rare blue mark with crown, c. 1788–1792.

 FLIGHT'S

Other rare marks comprise the name 'Flight' or 'Flight's' or incorporate the name, c. 1788–1792.

Barr, also Flight & Barr Period, 1792–1807
Standard incised 'B' marks, often with a small cross, c. 1792–1807.

F. & B.

FLIGHT & BARR

Other rather rare marks incorporate or comprise the name 'Flight & Barr', or the initials 'F. & B.'

Barr, Flight & Barr Period, c. 1807–13
Standard impressed or incised B. F. B. marks (with or without crown), c. 1807–13.

BARR FLIGHT
& BARR
ROYAL PORCELAIN
WORKS
WORCESTER

One of several printed or written marks incorporating the name 'Barr, Flight & Barr', c. 1807–13.

HBP—K

FBB

Flight, Barr & Barr Period, 1813–40
Standard impressed mark, the initials 'F. B. B.'
under a crown, c. 1813–40.

FLIGHT, BARR & BARR Several different printed or written marks
occur with the title in full, c. 1813–40.

Messrs Chamberlains continued the works
from 1840 to 1852 (see page 50).

Kerr & Binns Period, c. 1852–62
Standard impressed or printed mark, *without*
crown over, c. 1852–62.

Rare printed shield mark on fine-quality
specimens; the last two numerals of the year
occur in the central bar, 57 for 1857, etc.

W. H. KERR & CO. Some rare marks incorporate the title 'W. H.
Kerr & Co.', c. 1856–62.

'Royal Worcester', c. 1862 to present day
Standard printed or impressed mark, with
crown above, c. 1862–75 (numerals under the
main mark are the last two of the year of
decoration—73 for 1873, etc.).

Amended printed or impressed mark, note
crescent instead of 'C' in centre and filled-in
crown settling on circle, c. 1876–91.

Post-1891 standard printed mark, note word-
ing around, not found on earlier versions.

Revised printed mark, c. 1944–55; from 1956 the words are placed *below* the main device.

Methods of dating Royal Worcester porcelain to the year are given in *Victorian Porcelain* by G. A. Godden and in the *Encyclopaedia of British Pottery and Porcelain Marks* (1964).

For further information and illustrations of Worcester porcelain, see *Worcester Porcelain* by R. L. Hobson (1910); *Worcester Porcelain* by F. Severne Mackenna (1950); *Worcester Porcelain* by F. A. Barrett (1953, revised edition 1966); *Coloured Worcester Porcelain of the First Period* by H. Rissik Marshall (1954); *Victorian Poreelain* by G. A. Godden (1961); *English Blue and White Porcelain of the 18th Century* by B. Watney (1963); *Marks and Monograms on Pottery and Porcelain* by W. Chaffers (15th revised edition, 1965); *English Porcelain 1745–1850* edited by R. J. Charleston (1965); and the *Illustrated Encyclopaedia of British Pottery and Porcelain* by G. A. Godden (1966).

WRIGHT & RIGBY
Manufacturers of earthenwares at Hanley, c. 1882–4.

W. & R.
H.

Impressed, moulded or printed initial mark, c. 1882–4.

WROTHAM
A distinguished class of slip-decorated earthenwares were made by several potters at or near Wrotham in Kent, in the 17th and early 18th centuries.

WROTHAM
1668
H. I.

Various slip-trailed inscriptions incorporate the place-name 'WROTHAM'. Potters' initials and dates also occur, as the sample reproduced. Research on these rare wares, by A. J. B. Kiddell, is included in the *Transactions of the English Ceramic Circle*, Vol. 3, Part 2. Examples are shown in the *Illustrated Encyclopaedia of British Pottery and Porcelain*, Plates 318–21.

Y

YNYSMEDW POTTERY

Earthenwares and stonewares were made at this Welsh factory, under several proprietors, c. 1854–70 +.

YNISMEDW
POTTERY
SWANSEA WARE

Rare impressed name-mark, c. 1854 +.

Y. M. P.
or
Y. P.

Rare marks incorporate or comprise the initials 'Y. M. P.' or 'Y. P.', c. 1854 +.

WILLIAMS

Impressed or printed marks incorporating the name 'WILLIAMS', c. 1854–60.

L. & M.

Printed marks incorporating the initials 'L. & M.' for the Lewis & Morgan partnership, c. 1860–70.

Fragments excavated from the factory site are reproduced in the *Illustrated Encyclopaedia of British Pottery and Porcelain*, Plates 570–1.

Z

W. ZILLWOOD

Potter at Amesbury, near Salisbury, Wiltshire, late 18th to early 19th century.

W. Z.

Incised initial mark on early-looking pottery in Salisbury Museum, with 17th-century dates. There is no record of this potter at the period given on these examples, which are believed to be spurious.

Check List of Initials or Combinations of Initials used as Marks (or incorporated in Various Marks) employed by British Potters from c. 1775

*Indicates an entry in main, Marks section

A. Bros	*G. L. Ashworth Bros Ltd, Hanley	1861–present day
A. & Co.	Edward Asbury & Co., Longton	c. 1875–1925
A. B.	Adams & Bromley, Hanley	c. 1873–86
A. B. & C.	Allman, Broughton & Co., Burslem	c. 1861–8
A. B. & Co.	Allman, Broughton & Co., Burslem	c. 1861–8
A. B. & Co.	A. Bullock & Co., Hanley	c. 1895–1902
A. & B.	Adams & Bromley, Hanley	c. 1873–86
A. B. J.	A. B. Jones, Longton	c. 1900
A. B. J. & S.	*A. B. Jones & Sons, Longton	c. 1900 +
A. B. J. & Sons	*A. B. Jones & Sons, Longton	c. 1900 +
A. & C.	Adams & Cooper, Longton	c. 1850–77
A. F. & S.	A. Fenton & Son, Hanley	c. 1887–1901
A. G. H. J.	*A. G. Harley JONES, Fenton	c. 1907–34
A. G. R.	A. G. Richardson, Cobridge	c. 1920–1
A. G. R. & Co. Ltd	A. G. Richardson & Co. Ltd, Tunstall	c. 1915 +
A. J. M.	A. J. Mountford, Burslem	c. 1897–1901
A. J. W.	A. J. Wilkinson, Burslem	c. 1885 +
A. M. L.	A. Mackee, Longton	c. 1892–1906
A. P. Co.	Anchor Porcelain Co., Longton	c. 1901–18
A. P. Co. L.	Anchor Porcelain Co. Ltd, Longton	c. 1901–18
A. & S.	Arkinstall & Sons, Stoke	c. 1904–24
A. S. B.	A. Stanyer, Burslem	c. 1916–41
A. S. & Co.	Ambrose Smith & Co., Burslem	c. 1784–6
A. S. W.	Rye Pottery, Sussex	c. 1920–39
A. W. L.	Arthur Wood, Longport	c. 1904–28
B. (incised)	*Worcester, Barr period	c. 1792–1807
B. (impressed)	J. & E. Baddeley, Shelton	c. 1784–1806
	Thomas Barlow, Longton	c. 1849–82
	T. W. Barlow & Son Ltd, Longton	c. 1882–1940
B. (painted)	*Bow factory, London	c. 1747–76
	*Bristol factory (porcelains)	c. 1770–81
B. (printed)	*Rockingham factory (earthenwares)	c. 1810–42
B. & Co.	L. A. Birks & Co., Stoke	c. 1896–1900
	Bodley & Co., Burslem	c. 1865
	Boulton & Co., Longton	c. 1892–1902

B. Ltd	Barlows (Longton) Ltd, Longton	c. 1920–52
B. & Son	Bodley & Son, Burslem	c. 1874–5
B. A. & B.	Bradbury, Anderson & Betteney, Longton	c. 1844–52
B. A. J.	*A. B. Jones, Longton	c. 1900 +
B. A. J. & S(ons)	*A. B. Jones, Longton	c. 1900 +
B. B.	*Minton, Stoke	c. 1820–60
B. B. B.	Booths Ltd, Tunstall	c. 1891–1948
B. B. B.	Bridgett, Bates & Beech, Longton	c. 1875–82
B. B. C.	J. Shaw & Sons Ltd, Longton	c. 1931–63
B. B. & Co.	*Baker, Bevans & Irwin, Swansea	c. 1813–38
B. & B.	Bailey & Batkin, Lane End	c. 1814–27
	Bates & Bennett, Cobridge	c. 1868–95
	Blackhurst & Bourne, Burslem	c. 1880–92
	L. A. Birks, Stoke	c. 1896–1900
	Bridgett & Bates, Longton	c. 1882–1915
B. & B. L.	*Baggerley & Ball, Longton	c. 1822–36
B. B. Ltd	Barker Bros Ltd, Longton	c. 1876 +
B. B. & I.	*Baker, Bevans & Irwin, Swansea	c. 1813–38
B. B. W. & M.	Bates, Brown-Westhead & Moore, Shelton	c. 1859–61
B. & C.	*Bridgwood & Clarke, Burslem	c. 1857–64
B. C. Co.	Britannia China Co., Longton	c. 1895–1906
B. C. G.	B. C. Godwin, Burslem	c. 1851
B. & E.	Beardmore & Edwards, Longton	c. 1856–8
B. E. & Co.	Bates, Elliott & Co., Burslem	c. 1870–5
B. F.	B. Floyd, Lane End	c. 1843
B. F. (monogram)	Burmantofts, Leeds	c. 1882–1904
B. F. B.	*Worcester—Barr, Flight & Barr	c. 1807–13
B. G.	B. Godwin, Cobridge	c. 1834–41
B. G. P. Co.	Brownfield's Guild Pottery Society Ltd, Cobridge	c. 1891–1900
B. G. & W.	Bates, Gildea & Walker, Burslem	c. 1878–81
B. H. & Co.	Beech Hancock & Co., Tunstall	c. 1851–5
B. & H.	Bednall & Heath, Hanley	c. 1879–99
	Beech & Hancock, Tunstall	c. 1857–76
	Blackhurst & Hulme, Longton	c. 1890–1932
	Bodley & Harrold, Burslem	c. 1863–5
B. & K.	Barkers & Kent, Fenton	c. 1889–1941
B. & K. L.	Barkers & Kent, Fenton	c. 1889–1941
B. L. & C.	Burgess, Leigh & Co., Burslem	c. 1862 +
B. L. & Co.	Burgess, Leigh & Co., Burslem	c. 1862 +
B. & L.	Bourne & Leigh, Burslem	c. 1892–1941
B. & L. B.	Bourne & Leigh, Burslem	c. 1892–1941
B. & L.	Burgess & Leigh, Burslem	c. 1862 +
B. & L. Ltd	Burgess & Leigh, Burslem	c. 1862 +

B. M.	*Bernard Moore, Stoke	c. 1905–15
B. & M.	Bagshaw & Mier, Burslem	c. 1802–8
B. M. & Co.	Bayley Murray, Glasgow	c. 1875–84
B. M. & T.	Boulton, Machin & Tennant, Tunstall	c. 1889–99
B. N. & Co.	Bourne, Nixon & Co., Tunstall	c. 1828–30
B. P.	Bovey Pottery & Co. Ltd, Devon	c. 1894–1957
B. P. Co.	Blyth Porcelain Co. Ltd, Longton	c. 1905–35
	Bovey Tracey Pottery Co., Devon	c. 1894–1957
	Bridge Products Co., Somerset	c. 1954–63
	Brownhills Pottery Co., Tunstall	c. 1872–96
B. P. Co. Ltd	Blyth Porcelain Co. Ltd, Longton	c. 1905–35
	Britannia Pottery Co. Ltd, Glasgow	c. 1920–35
B. R. & Co.	Birks, Rawlins & Co., Stoke	c. 1900–33
B. R. & T.	Baxter, Rowley & Tams, Longton	c. 1882–5
B. & S.	Barker & Son, Burslem	c. 1850–60
	Beswick & Son, Longton	c. 1916–30
	*Bishop & Stonier, Hanley	c. 1891–1939
	Brown & Stevenson, Burslem	c. 1900–23
B. S. & T.	Barker, Sutton & Till, Burslem	c. 1834–43
B. & T.	Blackhurst & Tunnicliffe, Burslem	c. 1879
B. T. P. Co.	Bovey Tracey Pottery Co., Devon	c. 1894–1957
B. T. & S. F.B.	B. Taylor & Sons, Ferrybridge Pottery, Yorkshire	c. 1852–6
B. & W.	Birch & Whitehead, Shelton	c. 1796
	Boughley & Wiltshire, Longton	c. 1892–5
B. W. & B.	Batkin, Walker & Broadhurst, Lane End	c. 1840–5
B. W. & Co.	Bates Walker & Co., Burslem	c. 1875–8
	Buckley, Wood & Co., Burslem	c. 1875–85
B. W. M.	*Brown-Westhead & Moore & Co., Hanley	c. 1862–1904
B. W. M. & Co.	*Brown-Westhead & Moore & Co., Hanley	c. 1862–1904
C.	*Caughley Porcelain Works, Shropshire	c. 1775–99
C. & Co.	Calland & Co., Swansea	c. 1852–6
	Clokie & Co., Castleford, Yorks.	c. 1888–1961
	Colclough & Co., Longton	c. 1887–1928
	J. H. Cope & Co., Longton	c. 1887–1947
C. A. L.	C. Amison, Longton	c. 1889–1962
C. A. & Co. Ltd	Ceramic Art Co. Ltd, Hanley	c. 1892–1903
C. A. & Sons	*C. Allerton & Sons, Longton	c. 1859–1942
C. B.	*Charles Bourne, Fenton	c. 1807–30
	Christie & Beardmore, Fenton	c. 1902–3
	Collingwood Bros, Longton	c. 1887–1957

C. B. **L.**	Collingwood Bros, Longton	c. 1887–1957
C. & B.	Cotton & Barlow, Longton	c. 1850–5
C. & B. **F.**	Christie & Beardmore, Fenton	c. 1902–3
C. C. & Co.	Cockson & Chetwyn, Cobridge	c. 1867–75
C. D.	*Coalport (Coalbrookdale) Works, Shropshire	c. 1815–30
C. & D.	Cooper & Dethick, Longton	c. 1876–88
C. & E.	Cartwright & Edwards, Longton	c. 1857 +
	*Cork & Edge, Burslem	c. 1846–60
C. & E. Ltd	Cartwright & Edwards, Longton	1857 +
C. E. & M.	Cork, Edge & Malkin, Burslem	c. 1860–71
C. F.	Charles Ford, Hanley	c. 1874–1904
C. & F.	Cockran & Fleming, Glasgow	c. 1896–1920
C. & F. **G.**	Cockran & Fleming, Glasgow	c. 1896–1920
C. & G.	Collingwood & Greatbatch	c. 1870–87
	*Copeland & Garrett, Stoke	c. 1833–47
C. H.	Charles Hobson, Burslem	c. 1865–73
C. H. Co.	Hanley China Co., Hanley	c. 1899–1901
C. H. & S.	C. Hobson & Son, Burslem	c. 1873–80
C. & H.	Coggins & Hill, Longton	c. 1892–8
	Cockson & Harding, Shelton	c. 1856–62
	Cumberlidge & Humphreys, Tunstall	c. 1886–95
C. J. M. & Co.	*C. J. Mason, Fenton	c. 1829–45
C. J. W.	*Wileman & Co., Fenton	c. 1892–1925
C. K.	Charles Keeling, Shelton	c. 1822–5
C. M.	Carlo Manzoni, Hanley	c. 1895–8
	*Charles Meigh, Hanley	c. 1835–49
C. & M.	Clokie & Masterman, Castleford, Yorks.	c. 1888–1961
C. M. & S.	*Charles Meigh & Son, Hanley	1851–61
C. M. S. & P.	Meigh & Pankhurst, Hanley	1850–1
C. & P.	Carr & Patton, North Shields	c. 1838–47
C. P. Co.	Campbellfield Pottery, Glasgow	c. 1850–1905
	Clyde Pottery, Greenock	c. 1850–1903
C. P. P. Co.	Crystal Porcelain Pottery Co., Cobridge	c. 1882–6
C. & R.	Chesworth & Robinson, Lane End	c. 1825–40
	Chetham & Robinson, Longton	c. 1822–37
C. T. M.	C. T. Maling, Newcastle-upon-Tyne	c. 1859–90
C. T. M. & Sons	C. T. Maling & Sons, Newcastle-upon-Tyne	1890–1963
C. V.	*Charles Vyse, London	c. 1919–63
C. W.	C. Waine, Longton	c. 1891–1920
C. & W.	Capper & Wood, Longton	c. 1895–1904
C. & W. K. H.	C. & W. K. Harvey, Longton	c. 1835–53
C. Y. & J.	Clementson, Young & Jameson, Hanley	c. 1844

D.	*Derby Porcelain, Derby	c. 1750–1848
	T. J. Dimmock & Co., Shelton	c. 1828–59
	Dillwyn & Co., Swansea	c. 1811–17
D. B. & Co.	*Davenport, Banks & Co., Hanley	c. 1860–73
	Davenport Beck & Co., Hanley	c. 1873–80
	Dunn Bennett & Co., Burslem	c. 1875+
D. & C. L.	Dewes & Copestake, Longton	c. 1894–1915
D. D. & Co.	*D. Dunderdale & Co., Castleford, Yorks.	c. 1790–1820
D. L. & Co.	D. Lockhart & Co., Glasgow	c. 1865–98
D. L. & S.	D. Lockhart & Sons, Glasgow	c. 1898–1953
D. M.	*W. De Morgan, London	c. 1872–1907
D. M. & S.	D. Methven & Sons, Kirkcaldy	c. 1875–1930
D. P. Co.	Diamond Pottery Co., Hanley	c. 1908–35
	Dresden Porcelain Co., Longton	c. 1896–1904
D. R.	Della Robbia Co., Birkenhead	c. 1894–1901
D. & S.	Dimmock & Smith, Hanley	c. 1826–33 and 1842–1859
E. & Co.	Edgerton & Co., Lane End	c. 1823–7
E. B. & B.	Edge, Barker & Barker, Fenton	c. 1836–40
E. B. & Co.	E. Brain & Co., Fenton	c. 1903–63
	Edge, Barker & Co., Fenton	c. 1835–6
E. & B.	Evans & Booth, Burslem	c. 1856–69
E. & B. L.	Edwards & Brown, Longton	c. 1882–1933
E. B. & S.	E. Booth & Son, Stoke	c. 1791–1802
E. B. & J. E. L.	Bourne & Leigh, Burslem	c. 1892–1941
E. C.	E. Challinor, Tunstall	c. 1842–67
E. & C. C.	E. & C. Challinor, Fenton	c. 1862–91
E. & E. W.	*Enoch Wood & Sons, Burslem	c. 1818–46
E. F. B.	E. F. Bodley & Co., Burslem	c. 1862–5
E. F. B. & Co.	E. F. Bodley & Co., Burslem	c. 1862–5
E. F. B. & Son	E. F. Bodley & Son, Longport	c. 1881–98
E. G. & C.	Everard, Glover & Colclough, Lane End	c. 1847
E. & G. P.	*E. & G. Phillips, Longport	c. 1822–34
E. & H.	Eardley & Hammersley, Tunstall	c. 1862–6
E. I. B.	*E. J. Birch, Shelton	c. 1796–1814
E. J.	Elizah Jones, Cobridge	c. 1831–9
E. J. D. B.	E. J. D. Bodley, Burslem	c. 1875–92
E. K. B.	Elkin, Knight & Bridgwood, Fenton	c. 1827–40
E. K. & Co.	Elkin Knight & Co., Fenton	c. 1822–6
E. M. & Co.	Edge, Malkin & Co., Burslem	c. 1871–1903
E. & N.	Elkin & Newton, Longton	c. 1844–5
E. P. Co.	Empire Porcelain Co., Stoke	c. 1896–1967
E. S. & Co.	Eardley, Spear & Co., Tunstall	c. 1873
E. U. & M.	Ellis, Unwin & Mountford, Hanley	c. 1860–1
E. W.	*Enoch Wood, Burslem	c. 1784–90

E. W. & S.	*Enoch Wood & Son, Burslem	1818–46
F. & Co.	*T. Fell & Co., Newcastle-upon-Tyne	c. 1817–90
F. & Sons	Ford & Sons, Burslem	c. 1893–1938
F. & Sons Ltd	Ford & Sons Ltd, Burslem	c. 1908–38
F. B.	Frederick Booth, Bradford, Yorks.	c. 1881
	*Ferrybridge Pottery, Yorks.	19th–20th century
F. B. & Co.	F. Beardmore & Co., Fenton	c. 1903–14
F.		
F. & B.	*Worcester, Flight & Barr	c. 1792–1807
F. B. B.	*Worcester, Flight, Barr & Barr	c. 1813–40
F. C.	F. Cartlidge & Co., Longton	c. 1889–1904
F. C. & Co.	Ford, Challinor & Co., Tunstall	c. 1865–80
F. & C.	Ford, Challinor & Co., Tunstall	c. 1865–80
F. G. B.	G. F. Bowers, Tunstall	c. 1842–68
F. & H.	Forester & Hulme, Fenton	c. 1887–93
F. M. & Co.	*F. Morley & Co., Hanley	c. 1845–58
F. & P.	Ford & Pointon, Hanley	c. 1917–36
F. & R.	Ford & Riley, Burslem	c. 1882–93
F. & R. P.	*F. & R. Pratt & Co., Fenton	1818 +
F. & R. P. & Co.	*F. & R. Pratt & Co., Fenton	1818 +
F. & S.	Ford & Son, Burslem	c. 1893–1964
F. T. & R.	Flacket, Toft & Robinson, Longton	c. 1858
F. W. & Co.	F. Winkle & Co., Stoke	c. 1890–1931
G. & Co.	Gallimore & Co., Longton	c. 1906–34
	*G. Grainger & Co., Worcester	c. 1839–1902
G. & A.	Galloway & Atkinson, Newcastle-upon-Tyne	c. 1870
G. Bros	J. & R. Godwin, Cobridge	c. 1834–66
	Grimwade Bros, Hanley and Stoke	c. 1886–1900
G. B.	Grimwades Ltd, Stoke	c. 1900 +
G. B. & Co.	G. Bennett & Co., Stoke	c. 1894–1902
G. & B.	Goodwin & Bullock, Longton	c. 1852–6
G. B. H.	Goodwin, Bridgwood & Harris, Lane End	c. 1829–31
G. B. & H.	Goodwin, Bridgwood & Harris, Lane End	c. 1829–31
G. B. O.	Goodwin, Bridgwood & Orton, Lane End	c. 1827–9
G. B. & O.	Goodwin, Bridgwood & Orton, Lane End	c. 1827–9
G. & C. J. M.	*G. M. & C. J. Mason, Lane Delph	c. 1813–29
G. C. P. Co.	Clyde Pottery Co., Greenock	c. 1850–1903
G. & D.	Guest & Dewsbury, Llanelly, Wales	c. 1877–1927
G. & E.	Goodwin & Ellis, Lane End	c. 1839–40
G. F. B.	G. F. Bowers, Tunstall	c. 1842–68
G. F. B. B. T.	G. F. Bowers, Tunstall	c. 1842–68

G. F. S.	G. F. Smith, Stockton-on-Tees	c. 1855–60
G. G. & Co.	*G. Grainger, Worcester	c. 1839–1902
G. G. W.	*G. Grainger, Worcester	c. 1839–1902
G. H. & Co.	Gater Hall & Co., Tunstall and Burslem	c. 1895–1943
G. & H. H.	Godwin & Hewitt, Hereford	c. 1889–1910
G. J.	*George Jones, Stoke	c. 1861–73
G. J. & Sons	*George Jones & Sons, Stoke	c. 1874–1951
G. L. A.	*G. L. Ashworth & Bros, Hanley	c. 1862 +
G. L. A. & Bros	*G. L. Ashworth & Bros, Hanley	c. 1862 +
G. L. B. & Co.	G. L. Bentley & Co., Longton	c. 1898–1912
G. M. C.	Creyke & Sons Ltd, Hanley	c. 1920–48
G. P. Co.	*Baker, Bevans & Irwin, Swansea	c. 1813–38
G. P. & Co.	George Proctor & Co., Longton	c. 1891–1940
G. R. & Co.	Godwin Rowley & Co., Burslem	c. 1828–31
G. S. & Co.	George Skinner & Co., Stockton-on-Tees	c. 1855–70
G. S. & S.	George Shaw & Sons, Rotherham, Yorks.	c. 1887–1948
G. & S.	Grove & Stark, Longton	c. 1871–85
G. & S. Ltd	Gibson & Sons, Burslem	c. 1885 +
G. T. M.	G. T. Mountford, Stoke	c. 1888–98
G. T. & S.	G. W. Turner & Sons, Tunstall	c. 1873–95
G. W.	*G. Grainger, Worcester	c. 1839–1902
G. W. & S.	G. Warrilow & Sons, Longton	c. 1887–1940
G. W. & Sons Ltd	G. Warrilow & Sons, Longton	c. 1887–1940
G. W. T. S.	G. W. Turner & Sons, Tunstall	c. 1873–95
G. W. T. & S.	G. W. Turner & Sons, Tunstall	c. 1873–95
G. & W.	Gildea & Walker, Burslem	c. 1881–5
G. & W. S. & Co.	G. & W. Smith & Co., Stockton-on-Tees	c. 1860
H.	*Hackwood, Hanley	19th cent.
	W. & J. Harding, Shelton	c. 1862–72
	E. Hughes & Co., Fenton	c. 1889–1953
	W. Hulme, Burslem	c. 1891–1941
H. & Co.	*Hackwood & Co., Hanley	c. 1807–27
	Hammersley & Co., Longton	c. 1887–1932
	Hill & Co., Longton	c. 1898–1920
H. A. & Co.	H. Alcock & Co., Cobridge	c. 1861–1910
	H. Adams & Co., Longton	c. 1870–85
	H. Aynsley & Co., Longton	c. 1873 +
H. & A.	Hammersley & Astbury, Longton	c. 1872–5
	Hulse & Adderley, Longton	c. 1869–75
H. B.	H. Burgess, Burslem	c. 1864–92
	Hawley Bros, Rotherham, Yorks.	c. 1868–1903
	Hines Bros, Fenton	c. 1886–1907
H. B. & Co.	Harvey, Bailey & Co., Lane End	c. 1833–5
	Heath, Blackhurst & Co., Burslem	c. 1859–77

H. & B.	Hampson & Broadhurst, Longton	c. 1847–53
	Harrap & Burgess, Hanley	c. 1894–1903
	Heath & Blackhurst, Burslem	c. 1859–77
	Hibbert & Boughey, Longton	c. 1889
H. & C.	Harding & Cockson, Cobridge	c. 1834–60
	Hope & Carter, Burslem	c. 1862–80
	Hulme & Christie, Fenton	c. 1893–1902
H. C. Co.	Hanley China Co., Hanley	c. 1899–1901
H. & D.	Hallam & Day, Longton	c. 1880–5
H. F.	E. Hughes & Co., Fenton	c. 1889–1953
H. F. W. & Co. Ltd	H. F. Wedgwood & Co. Ltd, Longton	c. 1954–9
H. & G.	Heath & Greatbatch, Burslem	c. 1891–3
	Holland & Green, Longton	c. 1853–82
	Hollinshead & Griffiths, Burslem	c. 1890–1909
H. H. & M.	Holdcraft, Hill & Mellor, Burslem	c. 1860–70
H. J.	*A. G. Harley JONES, Fenton	c. 1907–34
H. J. C.	H. J. Colclough, Longton	c. 1897–1937
H. J. W.	H. J. Wood, Burslem	c. 1884 +
H. & K.	Hackwood & Keeling, Hanley	c. 1835–6
	Hollinshead & Kirkham, Tunstall	c. 1870–1956
H. L. & Co.	Hancock, Leigh & Co., Tunstall	c. 1860–2
H. M.	Hudson & Middleton, Longton	c. 1941 +
	Holbeck Moor Pottery, nr Leeds	Late 18th cent.
H. M. I.	*Hicks, Meigh & Johnson, Shelton	c. 1822–35
H. M. & I.	*Hicks, Meigh & Johnson, Shelton	c. 1822–35
H. M. J.	*Hicks, Meigh & Johnson, Shelton	c. 1822–35
H. M. & J.	*Hicks, Meigh & Johnson, Shelton	c. 1822–35
H. M. W. & Sons	H. M. Williamson & Sons, Longton	c. 1879–1941
H. N. & A.	Hulse, Nixon & Adderley, Longton	1853–68
H. P.	*Liverpool porcelains	Late 18th cent.
	*H. Palmer, Hanley	c. 1760–80
H. P. Co.	Hanley Porcelain Co., Hanley	c. 1892–9
H. & P.	Harrison & Phillips, Burslem	c. 1914–15
H. P. & M.	Holmes, Plant & Maydew, Burslem	c. 1876–85
H. & R.	Hall & Read, Burslem	c. 1882–8
	Hughes & Robinson	
H. & R. J.	H. & R. Johnson, Cobridge and Tunstall	c. 1902 +
H. & S.	Hart & Son (Retailers), London	c. 1826–69
	*Hilditch & Sons, Lane End	c. 1822–30
	Holmes & Son, Longton	c. 1898–1903
H. W. & Co.	Hancock, Whittington & Co., Burslem	c. 1863–72
	Hawley, Webberley & Co., Longton	c. 1895–1902
H. & W.	Hancock & Whittingham, Stoke	c. 1873–9

I. D. B.	J. D. Baxter, Hanley	c. 1823–7
I. E. B.	J. & E. Baddeley, Shelton	c. 1784–1806
I. H.	*J. Heath, Hanley	c. 1770–1800
I. H. & Co.	J. Heath & Co., Tunstall	c. 1828–41
I. K.	*J. Kishere, London	c. 1800–43
I. M.	*J. Meir, Tunstall	c. 1812–36
I. M. & Co.	J. Miller & Co., Glasgow	c. 1869–75
I. M. & S.	*J. Meir & Sons, Tunstall	ç. 1837–97
I. R. & Co.	*J. Rose & Co., *Coalport* mark	c. 1820–50
I. T.	*J. Twigg, Kilnhurst, Yorks.	c. 1822–81
I. W. & Co.	I. Wilson & Co., Middlesbrough, Yorks.	c. 1852–87
J. & Co.	J. Jackson & Co., Rotherham, Yorks.	c. 1870–87
J. B.	J. Beech, Tunstall and Burslem	c. 1877–89
	J. & M. P. Bell & Co., Glasgow	c. 1842–1928
	J. Broadhurst & Sons, Fenton	c. 1862 +
J. B. & Co.	J. Bennett & Co., Hanley	c. 1896–1900
	Bennett & Shenton, Hanley	c. 1900–3
	J. Bevington & Co., Hanley	c. 1869–71
J. B. & S.	J. Beech & Son, Longton	c. 1860–98
	J. Broadhurst & Sons, Fenton	c. 1862 +
J. B. W.	J. B. Wathen, Fenton	c. 1864–9
J. C.	*J. Clementson, Shelton	c. 1839–64
J. C. L.	J. Chew, Longton	c. 1903–4
J. C. & Co.	J. Carr & Co., North Shields	c. 1845–1900
J. & C. W.	J. & C. Wileman, Fenton	c. 1864–9
J. D.	J. Dudson, Hanley	c. 1838–88
J. D. & Co.	J. Dimmock & Co., Hanley	c. 1862–1904
J. D. B.	J. D. Baxter, Hanley	c. 1823–7
J. E. B.	J. & E. Baddeley, Shelton	c. 1784–1806
J. E. & Co.	J. Edwards & Co., Fenton	c. 1847–1900
J. E. & S.	J. Edwards & Son, Burslem	c. 1851–82
J. F. A.	J. F. Adderley, Longton	c. 1901–5
J. F. & Co.	J. Furnival & Co., Cobridge	c. 1845–70
J. F. & C. W.	J. & C. Wileman, Fenton	c. 1864–7
J. F. E.	J. F. Elton & Co. Ltd, Burslem	c. 1901–10
J. F. E. & Co. Ltd	J. F. Elton & Co. Ltd, Burslem	c. 1901–10
J. F. W.	J. F. Wileman, Fenton	c. 1869–92
J. G.	J. Gildea, Burslem	c. 1885–8
	*George Jones, Stoke	c. 1861–1951
J. & G. L.	Jackson & Gosling, Longton	c. 1866 +
J. & G. A.	J. & G. Alcock, Cobridge	c. 1839–46
J. G. S. & Co.	J. Goodwin, Stoddard & Co., Longton	c. 1898–1940
J. & G. V.	J. & G. Vernon, Burslem	c. 1880–9

J. H.	J. Holdcroft, Longton	c. 1865–1939
J. H. & Co.	Joseph Heath & Co., Tunstall	c. 1828–41
J. H. C. & Co.	J. H. Cope & Co., Longton	c. 1887–1947
J. H. W.	J. H. Walton, Longton	c. 1912–21
J. H. W. & Sons	J. H. Weatherby & Sons, Hanley	c. 1891 +
J. J. & Co.	J. Jackson & Co., Rotherham, Yorks.	c. 1870–87
J. K.	J. Kent, Longton	c. 1897 +
J. K. L.	J. Kent, Longton	c. 1897 +
J. L. C.	J. L. Chetham, Longton	c. 1841–62
J. M.	*J. Meir, Tunstall	c. 1812–36
	J. Miller, Glasgow	c. 1869–75
J. M. & Co.	*James Macintyre & Co., Burslem	c. 1860
	John Marshall & Co., Bo'ness	c. 1860–99
	J. Maudesley & Co., Tunstall	c. 1862–4
	J. Miller & Co., Glasgow	c. 1869–75
J. M. & S.	*J. Meir & Son, Tunstall	c. 1837–97
J. & M. P. B. & Co.	J. & M. P. Bell & Co., Glasgow	c. 1842–1928
J. P.	J. Proctor, Longton	1843–6
J. P. & Co. (L)	J. Pratt & Co. Ltd, Fenton	c. 1872–8
J. P. Ltd	J. Pearson Ltd, Brampton	c. 1907 +
J. & P.	Jackson & Patterson, Newcastle-upon-Tyne	1830–45
J. R.	James Reeves, Fenton	c. 1870–1948
	*J. Ridgway, Shelton	c. 1830–55
	J. Robinson, Burslem	c. 1876–98
J. R. & Co.	*J. Ridgway & Co., Shelton	c. 1830–55
	*J. Rose & Co., *Coalport*	c. 1820–60
J. R. B. & Co.	J. Ridgway, Bates & Co., Shelton	c. 1856–58
J. R. & F. C.	J. R. & F. Chetham, Longton	c. 1846–69
J. & R. G.	J. & R. Godwin, Cobridge	c. 1834–66
J. R. H.	J. & R. Hammersley, Hanley	c. 1877–1917
J. R. & S.	J. Robinson & Son, Castleford	c. 1905–33
J. S. & Co.	Jones, Shepherd & Co., Longton	c. 1867–8
	J. Shore & Co., Longton	c. 1887–1905
J. S. H.	Hill Pottery & Co., Burslem	c. 1861–7
J. S. S. B.	J. Sadler & Sons, Burslem	c. 1899 +
J. S. W.	J. S. Wild, Longton	c. 1904–27
J. T.	J. Tams (& Sons Ltd), Longton	c. 1875 +
	J. Twenlow, Shelton	c. 1795–7
	*J. Twigg, Kilnhurst, Yorks.	c. 1822–81
J. T. Ltd	J. Tams Ltd, Longton	c. 1912 +
J. T. & S(ons)	J. Tams & Sons, Longton	c. 1903–12
	J. Thomson & Sons, Glasgow	c. 1816–84
J. & T. B.	J. & T. Bevington, Hanley	c. 1865–78
J. & T. E.	J. & T. Edwards, Burslem	c. 1839–41
J. & T. F.	J. & T. Furnival, Shelton	c. 1843
J. T. H.	J. T. Hudden, Longton	c. 1859–85
J. V.	James Vernon, Burslem	c. 1860–80

J. V. junr	James Vernon, Burslem	c. 1860–80
J. V. & S.	James Vernon, Burslem	c. 1860–80
J. W.	J. Woodward, Swadlincote	c. 1859–88
J. & W.	Jones & Walley, Cobridge	c. 1841–3
J. W. D.	*Ashby Potters Guild, Woodville, Derbyshire	c. 1909–22
J. W. P. & Co.	J. W. Pankhurst & Co., Hanley	c. 1850–82
J. W. R.	*J. & W. Ridgway, Shelton	c. 1814–30
J. & W. R.	*J. & W. Ridgway, Shelton	c. 1814–30
J. W. & S.	J. Wilson & Sons, Fenton	c. 1898–1926
J. Y.	J. Yates, Hanley	c. 1784–1835
K. & Co.	Keeling & Co., Burslem	c. 1886–1936
	W. Kirby & Co., Fenton	c. 1879–85
	Kirkland & Co., Etruria	c. 1892+
K. & B.	*Kerr & Binns, *Worcester*	1852–62
	King & Barratt, Burslem	c. 1898–1940
	Knapper & Blackhurst, Tunstall and Burslem	c. 1867–88
K. & Co. B.	Keeling & Co., Burslem	c. 1886–1936
K. E. & Co.	Knight, Elkin & Co., Fenton	c. 1826–46
K. E. B.	King, Edge & Barratt, Burslem	c. 1896–7
	Knight, Elkin & Bridgwood, Fenton	c. 1829–40
K. F. A. P. Co.	Kensington Fine Art Pottery Co., Hanley	c. 1892–9
K. & M.	Keys & Mountford, Stoke	c. 1850–7
K. P. B.	Kensington Pottery Ltd, Hanley	1922+
K. P. H.	Kensington Pottery Ltd, Hanley	1922+
L. & Sons	Lancaster & Sons, Hanley	c. 1900–44
L. & A.	Lockhart & Arthur, Glasgow	c. 1855–64
L. E. & S.	Liddell, Elliot & Son, Burslem	c. 1862–70
L. H.	Lockett & Hulme, Lane End	c. 1822–6
L. & L.	Lovatt & Lovatt, Langley Mill, Notts.	c. 1895+
L. & M.	*Ynysmedw Pottery, Swansea	c. 1860–70
L. P.	*Leeds Pottery, Leeds	c. 1780–1810
L. & P.	*Lakin & Poole, Burslem	c. 1791–5
L. P. & Co.	Livesley, Powell & Co., Hanley	c. 1851–66
L. P. Co. Ltd	Longton Pottery Co. Ltd, Longton	c. 1946–55
L. S.	Lancaster & Sons, Hanley	c. 1900–44
L. W.	Lewis Woolf & Sons, Ferrybridge, Yorks.	c. 1856–83
L. W. & S.	Lewis Woolf & Sons, Ferrybridge, Yorks.	c. 1856–83
M.	J. Maddock, Burslem	c. 1842–55
	Malings, Newcastle-upon-Tyne	c. 1817–30
	*Mintons, Stoke	c. 1793+
	Royal Albion China Co., Longton	c. 1921–48

M. & Co.	*Minton, Stoke	c. 1841–73
	Moore & Co., Hanley	c. 1898–1903
	Moore & Co., Fenton	c. 1872–92
M. & A.	*Morley & Ashworth, Hanley	c. 1859–61
M. & B.	Minton & Boyle, Stoke (see *Minton	c. 1836–41
M. & C. L.	Matthews & Clark, Longton	c. 1902–6
M. & E.	Mayer & Elliott, Longport	c. 1858–61
M. E. & Co.	*Middlesbrough Earthenware Co., Yorks.	c. 1844–52
M. F. & Co.	Morley, Fox & Co., Fenton	c. 1906–44
M. H. & Co.	Mason, Holt & Co., Longton	c. 1857–84
	Minton, Hollins & Co., Stoke	c. 1845 +
M. & H.	Minton & Hollins, Stoke (see *Minton)	c. 1845–68
M. L. & Co.	Moore, Leason & Co., Fenton	c. 1892–6
M. & M.	Mayer & Maudesley, Tunstall	c. 1837–8
	Price Bros., Burslem	c. 1896–1903
M. & N.	Mayer & Newbold, Lane End	c. 1817–33
M. P. & Co.	*Middlesbrough Pottery Co., Yorks.	c. 1834–44
M. & P.	Meigh & Pankhurst, Hanley	c. 1850–1
M. & S.	Maddock & Seddon, Burslem	c. 1839–42
	Mayer & Sherratt, Longton	c. 1906–41
	*C. Meigh & Son, Hanley	c. 1851–61
M. S. & Co.	Myatt & Sons Co., Stoke, Cobridge and Hanley	c. 1898 +
M. & T.	Machin & Thomas, Burslem	c. 1831–2
M. & U.	Mogridge & Underhay (retailers) Ltd	c. 1912 +
M. V. & Co.	Mellor, Venables & Co., Burslem	c. 1834–51
M. W. & Co.	Massey & Wildblood & Co., Longton	c. 1887–9
	Morgan, Wood & Co., Burslem	c. 1860–70
M. W. H.	Malkin, Walker & Hulse, Longton	c. 1858–64
N. H.	*New Hall Porcelain Co., Shelton	c. 1820–35
N. H. & Co.	Neale, Harrison & Co., Hanley	c. 1875–85
N. S.	*Spode (on 'New Stone' wares), Stoke	c. 1805–25
N. W. P. Co.	New Wharf Pottery Co., Burslem	c. 1878–94
O. H. E. C.	*Old Hall Earthenware Co., Hanley	c. 1861–86
O. P.	Ollivant Potteries Ltd, Stoke	1948–54
O. P. L.	Ollivant Potteries Ltd, Stoke	1948–54
P.	Pennington, Liverpool	c. 1770–85
	*Pilkingtons, nr Manchester	c. 1897–1957
	*Pinxton Porcelain Works, Derbyshire	c. 1796–1813
	J. H. Proctor, Longton	c. 1857–84

P. & Co.	Pearson & Co., Chesterfield	c. 1805 +
	*Pountney & Co., Bristol	c. 1849–89
P. & Co. Ltd	*Pountney & Co. Ltd, Bristol	c. 1889 +
P. & A.	Pountney & Allies, Bristol	c. 1815–35
P. A. B. P.	Pountney & Allies, Bristol	c. 1815–35
P. B.	Poulson Bros, Ferrybridge, Yorks.	c. 1884–1927
P. & B.	*Powell & Bishop, Hanley	c. 1876–8
P. B. & Co.	*Pinder Bourne & Co., Burslem	c. 1862–82
P. B. & H.	Pinder, Bourne & Hope, Burslem	1851–62
P. B. L.	Plant Bros, Longton	c. 1898–1906
P. B. & S.	Powell, Bishop & Stonier, Hanley	c. 1878–91
P. & C.	Physick & Cooper, Hanley	c. 1899–1900
P. & F. W.	*P. & F. Warburton, Cobridge	c. 1795–1802
P. G.	Sampson Bridgwood & Son, Longton	c. 1870 +
P. H. Co.	Hanley Porcelain Co., Hanley	c. 1892–9
P. H. & Co.	P. Holdcroft & Co., Burslem	c. 1846–52
P. H. G.	Pratt, Hassall & Gerrard, Fenton	c. 1822–34
P. L.	*R. H. & S. L. Plant (Ltd), Longton	c. 1898 +
P. P.	Pearl Pottery Co. Ltd, Hanley	c. 1894–1912
P. P. Co. Ltd	Pearl Pottery Co. Ltd, Hanley	c. 1912–36
	Plymouth Pottery Co. Ltd	c. 1856–63
P. & S.	Pratt & Simpson, Fenton	c. 1878–83
P. & S. L.	R. Plant & Sons, Longton	c. 1895–1901
P. & U.	Poole & Unwin, Longton	c. 1871–6
P. W.	*P. Warburton, Cobridge	c. 1802–12
P. W. & Co.	Podmore, Walker & Co., Tunstall	c. 1834–59
P. W. & W.	Podmore, Walker & Co., Tunstall	c. 1834–59
R.	W. Ratcliffe, Hanley	c. 1831–40
	*J. Ridgway, Hanley	c. 1830–55
R. & Co.	Reid & Co., Longton	c. 1913–46
R. B.	Robinson Bros, Castleford, Yorks.	c. 1897–1904
R. B. & Co.	R. Britton & Co., Leeds	c. 1850–3
R. B. & S.	R. Britton & Son, Leeds	c. 1872–8
R. C. & A.	Read, Clementson & Anderson, Hanley	c. 1836
R. C. & Co.	*R. Cockran & Co., Glasgow	c. 1846–1918
R. & C.	Read & Clementson, Hanley	c. 1833–5
R. (C) Ltd	A. G. Richardson, Cobridge	c. 1920–1
R. C. R.	S. & E. Collier, Reading	c. 1870–1957
R. & D.	Redfern & Drakeford, Longton	c. 1892–1933
R. F. & S.	R. Floyd & Sons, Stoke	c. 1907–30
R. G.	R. Gallimore, Longton	c. 1906–34
	R. Garner, Fenton	18th cent.
R. G. S.	R. G. Scrivener & Co., Hanley	c. 1870–83
R. G. S. & Co.	R. G. Scrivener & Co., Hanley	c. 1870–83

R. H.	R. Hammersley, Burslem and Tunstall	c. 1860–83
R. H. & Co.	R. Hall & Co., Tunstall	c. 1841–9
R. H. & S.	R. Hammersley & Son, Burslem and Tunstall	c. 1884–1905
R. H. & S.	*R. Heron & Son, Sinclairtown, Scotland	c. 1837–1929
R. H. P. & Co.	R. H. Plant & Co., Longton	c. 1881–98
R. H. & S. L. P.	*R. H. & S. L. Plant, Longton	c. 1898 +
R. & L.	*Robinson & Leadbeater, Stoke	c. 1864–1924
R. & M.	*Ridgway & Morley, Hanley	c. 1842–5
R. & M.	Roper & Meredith, Longton	c. 1913–24
R. M. A.	R. M. Astbury, Lane End, Staffs.	c. 1790
R. M. & S.	R. Malkin & Sons, Fenton	c. 1882–92
R. M. W. & Co.	*Ridgway, Morley, Wear & Co., Hanley	c. 1836–42
R. & N.	Rowley & Newton Ltd, Longton	c. 1896–1901
R. & P.	Rhodes & Proctor, Burslem	c. 1883–5
R. S.	S. Radford, Fenton	c. 1879–1957
	R. Stevenson & Son, Cobridge	c. 1810–32
R. & S.	Rigby & Stevenson, Hanley	c. 1894–1954
	Robinson & Son, Longton	c. 1881–1903
R. S. & Co.	Rathbone, Smith & Co., Tunstall	c. 1883–97
R. S. R.	Ridgway, Sparkes & Ridgway, Hanley	c. 1873–9
R. S. & S.	R. Stevenson & Son, Cobridge	c. 1832–5
R. S. W.	*Stevenson & William, Cobridge	c. 1825
	Rye Pottery, Sussex	c. 1869–1920
R. & T.	Reed & Taylor, Ferrybridge Pottery, Yorks.	c. 1843–50
R. T. & Co.	Reed & Taylor, Ferrybridge Pottery, Yorks.	c. 1843–50
R. V. W.	R. V. Wildblood, Longton	c. 1887–8
R. & W.	Robinson & Wood, Hanley	c. 1832–6
R. W. & B.	Robinson, Wood & Brownfield, Cobridge	c. 1838–41
R. W. M.	*Martin Brothers, London	c. 1873–1914
S. (printed)	*Caughley Porcelain Works, Shropshire	c. 1775–99
S. (impressed)	*Spode, Stoke	c. 1777–1805
S. Bros	Stubbs Bros, Fenton	c. 1899–1904
S. & C.	Shore & Coggins, Longton	c. 1911 +
S. Ltd	Swinnertons Ltd, Hanley	c. 1906 +
S. & Sons	Southwick Pottery, Sunderland	c. 1829–38
S. A. & Co.	*S. Alcock & Co., Cobridge and Burslem	c. 1830–59
S. B. & S.	S. Barker & Son, Swinton, Yorks.	c. 1834–93
	S. Bridgwood & Son, Longton	c. 1853 +

S. & B. **F. B.**	Sefton & Brown, Ferrybridge, Yorks.	c. 1897–1919
S. & B. **T.**	Smith & Binnall, Tunstall	c. 1897–1900
S. C.	S. Clive, Tunstall	c. 1875–80
S. & C.	Shore & Coggins, Longton	c. 1911 +
S. C. C.	Star China Co., Longton	c. 1900–19
S. C. & Co.	S. Clive, Tunstall	c. 1875–80
S. C. H. **L.**	Shore, Coggins & Holt, Longton	c. 1905–10
S. E.	S. Elkin, Longton	c. 1856–64
S. & E.	Swift & Elkin, Longton	c. 1840–3
S. & F.	Smith & Ford, Burslem	c. 1895–8
S. F. & Co.	*S. Fielding & Co., Stoke	c. 1879 +
S. H.	S. Hancock, Stoke	c. 1858–91
	Stevenson & Hancock, *Derby**	c. 1861–1935
S. H. & S.	S. Hancock & Sons, Stoke	c. 1891–1935
S. J.	S. Johnson, Burslem	c. 1887–1912
S. J. B.	S. Johnson, Burslem	c. 1887–1912
S. & J. B.	S. & J. Burton, Hanley	c. 1832–45
S. K. & Co.	S. Keeling & Co., Hanley	c. 1840–50
S. L.	S. Longbottom, Nafferton, Yorks.	Late 19th cent.
S. & L.	Stanley & Lambert, Longton	c. 1850–4
S. M. & Co.	*S. Moore & Co., Sunderland, Co. Durham	c. 1803–74
S. & N. **L.**	Salt & Nixon, Longton	c. 1897–1904
So. (printed)	*Caughley Porcelain Works, Shropshire	c. 1775–99
S. P. **G. G. W.**	*G. Grainger, Worcester	c. 1848–65
S. P. Ltd	Sylvan Pottery Ltd, Hanley	c. 1946 +
S. S.	S. Smith Ltd, Longton	c. 1846–1963
	Southwick Pottery, Sunderland, Co. Durham	c. 1872–82
S. & S.	D. Sutherland & Sons, Longton	c. 1865–75
S. & S. **S.**	Shaw & Sons, Tunstall	c. 1892–1910
S. & V.	Sant & Vodrey, Cobridge	c. 1887–93
S. & W.	Skinner & Walker, Stockton-on- Tees, Yorks.	c. 1870–80
S. W. P.	*South Wales Pottery, Llanelly	c. 1839–58
Sx. (printed)	*Caughley Porcelain Works, Shropshire	c. 1775–99
T.	Tebo (modeller and 'repairer', see page 125)	
T. A.	T. Ainsworth, Stockton, Co. Durham	c. 1858–67

T. A. & S. G.	*T. A. & S. Green, Fenton	c. 1876–89
T. B.	T. Bevington, Hanley	c. 1877–91
T. & B.	Tomkinson & Billington, Longton	c. 1868–70
T. B. & Co.	T. Booth & Co., Burslem and Tunstall	c. 1868–72
T. B. & S.	T. Boote & Son, Burslem	c. 1842 +
	T. Brown & Sons, Ferrybridge, Yorks.	c. 1919 +
T. B. G.	T. & B. Godwin, Burslem	c. 1809–34
T. & B. G.	T. & B. Godwin, Burslem	c. 1809–34
T. C.	T. Cone, Longton	c. 1892 +
T. & C. F.	T. & C. Ford, Hanley	c. 1854–71
T. C. W.	T. Wild & Co., Longton	c. 1896–1904
T. F.	T. Ford, Hanley	c. 1871–4
	*T. Fradley, Stoke	c. 1875–85
T. F. & Co.	*T. Fell & Co., Newcastle-upon-Tyne	c. 1830–90
	T. Forester & Co., Longton	c. 1888
	T. Furnival & Co., Hanley	c. 1844–6
T. F. & S.	T. Forester & Sons, Longton	c. 1883–1959
T. F. & Sons	T. Furnival & Sons, Cobridge	c. 1871–90
T. F. & S. Ltd	T. Forester & Sons Ltd, Longton	c. 1891–1959
T. G.	*T. Godwin, Burslem	c. 1834–54
	T. Green, Fenton	c. 1847–59
T. G. B.	T. G. Booth, Tunstall	c. 1876–83
T. G. & F. B.	T. G. & F. Booth, Tunstall	c. 1883–91
T. G. G. & Co. Ltd	T. G. Green & Co. Ltd, Church Gresley, Derbyshire	c. 1864 +
T. I. & Co.	T. Ingleby & Co., Tunstall	c. 1834–5
T. I. & J. E.	T. I. & J. Emberton, Tunstall	c. 1869–82
T. J. & J. M.	T. J. & J. Mayer, Burslem	c. 1843–55
T. & K. L.	Taylor & Kent, Longton	c. 1867 +
T. & L.	Tams & Lowe, Longton	c. 1865–74
T. L. K.	Taylor & Kent Ltd, Longton	c. 1867 +
T. M.	T. Mayer, Stoke	c. 1956 +
	T. Morris, Longton	c. 1897–1901
T. M. R.	T. M. Randall (decorator), Madeley	c. 1825–40
T. N. & Co.	T. Nicholson & Co., Castleford, Yorks.	c. 1854–71
To.	Tebo (modeller and 'repairer', see page 125)	
T. P.	T. Plant, Lane End	c. 1825–50
T. P. L.	T. P. Ledgar, Longton	c. 1900–5
T. R. & Co.	T. Rathbone & Co., Tunstall	c. 1898–1923
	T. Rathbone & Co., Portobello	c. 1810–45
T. & R. B.	*T. & R. Boote, Burslem	c. 1842 +
T. R. & P.	Tundley, Rhodes & Proctor, Burslem	c. 1873–83

T. S. & C(oy)	T. Shirley & Co., Greenock	c. 1840–57
T. T.	Taylor, Tunnicliffe & Co., Hanley	c. 1868 +
T. T. & Co.	Taylor, Tunnicliffe & Co., Hanley	c. 1868 +
T. & T.	Turner & Tomkinson, Tunstall	c. 1860–72
T. T. & S.	Thomas Till & Sons, Burslem	c. 1850–1929
T. U. & Co.	U. Thomas & Co., Hanley	c. 1888–1905
T. W. & Co.	T. Wood & Co., Burslem	c. 1885–96
T. W. & S.	T. Wood & Sons, Burslem	c. 1896–7
U. C. & N.	U. Clark & Nephews, Dicker, Sussex	c. 1900–20
U. H. P. Co.	Upper Hanley Pottery Co., Hanley and Cobridge	c. 1895–1910
U. H. & W.	*Unwin, Holmes & Worthington, Hanley	c. 1865–8
U. M. & T.	Unwin, Mountford & Taylor, Hanley	c. 1864
U. T. & Co.	U. Thomas & Co., Hanley	c. 1888–1905
W.	E. Walley, Cobridge	c. 1845–56
	Wardle & Co., Hanley	c. 1871–1935
	T. Wolfe, Stoke	c. 1784–1818
	*E. Wood, Burslem	c. 1784–92
	*Worcester porcelains (mainly blue and white)	c. 1760–75
Wxxx (impressed)	*E. Wood, Burslem	c. 1784–92
W. & Co.	Wade & Co., Burslem	c. 1887–1927
	Whittaker & Co., Hanley	c. 1886–92
	*Wileman & Co., Longton	c. 1892–1925
W. & Sons	H. M. Williamson & Son, Longton	c. 1874–1941
W. & A.	Wardle & Ash, Hanley	c. 1859–62
	Wild & Adams, Longton	c. 1909–27
W. A. & Co.	*William Adams, Tunstall and Stoke	c. 1893–1917
W. A. & S.	*William Adams, Tunstall and Stoke	c. 1819–64
W. A. A.	W. A. Adderley & Co., Longton	c. 1876–1905
W. A. A. & Co.	W. A. Adderley & Co., Longton	c. 1876–1905
W. B.	W. Bennett, Hanley	c. 1882–1937
	*W. Brownfield, Cobridge	c. 1850–71
W. & B.	Wagstaff & Brunt, Longton	c. 1880–1927
	*Wedgwood & Bentley, Etruria	c. 1768–80
	Wood & Baggaley, Burslem	c. 1870–80
	Wood & Bowers, Burslem	c. 1839
	Wood & Brownfield, Cobridge	c. 1838–50
W. & B. Ltd	Wood & Barker Ltd, Burslem	c. 1897–1903
W. B. & S.	*W. Brownfield & Sons, Cobridge	1871–91
W. B. & Sons	*W. Brownfield & Sons, Cobridge	1871–91

W. & C.	Walker & Carter, Longton and Stoke	c. 1872–89
	*Wileman & Co., Fenton	c. 1892–1925
	Wood & Challinor, Tunstall	c. 1828–43
	Wood & Clarke & Co., Burslem	c. 1871–2
W. C. & Co.	*Chamberlain & Co., Worcester	c. 1845–52
	Wood, Challinor & Co., Tunstall	c. 1860–4
W. D. M.	*W. De Morgan, London	c. 1872–1907
W. E.	W. Emberton, Tunstall	c. 1851–69
W. & E. C.	W. & E. Corn, Longport	c. 1864–1904
W. E. W.	W. E. Withinshaw, Burslem	c. 1873–8
W. F.	W. Fifield (decorator), Bristol	c. 1810–55
W. F. & Co.	Whittingham, Ford & Co., Burslem	c. 1868–73
W. F. & R.	Whittingham, Ford & Riley, Burslem	c. 1876–82
W. H.	W. Hackwood, Hanley	c. 1827–43
	W. Hudson, Longton	c. 1889–1941
W. & H.	Wildblood & Heath, Longton	c. 1889–99
	Wood & Hulme, Burslem	c. 1882–1905
	Worthington & Harrop, Hanley	c. 1856–73
W. H. & Co.	Whittaker, Heath & Co., Hanley	c. 1892–8
W. H. & S.	W. Hackwood & Sons, Hanley	c. 1846–9
	Wildblood, Heath & Sons, Longton	c. 1899–1927
W. H. G.	*W. H. Goss, Stoke	c. 1858–1944
W. H. L.	W. H. Lockitt, Hanley	c. 1901–19
W. & J. B.	W. & J. Butterfield, Tunstall	c. 1854–61
W. & J. H.	W. & J. Harding, Hanley	c. 1862–72
W. K. & Co.	W. Kirkby & Co., Fenton	c. 1879–85
W. L. **L.**	W. Lowe, Longton	c. 1874–1930
W. & L.	Wildblood & Ledgar, Longton	c. 1896–1900
W. & L. **L.**	Wathen & Lichfield, Fenton	c. 1862–4
W. & P.	Wood & Piggott, Tunstall	c. 1869–71
W. P. Co.	Wellington Pottery Co., Hanley	c. 1899–1901
W. R.	*W. Ridgway, Hanley	1830–4
W. & R.	Carlton Ware Ltd, Stoke	c. 1958+
	*Wiltshaw & Robinson Ltd, Stoke	c. 1890–1957
	Wittman & Roth, London importers of foreign wares	Late 19th cent.
	Wright & Rigby, Hanley	1882–4
W. R. & Co.	*W. Ridgway & Co., Hanley	c. 1834–54
W. R. S. & Co.	*W. Ridgway, Son & Co., Hanley	c. 1838–48
W. S.	W. Smith & Co., Stockton-on-Tees, Yorks.	c. 1845–84
W. S. & Co.	W. Smith & Co., Stockton-on-Tees, Yorks.	c. 1825–55
W. S. junr & Co.	W. Smith & Co., Stockton-on-Tees, Yorks.	c. 1845–55
W. & Sons	H. M. Williamson & Sons, Longton	c. 1879–1941

W. & S. E.	W. & S. Edge, Lane Delph	c. 1841–8
W. T. H.	W. T. Holland, South Wales Pottery	c. 1860's
W. W.	J. Wedg-Wood, Burslem and Tunstall	c. 1841–60
	Wilkinson & Wardle, Denby, Yorks.	c. 1864–6
W. & W. B.	Wooldridge & Walley, Burslem	c. 1898–1901
W. & W. Co.	W. Wood & Co., Burslem	c. 1873–1932
Y.	Yale & Barker, Longton	c. 1841–53
Y. M. P.	*Ynysmendw Pottery, Swansea	c. 1850
Y. P.	*Ynysmendw Pottery, Swansea	c. 1850
Z. B.	*Z. Boyle, Hanley	c. 1823–8
Z. B. & S.	*Z. Boyle & Son, Hanley	c. 1828–50

Further details of many of the marks listed in this Appendix I will be found in the *Encyclopaedia of British Pottery and Porcelain Marks* (Herbert Jenkins Ltd, 1964).

Staffordshire Potters of the 1780's

(taken from W. Tunnicliff's *A Topographical Survey of the County of Stafford*, c. 1786) with approximate working periods added, in brackets

BURSLEM
(including Tunstall and Longport

William Adams & Co.	Manufacturers of cream-coloured ware
	(18th century to present day, see page 37)
William Bagley	Potter
John Bourne	Manufacturer of . . . blue painted, enamelled and cream-colour earthenware (c. 1784–6)
Bourne & Malkin	Manufacturers of . . . blue and cream-colour ware (c. 1784–7)
S. & J. Cartlidge	Potters (c. 1784–6)
John Daniel	Manufacturer of cream-coloured and red earthenware (c. 1770–88)
Thomas Daniel	Potter (c. 1784–6)
Timothy Daniel	Manufacturer of cream-coloured and red earthenware (c. 1784–95)
Walter Daniel	Manufacturer of cream-coloured and red earthenware (c. 1784–95)
John Graham, Jnr	Manufacturer of white stone, earthenware, enamelled white and cream-colour (c. 1784–6)
John Green	Potter (c. 1784–6)
Thomas Holland	Manufacturer of black and red china ware and gilder (c. 1784–1812)
Anthony Keeling	Manufacturer of Queen's ware, in general blue painted and enamelled, Egyptian black . . .
	(also at Tunstall, c. 1777–90)
T. & J. Lockett	White stone (saltglaze ware?) potters (c. 1784–97)
Burnham Malkin	Potter (c. 1784–6)
John & George Rogers	Manufacturers of blue painted wares and cream-colour (c. 1784–1814, see page 115)
Ambrose Smith & Co.	Manufacturers of cream-coloured ware (1784–6)
John & Joseph Smith	Potters (c. 1784–6)

Charles Stevenson & Son	Manufacturers of cream-coloured ware, blue painted, etc. (c. 1784–6)
Thomas Wedgwood	Manufacturer of cream-coloured ware . . .
	(continued to present day as Josiah Wedgwood & Sons Ltd)
John Wood	Potter (c. 1786–1812)
Enoch & Ralph Wood	Manufacturer of all kinds of useful and ornamental earthenware, Egyptian-black, cane and various other colours, also black figures, seals and ciphers
	(c. 1784–6, continued as Ralph Wood, see page 135)
Josiah Wood	Manufacturer of fine black glazed, variegated and cream-coloured ware and blue (c. 1784–6)

COBRIDGE

Joseph Blackwell	Manufacturer of blue and white stoneware, cream and painted wares (c. 1784–95)
John Blackwell	Manufacturer of blue and white stoneware, cream and painted wares (c. 1784–1814)
Robert Bucknall	Manufacturer of Queen's ware, blue painted, enamelled, printed, etc. (c. 1786)
Thomas & Benjamin Godwin	Manufacturers of Queen's ware and china-glazed blue
	(c. 1784–90, continued at Burslem)
Hales & Adams	Potters (c. 1775–90)
Robinson & Smith	Potters (c. 1784–95)
Jacob Warburton	Potter (c. 1770–96)

FENTON
(including Etruria and Lane Delph)

William Bacchus	Manufacturer of Queen's ware, in all its various branches (c. 1784–6)
Edward Boon	Manufacturer of Queen's ware and blue painted (c. 1784–6)
Taylor Brindley	Potter (c. 1784–6)
Clowes & Williamson	Potters (c. 1784–6)
John Turner	Potter (c. 1784–6, at Lane End c. 1762–80)
Josiah & Thomas Wedgwood	Potters
	(continued to present time as Josiah Wedgwood & Sons Ltd)

HANLEY

Sampson Bagnall	Potter	(c. 1784–6)
Joseph Boon	Potter	(c. 1776–1814)
C. & E. Chatterley	Potters	(c. 1771–93)
John Glass	Potter	(c. 1784–1812)
Heath, Warburton & Co.	China manufacturers	(c. 1782–6)
Edward Keeling	Potter	(c. 1784–95)
John & Richard Mare	Potters	(c. 1770–86)
Elijah Mayer	Enameller	(c. 1784–1804)
William Miller	Potter	(c. 1784–6)
Neale & Wilson	Potters (c. 1784–95, see page 100)	
Samuel Perry	Potter	(c. 1784–6)
George Taylor	Potter	(c. 1784–1811)
Thomas Wright	Potter	(c. 1784–6)
John Yates	Potter	(c. 1784–1835)

LANE END
(including Longton and Foley)

John Barker	Manufacturer of cream-coloured . . . and blue wares	(c. 1784–6)
Richard Barker	Potter	(c. 1784–1808)
William Barker	Potter	(c. 1784–6)
Joseph Cyples	Manufacturer of Egyptian-black and pottery in general	(c. 1784–6)
William Edwards	Potter	(c. 1784–6)
Forrester & Meredith	Manufacturers of Queen's ware and various other wares	(c. 1784–6)
Joseph Garner	Potter	(c. 1784–90)
Robert Garner	Manufacturer of Queen's ware and various other wares (c. 1784–1821)	
Michael Shelley	Potter	(c. 1781–6)
Thomas Shelley	Potter	(c. 1784–1811)
Turner & Abbott	Potters to the Prince of Wales	(c. 1783–7)
Mark Walklete	Potter	(c. 1784–1810)

SHELTON

J. & E. Baddeley	Potter	(c. 1784–1808)
John Hassels	Potter	(c. 1784–6)
Heath & Bagnell	Potter	(c. 1784–6)
Samuel Hollins	Potter	(c. 1784–1813, see page 79)
Anthony Keeling	Potter	(c. 1784–6, also at Tunstall c. 1777–90)
Taylor & Pope	Potters	(c. 1784–6)
G. Twemlow	Potter	(c. 1784–6)

| Christopher Whitehead | Potter | (c. 1784–1808) |
| John Yates | Potter | (c. 1784–1835) |

STOKE

Sarah Bell	Potter	(c. 1784–6)
Hugh Booth	Manufacturer of china, china-glaze, and Queen's ware in all its branches	(c. 1784–9)
James Brindley	Potter	(c. 1784–6)
Josiah Spode	Potter	
	(c. 1777–1833, see page 119)	
Thomas Wolfe	Manufacturer of Queen's ware in general, blue printed and Egyptian black, cane, etc.	(c. 1784–97)

Staffordshire Potters of 1818

(taken from Pigot & Co.'s *The Commercial Directory* frontispiece dated 1818) with approximate working periods added, in brackets

William Adams	Stoke	(continued to present day, see page 37)
Benjamin Adams	Tunstall	(c. 1800–22)
Thomas Bagley China Manufacturer	Lane Delph	(c. 1807–18)
William Barker China Manufacturer	Fenton	(c. 1818)
Barlow & Ford	Bridge Street, Lane End	(c. 1818–30)
Bakin (Batkin?) & Deakin	Waterloo Place, Lane End	(c. 1818)
Thomas Bathwell & Co.	Red Lion Square, Burslem	(c. 1818)
Beardmore & Carr	High Street, Lane End	(c. 1810–23)
James Beech	St Johns Street, Burslem	(c. 1818)
John & Robert Blackwell	Cobridge	(c. 1818)
John Boden	Tunstall	(c. 1818–29)
John Boon	Queen Street, Burslem	(c. 1818)
Bourne, Baker & Bourne	Fenton	(c. 1796–1835)
William Bourne & Co.	Burslem	(c. 1812–18)
William Bourne	Foley	(c. 1815–25)
Joseph Bradshaw	Booden Street, Hanley	(1818–20)
William Breeze	Shelton	(c. 1812–20)
Jesse Breeze	Tunstall	(c. 1812–22)

Kitty Bridgwood & Son	High Street, Lane End
	(c. 1809–18)
Brookes & Co.	Burslem (c. 1818)
China Manufacturers	
Thomas Brough	Green Dock, Lane End
	(c. 1818–22)
George Brownfield	Keeling, Lane End (c. 1818)
John Carey & Son	High Street, Lane End
	(c. 1813–35)
Cartlidge & Beech	Red Lion Square, Burslem
Egyptian-black	(c. 1818–28)
Richard Cartlidge	Golden Hill (c. 1818–22)
Black Ware	
William Cartwright	Lane Delph (c. 1809–21)
Ralph & James Clews	Cobridge (c. 1818–34)
James Collinson	Golden Hill (c. 1818–35)
Black Ware	
John Cornie	Burslem (c. 1818–34)
Lydia Cyples	Market Street, Lane End
Egyptian-black	(c. 1812–34)
John & James Davenport	Longport
China and Earthenware	(continued under various
Manufacturers	titles to 1887, see page 59)
Francis & Nicholas Dillon	Cobridge (c. 1818–30)
George Forrister (Forrester?)	Market Place, Lane End
	(c. 1805–31)
Robert Garner	Church Street, Lane End
	(c. 1784–1821)
Samuel Ginder & Co.	Lane Delph (c. 1811–43)
(John?) Glass & Sons	Hanley (c. 1818–22)
T. & B. Godwin	New Wharf, Burslem (c. 1809–34)
Benjamin Godwin & Sons	Cobridge (c. 1811–18)
Daniel Goosetree	Lane Delph (c. 1818–19)
China Manufacturers	
Hackwood, Dimmock & Co.	Hanley (c. 1807–25)
John & Ralph Hall	Tunstall (c. 1809–22)
John & Ralph Hall	Burslem Bank (c. 1802–22)
Robert Hamilton	Stoke (c. 1811–26)
Harley & Seckerson	High Street, Lane End
	(c. 1808–25)
Charles Harvey & Son	Charles Street, Lane End
	(c. 1805–26)
John Heath	Old Sytch, Burslem (c. 1809–22)
Thomas Heath	near New Road, Burslem
	(c. 1818–22)
Henshall & Williamson	Longport (c. 1805–30)
John Hewitt & Son	Green Dock, Lane End
	(c. 1812–18)
Hilditch & Martin	near Toll Bar, Lane End
	(c. 1815–22)

Thomas, John & Richard Hollins	Far Green, Hanley	(c. 1810–22)
Hollins, Warburton, Daniels &	Hanley	(c. 1781–1835)
Co. (The 'New Hall' partners)		
Thomas Hughes	Lane Delph	(c. 1818)
Jarvis & Love	near Church, Burslem	(c. 1818)
George Johnson	Sytch, Burslem	(c. 1818)
Ralph Johnson	Silvester Square, Burslem	
		(c. 1818–22)
Reuben Johnson	Hanley (c. 1817–23, see page 80)	
James Keeling	New Street, Hanley	(1787–1831)
Keeling, Toft & Co.	Charles Street, Hanley	
		(c. 1804–26, see page 82)
Thomas & Joseph Knight	Tunstall	(1813–19)
Jonathan Leak	Burslem	(c. 1812–18)
Egyptian-black		
Machin & Co.	Nile Street, Burslem	(c. 1812–22)
China Manufacturers		
John Mallard	Market Place, Burslem	(c. 1818)
Marsh & Heywood	Brownhill Potteries, Burslem	
		(c. 1818–37)
Jacob Marsh	Lane Delph	(c. 1809–32)
George & Charles Mason	Lane Delph	
	(c. 1815–29, but see page 89)	
William Mason	Lane Delph	(c. 1811–24)
Samuel Massey	Back of Methodist Chapel, Burslem	
		(c. 1818)
Mathers & Balls	High Street, Lane End	
		(c. 1805–20)
Mayer & Newbold	Market Place, Lane End	
	(c. 1817–33, see page 91)	
Joseph Mayer & Son	High Street, Hanley	(c. 1818)
Job Meigh & Son	Hill Street, Hanley	
		(c. 1805–34, see page 92)
John Meir	Tunstall	
		(c. 1812–36, see page 92)
Thomas Minton & Sons	Stoke	(c. 1793 to present day, see pages 93–6)
John Mosley	Queen Street, Burslem	
Egyptian-black		(c. 1812–22)
B. & J. Myatt	High Street, Lane End	
		(c. 1816–22)
John, William & James Myatt	High Street, Lane End	
		(c. 1818–25)
Nixon & Walley	Tunstall	(c. 1818)
William Nutt	Great Charles Street, Lane End	
		(c. 1818–30)
Oliver & Bourne	Cobridge	(c. 1817–20)
James Pattison	Lane End	(c. 1818–30)
Frederick Peover	Edmund Street, Hanley	(c. 1818)
Platt & Bridgwood	High Street, Lane End (c. 1812–24)	

Poulson & Dale	Dale Street, Stoke	(c. 1818)
(William?) Poulson	Lane End	(c. 1818)
Henry & Charles Powers	Sandiford, Golden Hill	(c. 1818)
Felix & Richard Pratt	Fenton	(c. 1818 to 1920's, see page 107)
John Pratt	Lane Delph	(c. 1805–35)
Pratt, Weston & Co.	Lane Delph	(c. 1818)
W. S. & J. Rathbone	Tunstall	(c. 1818–23)
Rhead (or Read) & Goodfellow	Burslem	(c. 1802–18)
Ridgway & Son (J. & W. Ridgway)	Albion Street, Shelton	(c. 1814–30, see page 111)
J. Ridgway & Son (J. & W. Ridgway)	Cauldon Place, Shelton	(c. 1814–30, see page 111)
John & Richard Riley	Burslem	(c. 1802–26, see page 113)
William Rivers & Co.	Shelton	(c. 1818–22)
John & Christopher Robinson	Hill Works, Burslem	(c. 1814–18)
John Rogers & Son	Longport	(c. 1814–36)
Cephas Shirley	Hanley	(c. 1818–20)
John Shorthose & Co.	Hill Street, Hanley	(c. 1815–23, see page 117)
Simkin, Waller	Lane End	(c. 1818)
George Sparkes	Hanley	(c. 1818)
Josiah Spode China and Earthenware Manufacturers	Stoke	(c. 1777–1833, see page 119)
William Stanley	Knowle Street, Burslem	(c. 1803–18)
Andrew Stevenson	Cobridge	(c. 1813–30, see page 120)
Ralph Stevenson	Cobridge	(c. 1810–32, see page 120)
Thomas & James Taylor	High Street, Hanley	(c. 1811–18)
Samuel Tomkinson	Queen Street, Burslem	(c. 1818–22)
Joseph Vodvill Black Ware	Golden Hill	(c. 1790–1822)
Hannah & Richard Walklate	High Street, Lane End	(c. 1809–23)
John Walton	Navigation Road, Burslem	(c. 1818–35)
Ward & Davenport	Cliff Bank, Stoke	(c. 1818–22)
Josiah Wedgwood	Etruria	(continued to present day, see pages 130–2)
Wedgwood & Co.	Rotten Row, High Street, Burslem	(c. 1818)
George Weston	High Street, Lane End	(c. 1802–30)
James Whitehead	Hill Street, Hanley	(c. 1818–22)
David Wilson & Sons	High Street, Hanley	(c. 1815–18)

Thomas Wolfe	Stoke	(c. 1811–18)
John Wood	Tunstall	(c. 1786–1818)
Samuel Wood	Hanley	(c. 1817–21)
Wood & Brettell	Brownhills, Burslem	(c. 1818–22)
Wood & Caldwell	High Street, Burslem	
	(c. 1795–July 1818, see page 134)	
Thomas Wright	Upper Green, Hanley	
		(c. 1818–25)
John Yates	Shelton	(c. 1784–1835)

Staffordshire Potters in 1830

(taken from Pigot & Co.'s *Directory* of 1830/1)
with working periods added, in brackets

William Adams	Stoke	(continued to present day, see page 37)
Thomas Alcock	Burslem	(c. 1828–30)
Samuel Alcock & Co.	Cobridge	
	(c. 1828–59, see page 38)	
Alcock, Mason & Co.	Lane End	(c. 1827–30)
William & David Bailey	Lane End	(c. 1828–30)
Baggerley & Ball	Lane End	
	(c. 1822–36, see page 41)	
J. & J. Barker	Lane End	(c. 1820–30)
James Barlow	Hanley	(c. 1828–30)
Barlow & Ford	Lane End	(c. 1818–30)
J. D. Baxter	Hanley	(c. 1823–30)
George Bettany	Lane End	(c. 1822–30)
Bill Simpson & Co.	Lane End	(c. 1828–34)
Charles Birks	Lane End	(c. 1822–35)
J. & T. Booth	Lane End	(c. 1818–30)
Richard Booth & Sons	Lane End	(c. 1824–34)
Charles Bourne	Fenton	
	(c. 1807–30, see page 44)	
Bourne, Baker & Bourne	Fenton	(c. 1796–1835)
Bourne, Nixon & Co.	Tunstall	(c. 1828–30)
Z. Boyle & Son	Hanley	
	(c. 1823–50, see page 46)	
J. Breeze & Co.	Cobridge	(c. 1828–30)
Sampson Bridgwood	Lane End	(c. 1822–45)
J. Brindley & Co.	Shelton (Hanley)	(c. 1827–30)
H. Brown & Co.	Lane End	(c. 1828–30)
J. Burrow, Jnr	Lane End	(c. 1822–30)
J. Carey & Sons	Lane End	
	(c. 1826–30, see also page 49)	
Chetham & Robinson	Lane End	(c. 1822–37)
J. & R. Clews	Cobridge	
	(c. 1818–34, see page 53)	

J. Collinson	Tunstall	(c. 1818–35)
Copestick, Hassal & Gerrard	Lane Delft	(c. 1828–30)
J. Cormic	Burslem	(c. 1818–34)
Lydia Cyples	Lane End	(c. 1812–34)
H. Daniel	Shelton	(c. 1823–33)
H. & R. Daniel	Stoke	
		(c. 1822–41, see page 59)
J. Davenport, Son & Co.	Longport	
		(c. 1793–1887, see page 59)
Deakin & Bailey	Lane End	(c. 1828–30)
F. & N. Dillon	Cobridge	(c. 1818–30)
T. Dimmock & Co.	Shelton	(c. 1828–47)
T. Dimmock, Jnr & Co.	Hanley	(c. 1830–50)
T. Drewery	Lane End	(c. 1824–30)
W. Edge	Tunstall	(c. 1828–34)
Elkin, Knight & Bridgwood	Lane End	(c. 1827–40)
Faulkner & Robinson	Lane End	(c. 1827–38)
S. Folch	Stoke	(c. 1820–30)
G. Forrister	Lane End	(c. 1805–31)
T. Gallimore	Burslem	(c. 1828–30)
Gerrard Cope & Co.	Lane End	(c. 1824–30)
S. Ginder & Co.	Lane Delft	(c. 1811–43)
Ginder & Hulse	Lane Delft	(c. 1827–31)
J. Glass	Hanley	
		(c. 1784–1812 and 1822–38)
B. Godwin & Sons	Cobridge	(c. 1811–34)
T. & B. Godwin	Burslem	(c. 1809–46)
Godwin, Rowley & Co.	Burslem	(c. 1828–31)
T. Goodfellow	Tunstall	(c. 1828–54)
Goodwins, Bridgwood & Orton	Lane End	(c. 1827–30)
T. Griffiths & Co.	Lane End	(c. 1826–30)
S. Grocott	Tunstall	(c. 1828–30)
W. Hackwood	Hanley	(c. 1827–55)
R. Hall	Tunstall	
		(c. 1822–49, see page 76)
J. Hall & Sons	Burslem	
		(c. 1814–32, see page 75)
J. & W. Handley	Burslem	(c. 1822–30)
E. Hawley & Son	Burslem	(c. 1828–30)
T. Heath	Burslem	(c. 1809–35)
J. Heath & Co.	Tunstall	(c. 1828–41)
Henshall & Williamson	Longport	(c. 1805–30)
Hicks, Meigh & Johnson	Shelton	(c. 1822–35)
W. Hilditch & Sons	Lane End	
		(c. 1822–30, see page 78)
T. Holland	Burslem	
		(c. 1784–1812 and 1830)
Holland & Pearson	Burslem	(c. 1828–30)
Hollins, Daniels, Warburton & Co. (The 'New Hall' partnership)	Shelton	
		(c. 1781–1835, see page 100)

Hughes & Taylor	Cobridge	(c. 1827–30)
J. Hulme & Sons	Lane End	(c. 1828–30)
W. Jarvis	Lane End	(c. 1822–46)
Phoebe Johnson	Hanley	
	(c. 1817–38, see page 80)	
E. Jones	Hanley	(c. 1827–31)
T. Jones & Co.	Shelton	(c. 1828–30)
J. Keeling	Hanley	(c. 1787–1831)
D. Lawton	Burslem	(c. 1828–30)
J. Lockett & Sons	Lane End	
	(c. 1828–35, see page 85)	
Lownds & Beech	Tunstall	(c. 1822–30)
J. Machin & Co.	Burslem	(c. 1824–30)
Mansfield & Hackney	Cobridge	(c. 1821–30)
J. Marsh	Lane End	(c. 1822–32)
Marsh & Haywood	Tunstall	(c. 1818–37)
W. Martin	Lane End	(c. 1827–35)
Mason & Co. (C. J. Mason & Co.)	Lane Delph	
	(c. 1829–45, see page 89)	
R. Massey	Burslem	(c. 1818–30)
T. Mayer	Stoke (c. 1826–35, see page 91)	
E. Mayer & Son	Hanley (c. 1805–34, see page 90)	
Mayer & Newbold	Lane End	
	(c. 1817–33, see page 91)	
Job Meigh & Son	Hanley	
	(c. 1805–34, see page 92)	
John Meir	Tunstall	
	(c. 1812–36, see page 92)	
Thomas Minton	Stoke (c. 1793 to present day, see page 93)	
T. Moreton	Hanley	(c. 1826–30)
R. Parr, Jnr	Burslem	(c. 1828–35)
J. Pattison	Lane End	(c. 1818–30)
Edward & George Phillips	Longport	
	(c. 1822–34, see page 103)	
W. Pointon	Burslem	(c. 1828–54)
John Pratt	Lane Delph	(c. 1805–35)
F. & R. Pratt	Fenton (c. 1818 to 20th century, see page 107)	
Pratt, Hassall & Gerrard	Lane Delph	(c. 1822–34)
S. & J. Rathbone	Tunstall	(c. 1812–35)
Read & Pratt (or Plant)	Burslem	(c. 1828–30)
J. & W. Ridgway	Shelton (c. 1814–30, see page 111)	
J. & R. Riley	Burslem	
	(c. 1802–28, see page 113)	
N. Robinson	Shelton	(c. 1826–30)
J. Rogers & Son	Longport	
	(c. 1814–36, see page 115)	
Ralph Salt	Shelton	
	(c. 1820–46, see page 116)	

J. Shaw	Lane End	(c. 1825–38)
O. Sherratt	Burslem	(c. 1822–41)
H. Simkin	Lane End	(c. 1817–40)
Josiah Spode	Stoke	(c. 1777 to present day, see page 119)
D. Steele & Son	Burslem	(c. 1822 and 1828–30)
Andrew Stevenson	Cobridge	(c. 1813–30, see page 120)
Ralph Stevenson	Cobridge	(c. 1810–32, see page 120)
S. Stretton	Lane Delph	(c. 1822–30)
Stubbs & Kent	Longport	(c. 1828–30)
T. Swettenham	Burslem	(c. 1828–30)
T. Taylor	Hanley	(c. 1818–30)
W. Taylor	Lane End	(c. 1828–30)
Toft & May	Hanley	(c. 1825–33)
M. Tunnicliffe	Tunstall	(c. 1828–41)
W. Turner	Lane End	(c. 1809–30)
John Walton	Burslem	(c. 1818–35)
T. Ward & Co.	Stoke	(c. 1815–30)
Josiah Wedgwood & Sons	Etruria	(c. 1759 to present day, see page 130)
G. Weston	Lane End	(c. 1802–30)
E(phraim) Wood	Burslem	(c. 1818–30)
Enoch Wood & Sons	Burslem	(c. 1818–46, see page 134)
Wood & Blood	Lane End	(c. 1827–30)
Wood & Challinor	Tunstall	(c. 1828–41)
John Yates	Shelton	(c. 1784–1835)

Staffordshire Potters in 1850

(taken from Slater's *Royal National and Commercial Directory*, 1850) with working periods added, in brackets

William Adams & Sons	Stoke and Tunstall	(continued to present day, see page 37)
J. & S. Alcock	Cobridge	(c. 1848–50)
Samuel Alcock & Co.	Burslem and Cobridge	(c. 1828–59, see page 38)
Allerton Brough & Green	Longton	(c. 1832–58)
G. Baguley	Hanley	(c. 1850–4)
Bailey & Ball	Longton	(c. 1843–50)
W. Baker & Co.	Fenton	(c. 1839–1932)
J. Bamford	Hanley	(c. 1850–83)
Barker & Till	Burslem	(c. 1846–50)
Thomas Barlow	Longton	(c. 1849–82)
W. Beech	Burslem	(c. 1834–62)

R. Beswick	Tunstall	(c. 1841–54)
T. Birch	Shelton	(c. 1850)
T. & R. Boote	Burslem	(c. 1842 to present day, see page 43)
G. Bowers	Tunstall	(c. 1842–68, see page 46)
Boyle & Son (S. Boyle)	Fenton	(c. 1849–52)
Bradbury, Anderson & Betteney	Longton	(c. 1844–54)
Sampson Bridgwood	Longton	(c. 1841–51)
Broadhurst & Green	Longton	(c. 1846–52)
R. Brunt	Fenton	(c. 1850)
Burgess & Gibson	Tunstall	(c. 1846–54)
Edward Challinor	Tunstall	(c. 1842–60)
J. L. Cheetham	Longton	(c. 1841–62)
J. Clementson	Shelton	(c. 1839–64, see page 53)
J. Colclough	Longton	(c. 1834–56)
A. Collingwood	Longton	(c. 1848–50)
Cooke & Griffiths	Longton	(c. 1850–1)
T. Cooper	Shelton	(c. 1850)
T. Cooper	Longton	(c. 1846–64)
Cooper & Smith	Longton	(c. 1850–1)
Cope & Edwards	Longton	(c. 1844–57)
J. Copeland	Hanley	(c. 1834–60)
W. T. Copeland	Stoke	(1847 to present day, see page 56)
W. Copestake, Jnr	Longton	(c. 1834–60)
Cork & Edge	Burslem	(c. 1846–60)
Cyples & Deakin	Longton	(c. 1850)
W. Dale	Shelton	(c. 1850–4)
R. Daniel	Stoke	(c. 1845–54)
W. Davenport & Co.	Longport	(c. 1793–1887, see page 59)
T. Dimmock & Co.	Shelton	(c. 1850)
T. Dimmock, Jnr & Co.	Hanley	(c. 1830–60)
J. Dudson	Hanley	(c. 1838–88, see page 67)
T. Edge	Burslem	(c. 1850–4)
Edgerton, Beech & Birks	Longton	(c. 1847–53)
J. Edwards	Burslem	(c. 1842–53)
John Edwards	Longton	(c. 1847–55)
J. & R. Edwards	Burslem	(c. 1839, 1841, and 1850)
Elkin & Newbon	Longton	(c. 1844–50)
W. Emberton & Co.	Tunstall	(c. 1850–1)
Evans & Poulson	Shelton	(c. 1850)
G. Everard	Longton	(c. 1841–50)
Jacob Floyd	Shelton	(c. 1850)
James Floyd	Fenton	(c. 1847–57)
John Floyd	Shelton	(c. 1850)

Forrister, Copestake & Forrister	Fenton	(c. 1848–51)
J. Furnival & Co.	Cobridge	(c. 1845–70)
R. Gallimore	Fenton	(c. 1840–50)
Glover & Colclough	Longton	(c. 1848–54)
James Godwin	Cobridge	(c. 1846–50)
Thomas Godwin	Burslem	
		(c. 1834–54, see page 72)
J. & R. Godwin	Cobridge	(c. 1834–66)
John Goodfellow	Longton	(c. 1850)
Thomas Goodfellow	Tunstall	(c. 1828–54)
Thomas Green	Fenton	(c. 1847–59)
T. Griffiths	Longton	(c. 1850)
William Hackwood & Son	Shelton	(c. 1846–50)
Ralph Hall	Tunstall	
		(c. 1841–48, see page 76)
Samuel Hall	Shelton	(c. 1841–56)
H. Hallen	Burslem	(c. 1850–79)
Hamilton & Moore	Longton	(c. 1841–58)
Hampson & Broadhurst	Longton	(c. 1847–53)
R. Hancock & Co.	Burslem	(c. 1850)
J. Harding	Burslem	(c. 1850–1)
Harding & Cockson	Cobridge	(c. 1834–61)
C. & W. K. Harvey	Longton	(c. 1835–53)
John Hawley	Fenton	(c. 1843–62)
J. Heath	Tunstall	(c. 1845–53)
Hilditch & Hopwood	Longton	(c. 1832–58)
George Hood	Burslem	
		(c. 1850–4, also 1839–41)
S. & E. Hughes	Cobridge	(c. 1846–51)
S. Keeling & Co.	Hanley	(c. 1840–50)
W. S. Kennedy	Burslem	(c. 1843–54)
S. Keys	Stoke	(1850 and 1860)
J. K. Knight	Fenton	(c. 1846–53)
M. Lawton	Shelton	(c. 1850–4)
W. Livesley & Co.	Shelton	(c. 1844–51)
G. Lockett	Shelton	(c. 1850)
J. & T. Lockett	Longton	(c. 1836–59)
J. Machin	Hanley	(c. 1850)
J. Maddock	Burslem	(c. 1842–55)
N. Massey	Burslem	(c. 1850–60)
T. Mayer	Shelton	(c. 1841–54)
T. J. & J. Mayer	Burslem	
		(c. 1843–55, see page 91)
J. Meakin	Shelton	(c. 1850–1)
C. Meigh, Son & Pankhurst	Hanley	
		(c. 1850–1, see page 91)
J. Meir & Son	Tunstall	
		(c. 1837–97, see page 92)
Mellor, Venables & Co.	Burslem	(c. 1834–51)
G. Mills	Hanley	(c. 1843–51)

H. Mills	Hanley	(c. 1834–52)
Herbert Minton & Co.	Stoke	(c. 1793 to present day, see page 93)
F. Morley & Co.	Shelton	
		(c. 1845–58, see page 97)
E. Pearson	Burslem	(c. 1850–4)
T. Pinder	Burslem	(c. 1848–51)
Podmore, Walker & Co.	Tunstall	(c. 1834–53)
J. J. & C. Pope	Shelton	(c. 1849–50)
F. & R. Pratt & Co.	Fenton	(c. 1818 to 20th century, see page 107)
J. & W. Pratt	Lane Delph	(c. 1836–59)
T. M. Randall	Shelton	(c. 1841–56)
R. Ray	Shelton	(c. 1849–52)
Riddle & Lightfoot	Longton	(c. 1835–51)
John Ridgway & Co.	Shelton	
		(c. 1841–55, see page 112)
E. Ridgway & Abbington	Hanley	(c. 1835–60)
T. Rowley	Tunstall	(c. 1846–50)
J. Seddon	Burslem	(c. 1850)
H. Sherratt	Burslem	(c. 1846–54)
Shoubotham & Webberley	Longton	(c. 1843–50)
J. Stevenson	Shelton	(c. 1850–4)
W. Stubbs	Hanley	(c. 1853–97)
Tipper & Co.	Longton	(1850–5)
G. Townsend	Longton	(c. 1850–64)
M. Tunnicliffe	Burslem	(c. 1828–41 and 1850)
J. Vernon & Co.	Burslem	(1841–51)
T. Walker	Tunstall	(1845–51)
E. Walley	Cobridge	
		(c. 1845–56, see page 129)
J. Walley	Burslem	(c. 1850–67)
J. Walton	Shelton	(c. 1846–60)
J. Warren	Longton	(c. 1841–53)
Josiah Wedgwood & Sons	Etruria	(c. 1759 to present day, see page 130)
G. Wood	Shelton	(c. 1851–4)
John Wedge Wood	Tunstall	(c. 1845–54)
Wood & Brownfield	Cobridge	(c. 1841–50)
Worthington & Green	Shelton	(c. 1844–64)
Wright & Simpson	Hanley	(c. 1850)
T. Wynne	Longton	(c. 1846–54)
Yale, Barker & Hall	Longton	(c. 1845–53)

Staffordshire Potters of 1875

(taken from *Keates's Directory* of 1875/6)
with working periods added, in brackets

W. Adams ⎫ W. & T. Adams ⎭	Tunstall	(continued to present day, see page 37)
Harvey Adams & Co.	Longton	(c. 1872–86)
Adams & Bromley	Hanley	(c. 1873–86)
Adams & Cooper	Longton	(c. 1850–77)
R. Alcock	Burslem	(c. 1870–81)
H. Alcock & Co.	Cobridge	(c. 1864–1910)
C. Allerton & Sons	Longton	
	(c. 1859–1942, see page 39)	
E. Asbury & Co.	Longton	(c. 1875–1925)
G. Ash	Hanley	(c. 1865–82)
G. L. Ashworth & Bros	Hanley	(c. 1861 to present day, see page 39)
J. Aynsley	Longton	(c. 1864–79)
H. Aynsley & Co.	Longton	(c. 1873 to present day)
C. Baker	Burslem	(c. 1875)
(W.) Baker & Co.	Fenton	(c. 1839–1932)
Bale & Co.	Hanley	(c. 1875–97)
J. Bamford	Hanley	(c. 1850–83)
Banks & Thorley	Hanley	(c. 1875–8)
T. Barlow	Longton	(c. 1849–82)
W. T. Barlow	Longton	(c. 1860–82)
J. P. Basford	Burslem	(c. 1875)
Bates & Bennett	Burslem	(c. 1868–95)
Bates, Elliott & Co.	Burslem	(c. 1870–5)
J. Beech & Son	Longton	(c. 1860–98)
Beech & Hancock	Tunstall	(c. 1857–76)
Beech & Podmore	Burslem	(c. 1875)
J. Bennett	Hanley	(c. 1873–88)
A. Bennison	Hanley	(c. 1875)
A. Bevington	Hanley	(c. 1871–9)
John Bevington	Hanley	(c. 1872–92, see page 42)
J. & T. Bevington	Hanley	(c. 1867–78)
Billington & Co.	Stoke	(c. 1875)
T. Birks & Co.	Longton	(c. 1875–6)
J. Blackhurst	Tunstall	(c. 1872–83)
R. Blackhurst	Tunstall	(c. 1868–77)
E. J. D. Bodley	Burslem	(c. 1875–92)
E. F. Bodley & Co.	Burslem	(c. 1862–98)
T. & R. Boote	Burslem	(c. 1842 to present day, see page 43)
T. Booth & Son	Tunstall	(c. 1872–6)
T. Booth & Sons	Hanley	(c. 1872–9)
Bradshaw & Bins	Hanley	(c. 1875 and 1879)
E. Brammall	Longton	(c. 1870–5)

Bridgett, Bates & Beech	Longton	(c. 1875–82)
S. Bridgwood	Fenton	(c. 1875)
S. Bridgwood & Son	Longton	(1853 to present day)
J. Broadhurst	Fenton	(c. 1864–96)
Brough & Blackhurst	Longton	(c. 1872–95)
Brown & Co.	Longton	(c. 1875–89)
W. Brownfield & Son	Cobridge	(1871–91, see page 48)
Brownhill Pottery Co.	Tunstall	(c. 1872–96)
Brown-Westhead, Moore & Co.	Hanley	
		(c. 1862–1904, see page 48)
J. Buckley	Hanley	(c. 1875–95)
Buckley, Wood & Co.	Burslem	(c. 1875–85)
Buller & Co.	Hanley	
		(c. 1870–84 and 1888–9)
H. Burgess	Burslem	(c. 1864–92)
Burgess, Leigh & Co.	Burslem	(c. 1869–78, also Burgess & Leigh, c. 1862 to present day)
W. E. Cartledge	Burslem	(c. 1875–96)
Cartwright & Edwards	Longton	
		(c. 1859 to present day)
E. & C. Challinor	Fenton	(c. 1862–91)
E. Clarke	Tunstall	(c. 1865–77)
Clementson Bros	Hanley	
		(c. 1865–1916, see page 53)
S. Clive	Tunstall	(c. 1875)
Cockson & Chetwynd	Cobridge	(c. 1867–75)
Collingwood & Greatbatch	Longton	(c. 1870–87)
R. Cooke	Hanley	(c. 1871–9)
Cooper Nixon & Co.	Longton	(c. 1863–75)
Cooper, Till & Co.	Longton	(c. 1875–6)
Copeland & Sons	Stoke	(1847 to present day, see page 56)
G. Copestake	Longton	(c. 1872–89)
Copestake & Allin	Longton	(c. 1867–80)
W. A. E. Corn	Burslem	(c. 1864–1904)
Dale, Page & Co.	Longton	(c. 1866–75)
W. Davenport & Co.	Longport	
		(c. 1793–1887, see page 59)
J. H. & J. Davis	Hanley	(c. 1871–81)
J. Dawson	Longton	(c. 1867–93)
John Dimmock & Co.	Hanley	(c. 1862–1904)
J. Dudson	Hanley	(c. 1838–88, see page 67)
Edge, Malkin & Co.	Burslem	(c. 1870–1902)
G. Edwards	Longton	(c. 1873–1904)
J. Edwards & Son	Burslem	(c. 1854–82)
John Edwards & Co.	Fenton	(c. 1873–1900)
W. Edwards	Longton	(c. 1875–1902)
T. Elsmore & Son	Tunstall	(c. 1872–87)
T. I. & J. Emberton	Tunstall	(c. 1869–82)
J. Ferneyhough (& Co.)	Longton	(c. 1867–92)

J. Finney	Longton	(c. 1858–1900)
C. Ford	Hanley	(c. 1875–1913)
Ford & Challinor	Tunstall	(c. 1865–80)
W. Freeman & Co.	Longton	(c. 1875)
T. Furnival & Son	Cobridge	(c. 1871–90)
Gaskell, Son & Co.	Burslem	(c. 1875–80)
Gelson Bros	Hanley	(c. 1867–76)
J. Green	Longton	(c. 1873–7)
M. Green & Co.	Fenton	(c. 1859–76)
Grove & Stark	Longton	(c. 1871–85)
G. Guest	Tunstall	(c. 1875)
Hallam, Johnson & Co.	Longton	(c. 1873–80)
Ralph Hammersley	Burslem and Tunstall	(c. 1860–85)
Hancock & Whittingham	Stoke	(c. 1873–9)
W. Harrop	Hanley	(c. 1875–9)
Hawley & Co.	Fenton	(c. 1862–93)
Heath & Blackhurst	Burslem	(c. 1859–77)
C. Hobson & Son	Burslem	(c. 1865–80)
R. Hobson	Longton	(c. 1862–5 and 1875)
J. Holdcroft	Longton	(c. 1865–1906)
W. Holdcroft	Burslem and Tunstall	(c. 1869–96)
Holland & Green	Longton	(c. 1853–82)
Hollinshead & Kirkham	Burslem	(c. 1870–1956)
C. Holmes	Hanley	(c. 1873–9)
Holmes, Plant & Whitehurst	Hanley	(c. 1873–5)
Hope & Carter	Burslem	(c. 1862–80)
G. Howson	Hanley	(c. 1867–96)
J. T. Hudden	Longton	(c. 1859–85)
Hudson & Son	Longton	(c. 1875–94)
T. Hughes	Burslem	(c. 1860–94)
Hulse & Adderley	Longton	(c. 1869–75)
Isaac & Son	Burslem	(c. 1875)
Jackson & Gosling	Fenton	(c. 1866–1908, continued at Longton)
J. L. Johnson	Longton	(c. 1873–7)
G. Jones	Stoke	(c. 1861–1951, see page 81)
E. Jones & Co.	Longton	(c. 1868–76)
W. Kirkham	Stoke	(c. 1863–92)
Knight & Rowley	Longton	(c. 1873–8)
J. Lockett	Longton	(c. 1851–79)
Mrs T. Lowe	Longton	(c. 1875)
W. Lowe	Longton	(c. 1874–1930)
W. Machin	Hanley	(c. 1875–1911)
Macintyre & Co.	Burslem	(c. 1860 to present day, see page 88)
J. Maddock & Sons	Burslem	(c. 1855 to present day)
Maddock & Gater	Burslem	(c. 1874–5)
R. Malkin	Fenton	(c. 1863–81)
Malkin, Edge & Co.	Burslem	(c. 1870–98)

A. Meakin (Ltd)	Tunstall	(c. 1875 to present day)
H. Meakin	Cobridge	(c. 1873–6)
J. & G. Meakin	Hanley	(c. 1859 to present day)
Meakin & Co.	Cobridge	(c. 1865–76)
John Meir & Son	Tunstall	
		(c. 1837–97, see page 92)
E. Mills	Hanley	(c. 1874–5)
Minton & Co.	Stoke	(c. 1793 to present day, see page 93)
Minton, Hollins & Co.	Stoke	
		(Tiles, c. 1849 to present day)
Moore Bros	Longton	
		(c. 1872–1905, see page 96)
Neal Harrison & Co.	Hanley	(c. 1875–85)
Old Hall Earthenware Co. Ltd	Hanley	(1861–86, see page 102)
J. Oldham & Co.	Hanley	(c. 1875–7)
W. Oulsnam & Son	Burslem	(c. 1872–92)
J. W. Pankhurst & Co.	Hanley	(c. 1851–83)
J. Parr	Burslem	(c. 1870–9)
Pinder Bourne & Co.	Burslem	
		(c. 1862–82, see page 104)
Poole, Stanway & Wood	Stoke	(c. 1875–7)
Poole & Unwin	Longton	(c. 1871–6)
L. J. Pope & Co.	Cobridge	(c. 1872–82)
Powell & Bishop	Hanley	(c. 1867–78)
F. & R. Pratt & Co.	Fenton	(c. 1818 to 20th century, see page 107)
J. Pratt & Co.	Fenton	(c. 1851–78)
J. Procter	Tunstall	(c. 1873–97)
J. H. Proctor & Co.	Longton	(c. 1859–84)
Pugh & Glover	Hanley	(c. 1875–86)
Radford, Amison & Perkins	Longton	(c. 1875)
Rathbone, Hill & Co.	Burslem	(c. 1872–9)
J. Reeves	Fenton	(c. 1870–1948)
Ridgway, Sparkes & Ridgway	Hanley	(c. 1873–9)
Robinson & Co.	Burslem	(c. 1873–5)
Robinson & Co.	Fenton	(c. 1873–88)
Robinson & Chapman	Longton	(c. 1872–81)
Robinson & Leadbeater	Stoke	
		(c. 1865–1924, see page 114)
Robinson, Repton & Robinson	Longton	(c. 1870–6)
W. Robinson & Co.	Fenton	(c. 1873–88)
R. G. Scrivener & Co.	Hanley	(c. 1870–83)
Anthony Shaw	Burslem	(1860–82)
Skelson & Plant	Longton	(c. 1868–92)
Sampson Smith	Longton	(c. 1846–1963)
Stanway Horne & Adams	Hanley	(c. 1865–79)
E. Steele	Hanley	(c. 1875–1900)
W. Stubbs	Hanley	(c. 1853–97)
Sutherland & Sons	Longton	(c. 1865–75)

J. Tams	Longton	(c. 1875–1903)
Taylor Tunnicliffe & Co.	Hanley	(c. 1868–75)
Thomas, Rathbone, Oakley & Co.	Burslem	(c. 1875–6)
Till & Son	Burslem	(c. 1850–1928)
Tinsley Bourne & Co.	Burslem	(c. 1868–82)
Tundley, Rhodes & Pinder	Burslem	(c. 1875–83)
G. W. Turner & Sons	Tunstall	(c. 1873–95)
Turner & Co.	Hanley	(c. 1871–5)
T. Twyford	Hanley	(c. 1860–89)
J. Vernon & Son	Burslem	(c. 1874–80)
Wade & Colclough	Burslem	(c. 1870–85)
Wade & Myatt	Burslem	(c. 1868–79)
J. Walker	Longton	(c. 1873–80)
T. Walker	Longton	(c. 1875)
Walker & Carter	Stoke	(c. 1866–89)
W. Walley	Burslem	(c. 1868–83)
Wardle & Co.	Hanley	(c. 1871–1909)
W. Webberley	Longton	(c. 1850–92)
Josiah Wedgwood & Sons	Etruria	(c. 1759 to present day, see page 130)
Wedgwood & Co.	Tunstall	(c. 1860 to present day, see page 130)
J. F. Wileman	Fenton	(c. 1869–92)
Williams, Oakes & Co.	Burslem	(c. 1874–5)
W. E. Withinshaw	Burslem	(c. 1873–8)
E. T. W. Wood	Tunstall	(c. 1860–75)
Wood, Son & Co.	Cobridge	(c. 1869–79)
Wood & Co.	Burslem	(c. 1875–82)
Wood & Baggaley	Burslem	(c. 1870–80)
Worthington & Son	Hanley	(c. 1864–87)
G. Yearsley & Co.	Longton	(c. 1875)

Staffordshire Manufacturers in 1900

(Compiled from *The Pottery Gazette* diary and reproduced by permission of the proprietors—Messrs Scott, Greenwood & Son Ltd) with working periods added, in brackets
N.B. In a few instances the address or title of the firm changed slightly during the period indicated

William Adams & Co.	Tunstall	(continued to present day, see page 37)
Wm. A. Adderley & Co.	Longton	(c. 1876–1905)
H. Alcock & Co.	Cobridge	(c. 1864–1910)
Charles Allerton & Sons	Longton	(c. 1859–1942, see page 39)
Charles Amison	Longton	(c. 1889–1962)
Arrowsmith & Co.	Longton	(c. 1900–5)

Art Pottery Co.	Hanley	(c. 1899–1911)
G. L. Ashworth & Bros	Hanley	(c. 1861 to present day, see page 39)
E. Asbury & Co.	Longton	(c. 1875–1925)
H. Aynsley & Co.	Longton	(c. 1873 to present day)
John Aynsley & Sons	Longton	(c. 1879 to present day)
Baker & Co. Ltd	Fenton	(c. 1839–1932)
J. Barber	Burslem	(c. 1886–1905)
Barker Bros (Ltd)	Longton	(c. 1876 to present day)
H. K. Barker	Fenton	(c. 1900–5)
Barkers & Kent Ltd	Fenton	(c. 1889–1941)
T. W. Barlow & Son	Longton	(c. 1882–1940)
Bates, Dewsberry & Co.	Hanley	(c. 1896–1922)
Bennett & Shenton	Hanley	(c. 1900–3)
W. Bennett	Hanley	(c. 1876–1937)
G. L. Bentley & Co.	Longton	(c. 1898–1912)
Beresford Bros	Longton	(c. 1900)
J. W. Beswick	Longton	(c. 1895 to present day)
W. Bettaney	Hanley	(c. 1900)
Biltons Ltd	Stoke	(c. 1900 to present day)
Birch Tile Co. Ltd	Hanley	(c. 1896–1913)
L. A. Birks & Co.	Stoke	(c. 1896–1900)
Bishop & Stonier	Hanley	(c. 1891–1939, see page 43)
Blackhurst & Hulme	Longton	(c. 1890–1932)
Blair & Co.	Longton	(c. 1880–1911)
T. & R. Boote Ltd	Burslem	(c. 1842 to present day, see page 43)
Booths Ltd	Tunstall	(c. 1891–1948, see page 44)
Boulton & Co.	Longton	(c. 1892–1902)
Boulton & Floyd	Stoke	(c. 1888–1902)
E. J. E. Leigh Bourne	Burslem	(c. 1892–1941)
T. Brian	Longton	(c. 1896–1907)
Bridgett & Bates	Longton	(c. 1882–1915)
S. Bridgwood & Son	Longton	(c. 1853 to present day)
R. Bridgwood	Longton	(c. 1887–1913)
Britannia China Co.	Longton	(c. 1895–1906)
British Anchor Pottery Co. Ltd	Longton	(c. 1884 to present day)
J. Broadhurst & Sons	Fenton	(c. 1897 to present day)
J. Bromley	Longton	(c. 1896–1921)
Brooks & Co.	Longton	(c. 1900–2)
J. W. Brough	Stoke	(c. 1899–1910)
Brown-Westhead, Moore & Co.	Hanley	(c. 1862–1904, see page 48)
Bullers Ltd	Hanley	(c. 1892 to present day)
A. Bullock & Co.	Hanley	(c. 1881–1915)
Burgess & Leigh	Burslem	(c. 1862 to present day)
Burslem Pottery Co.	Burslem	(c. 1894–1933)
G. & T. Burton	Stoke	(c. 1899–1901)

Campbell Tile Co.	Stoke	(c. 1882 to present day)
Capper & Wood	Longport	(c. 1895–1904)
Cartlidge & Matthias	Hanley	(c. 1886–1915)
F. Cartlidge & Co.	Longton	(c. 1892–1904)
Cartwright & Edwards	Longton	(c. 1859 to present day)
D. Chapman & Sons	Longton	(c. 1882–1902)
Clementson Bros	Hanley	(c. 1865–1916)
Colclough & Co.	Longton	(c. 1891–1928)
Collingwood Bros	Longton	(c. 1887–1949)
T. Cone	Longton	(c. 1892 to present day)
J. H. Cope & Co.	Longport	(c. 1887–1946)
W. T. Copeland & Sons	Stoke	(c. 1847 to present day, see page 56)
W. & E. Corn	Longport	(c. 1864–1904)
E. Cotton	Hanley	(c. 1890 to present day)
Davison & Sons	Burslem	(c. 1898–1952)
M. Dean	Hanley	(c. 1897–1916)
T. Dean	Stoke	(c. 1879–1912)
Decorative Art Tile Co. Ltd	Hanley	(c. 1881–1913)
Dewes & Copestake	Longton	(c. 1895–1915)
J. Dimmock & Co.	Hanley	(c. 1862–1904)
Doulton & Co. Ltd	Burslem	(c. 1882 to present day, see page 66)
Dresden Porcelain Co.	Longton	(c. 1896–1904)
Dudson Bros	Hanley	(c. 1898 to present day)
Dunn, Bennett & Co.	Burslem	(c. 1878 to present day)
Edge, Malkin & Co. Ltd	Burslem	(c. 1870–1902)
Edwards Bros	Burslem	(c. 1898–1903)
G. Edwards	Longton	(c. 1873–1904)
W. Edwards & Sons	Burslem	(c. 1895–1904)
W. J. Edwards	Longton	(c. 1875–1902)
Edwards & Brown	Longton	(c. 1882–1933)
J. F. Elton & Co.	Stoke	(c. 1900–10)
Empire Porcelain Co.	Stoke	(c. 1896–1967)
S. Fielding & Co.	Stoke	(c. 1879 to present day, see page 70)
W. Fielding	Hanley	(c. 1892–1907)
Ford & Sons	Burslem	(c. 1893–1938)
C. Ford	Hanley	(c. 1875–1913)
S. Ford & Co.	Burslem	(c. 1898–1939)
T. Forester & Sons Ltd	Longton	(c. 1883–1959)
Furnivals Ltd	Cobridge	(c. 1895 to present day)
Gaskell & Grocott	Longport	(c. 1881 to present day)
Gater, Hall & Co.	Tunstall	(c. 1895–1943)
Gibson & Sons	Burslem	(c. 1885 to present day)
Gilmore Bros	Fenton	(c. 1899–1904)
J. Goodwin, Stoddard & Co.	Foley (Longton)	(c. 1898–1940)
W. H. Goss	Stoke	(c. 1858–1914, see page 72)
Gray & Co.	Hanley	(c. 1895–1901)

T. A. & S. Green	Fenton	(1876–90, continued as 'Crown Staffordshire Porcelain Co.', see page 74)
Grimwades Ltd	Stoke	(c. 1900 to present day)
W. H. Grindley & Co.	Tunstall	(c. 1880 to present day)
Grove & Co.	Longton	(c. 1899–1904)
A. G. Hackney	Hanley	(c. 1899–1902)
J. & R. Hammersley	Hanley	(c. 1877–1917)
R. Hammersley & Son	Burslem	(c. 1884–1905)
S. Hancock & Sons	Stoke	(c. 1891–1937)
Hanley China Company	Hanley	(c. 1900–1)
Harrop & Burgess	Hanley	(c. 1895–1903)
Hawley, Webberley & Co.	Longton	(c. 1896–1903)
T. Heath	Longton	(c. 1882–1913)
Hill & Co.	Longton	(c. 1897–1920)
Hines Bros	Fenton	(c. 1886–1908)
G. & J. Hobson	Burslem	(c. 1880–1901)
Holdcroft & Co.	Tunstall	(c. 1896–1905)
J. Holdcroft	Longton	(c. 1872–1906)
Hollinshead & Griffiths	Burslem	(c. 1889–1910)
Hollinshead & Kirkham	Tunstall	(c. 1870–1956)
J. Hollinson	Longton	(c. 1899–1907)
Holmes & Son	Longton	(c. 1899–1904)
J. W. Holt	Longton	(c. 1900)
J. Howlett & Co.	Hanley	(c. 1887–1907)
Howson & Sons Ltd	Hanley	(c. 1879 to present day)
W. Hudson	Longton	(c. 1889–1941)
E. Hughes & Co.	Fenton	(c. 1889–1953)
T. Hughes & Son	Longport	(c. 1895–1957)
A. J. Hull	Longton	(c. 1900)
Hulme & Christie	Fenton	(c. 1894–1902)
W. Hulme	Burslem	(c. 1891–1954)
Jackson & Gosling	Fenton	(c. 1866 to present day)
Johnson Bros Ltd	Tunstall	(c. 1899–c. 1948)
Johnson Bros, Hanley, Ltd	Hanley	(c. 1883 to present day)
Johnson, McAlister Tile Co.	Burslem	(c. 1900–2)
S. Johnson Ltd	Burslem	(c. 1887–1931)
A. B. Jones & Sons	Longton	(c. 1900 to present day, see page 80)
G. Jones & Sons Ltd	Stoke	(c. 1861–1951? see page 81)
W. Jones	London	(c. 1892–1905)
Keeling & Co.	Burslem	(c. 1886–1937)
J. Kent	Longton	(c. 1897 to present day)
W. Kent	Burslem	(c. 1894–1944)
King & Barrett	Burslem	(c. 1898–1941)
W. Kirkham	Stoke	(c. 1863–1961)
Kirkland & Co.	Etruria, Hanley	(c. 1892–1938+)
Knight & Sproston	Stoke	(c. 1900–1)
Lancaster & Sons	Hanley	(c. 1899–1944)

T. Lawrence	Longton	(c. 1897–1964)
Lea & Boulton	Tunstall	(c. 1897–1923)
T. Ledgar	Longton	(c. 1900–5)
Lingard & Webster	Tunstall	(c. 1900 to present day)
J. Lockett & Co.	Longton	(c. 1882 to present day)
Longton Porcelain Co.	Longton	(c. 1892–1908)
W. Lowe	Longton	(c. 1874–1931)
J. Macintyre & Co. Ltd	Burslem	(c. 1860 to present day, see page 88)
A. Machin & Co.	Longton	(c. 1900)
W. Machin	Hanley	(c. 1875–1911)
A. Mackee	Longton	(c. 1892–1906)
J. Maddock & Sons Ltd	Burslem	(c. 1860 to present day)
F. Malkin (decorator)	Burslem	(c. 1891–1905)
Malkin Tile Works Co.	Burslem	(c. 1899 to present day)
Marsden Tile Co. Ltd	Burslem	(c. 1892–1928)
McNeal & Co.	Longton	(c. 1895–1906)
A. Meakin Ltd	Tunstall	(c. 1875 to present day)
J. & G. Meakin Ltd	Hanley	(c. 1859 to present day)
Meller, Taylor & Co.	Burslem	(c. 1887–1904)
J. H. Middleton	Longton	(c. 1889–1941)
Mintons Ltd	Stoke	(c. 1793 to present day, see page 93)
Minton, Hollins & Co.	Stoke	(c. 1849 to present day)
Moore Bros	Longton	(c. 1872–1905, see page 96)
M. Moore & Co.	Hanley	(c. 1898–1903)
W. Morley	Fenton	(c. 1883–1906)
Morris & Co.	Hanley	(c. 1888–1912)
T. Morris	Longton	(c. 1897–1901)
T. Morris	Regent Works, Longton	(c. 1892–1941)
Morris & Davies	Longton	(c. 1900)
A. J. Mountford	Burslem	(c. 1897–1901)
Myott, Son & Co.	Stoke	(c. 1899 to present day)
New Hall Porcelain Co.	Hanley	(c. 1899–1959)
Old Hall Porcelain Works Ltd	Hanley	(c. 1886–1902)
J. Peake	Hanley	(c. 1895–1906)
S. A. Peake	Shelton, Hanley	(c. 1899–1908)
Pearl Pottery Co.	Hanley	(c. 1894–1936)
Pidduck, Rushton & Co.	Cobridge	(c. 1900–3)
Pitcairns Ltd	Tunstall	(c. 1895–1901)
Plant Bros	Longton	(c. 1898–1907)
E. Plant	Burslem	(c. 1899–1905)
R. Plant & Sons	Longton	(c. 1895–1902)
R. H. & S. L. Plant	Longton	(c. 1898 to present day, see page 105)
Pointon & Co. Ltd	Hanley	(c. 1883–1916)
T. Poole	Longton	(c. 1880–1952)
Porcelain Tile Co.	Cobridge	(c. 1879–1907)

F. & R. Pratt & Co.	Fenton	(c. 1818 to 20th century, see page 107)
Price Bros	Burslem	(c. 1896–1961)
G. Proctor & Co.	Longton	(c. 1892–1940)
S. Radford	Fenton	(c. 1885–1957)
Ratcliffe & Co.	Longton	(c. 1892–1914)
T. Rathbone & Co.	Tunstall	(c. 1898–1924)
Redfern & Drakeford	Longton	(c. 1892–1933)
J. Reeves	Fenton	(c. 1870–1948)
Ridgways	Shelton, Hanley	(c. 1879 to present day)
Rigby & Stevenson	Hanley	(c. 1894–1954)
D. Roberts	Hanley	(c. 1896–1904)
Robinson & Leadbeater	Stoke	(c. 1865–1924)
Robinson & Son	Longton	(c. 1881–1903)
Rowley & Newton Ltd	Longton	(c. 1896–1901)
Royal Art Pottery Co.	Longton	(c. 1897–1915)
Sadler & Son	Tunstall	(c. 1900–19)
J. Sadler & Sons	Burslem	(c. 1899 to present day)
Salt Bros	Tunstall	(c. 1897–1904)
W. Sandland	Hanley	(c. 1895–1904)
W. H. Sharpe	Fenton	(c. 1896–1907)
Shaw & Sons	Tunstall	(c. 1893–1910)
Sheaf Pottery Co.	Longton	(c. 1896–1903)
Sherwin & Cotton	Hanley	(c. 1877–1930)
J. Shore & Co.	Longton	(c. 1887–1905)
Shorter & Boulton	Stoke	(c. 1879–1905)
T. A. Simpson & Co. Ltd (Tiles)	Stoke	(c. 1899 to present day)
Smith & Co.	Hanley	(c. 1882–1924)
J. Smith	Stoke	(c. 1898–1922)
W. T. H. Smith & Co.	Longton	(c. 1899–1905)
J. & J. Snow	Hanley	(c. 1877–1907)
Soho Pottery Co.	Tunstall	(c. 1900–44)
Star China Co.	Longton	(c. 1900–19)
R. Sudlow & Sons	Burslem	(c. 1886–1965)
J. Tams	Longton	(c. 1875 to present day)
Taylor & Kent	Longton	(c. 1867 to present day)
Taylor, Tunnicliff & Co.	Hanley	(c. 1868 to present day)
U. Thomas & Co.	Hanley	(c. 1882–1905)
T. Till & Sons	Burslem	(c. 1850–1928)
Tilstone Bros	Burslem	(c. 1899–1905)
J. Timmis & Sons	Tunstall	(c. 1895–1929)
J. Unwin & Co.	Longton	(c. 1891–1926)
Upper Hanley Pottery Co.	Hanley	(c. 1895–1910)
Victoria Pottery Co.	Hanley	(c. 1895–1927)
Wade & Co.	Burslem	(c. 1886–1927)
J. & J. Wade & Co.	Burslem	(c. 1892–1927)
Wagstaff & Brunt	Longton	(c. 1880–1927)
C. Waine	Longton	(c. 1891–1920)
T. Walters	Longton	(c. 1879–1902)

Walton Pottery Co.	Longton	(c. 1900)
Wardle & Co.	Hanley	(c. 1871–1909)
C. Warrilow & Sons	Longton	(c. 1892–1941)
J. H. Weatherby & Sons	Hanley	(c. 1892 to present day)
Josiah Wedgwood & Sons Ltd	Etruria, Hanley	(c. 1759 to present day, see page 130)
Wellington Pottery Co.	Hanley	(c. 1899–1901)
T. Wild & Co.	Longton	(c. 1896–1904)
Wildblood, Heath & Sons	Longton	(c. 1889–1927)
Wileman & Co.	Longton	(c. 1892–1925, see page 132)
A. J. Wilkinson Ltd	Burslem	(c. 1886 to present day)
H. M. Williamson & Sons	Longton	(c. 1879–1941)
J. Wilson & Sons	Fenton	(c. 1898–1926)
Wiltshaw & Robinson	Stoke	(c. 1890–1957, see page 133)
F. Winkle & Co.	Stoke	(c. 1891–1931)
Wood & Barker Ltd	Burslem	(c. 1897–1903)
H. J. Wood	Burslem	(c. 1885 to present day)
Wood & Hulme	Burslem	(c. 1882–1905)
J. B. Wood & Co.	Longton	(c. 1897–1926)
Wood & Son	Burslem	(c. 1880 to present day)
W. Wood & Co.	Burslem	(c. 1875–1932)
Wooldridge & Walley	Burslem	(c. 1899–1902)
G. Woolliscroft & Son	Hanley	(c. 1880 to present day)

A Guide to dating Duty-free Ceramics

For over thirty years the United States Customs have admitted free of duty antiques made prior to 1830, but the new American Public Law 89-651 now allows duty-free entry of antiques made prior to one hundred years before the date of importation. Canada has recently followed the American example, so that the duty-free ruling for the whole of North America now covers articles over one hundred years old.

There are many reasons why, in the past, both the U.S. Customs and many of the English dealers have opposed the advance of the datum line from the accustomed 1830. The principal objection has concerned the great difficulty thought likely to be encountered in dating accurately mid-19th-century items. This difficulty should not occur in the case of English pottery and porcelain, for by the 1860's a very large proportion of such wares bore a clear datable factory mark and in the case of some of the major factories the exact year of production can be ascertained by reference to modern international reference books. Furthermore, many of the fashionable 'collectable' factories had closed by the 1860's so that *all* their productions are now duty free.

The following table has been compiled to show at a glance exactly which of the 19th-century products of the major English potters should be entitled to duty-free entry into Canada and the United States under the new rule. The working period and marks of a host of smaller firms are given in the *Encyclopaedia of British Pottery and Porcelain Marks* by Geoffrey A. Godden (published by Herbert Jenkins in England and Crown Publishers Inc. in America), so that there should be little or no doubt about the dating of marked 19th-century English pottery or porcelain.

In the following table a dutiable decision has been given to firms established in the early 1860's, as the greater proportion of their products were obviously made after 1868.*

* Some revision of these rulings will be required when the hundred years brings articles made in the late 1870's into the duty-free category.

Samuel Alcock & Co.	Duty Free	Closed 1859
G. L. Ashworth & Co.	Dutiable	Est. 1861
Belleek Pottery	Dutiable	Est. c. 1863
W. Brownfield (& Sons)	Most specimens bear impressed year-marks, '77' for 1877, etc. ('& Sons' added to mark in 1871)	
Brown-Westhead, Moore & Co.	Dutiable	Est. 1862
Chamberlains (Worcester)	Duty free	Pre-1852
Coalport Porcelain Co.	Standard mark changed in 1861, so giving clear demarcation	
Copeland	Changing marks and later year-numerals enable specimens to be dated	
Copeland & Garrett	Duty free	Title changed to Copeland in 1847
Derby	Original factory closed 1848. Re-established 1878 with *new clearly defined* mark	
T. Dimmock	Duty free	Closed 1859
Doulton	Dutiable	Clearly dated (in full) or marks datable
George Jones	Dutiable	Est. 1861. '& Sons' added to marks in 1873
Martin Bros	Dutiable	Est. 1873
Masons	Duty free	Failed 1848
Charles Meigh & Co.	Duty free	Ceased March 1861
Mintons	From at least 1850 wares datable to the year by means of year-cyphers (see page 95)	
Francis Morley (& Co.)	Duty free	Ceased 1858
New Hall Porcelains	Duty free	Ceased 1835
Pinder, Bourne & Hope	Duty free	Ceased January 1862
Podmore, Walker & Co.	Duty free	Ceased 1859
John Ridgway (& Co.)	Duty free	Ceased 1855
J. & W. Ridgway	Duty free	Ceased c. 1830
William Ridgway (& Co.)	Duty free	Ceased 1854
Rockingham wares	Duty free	Ceased 1842
William Smith (& Co.)	Duty free	Ceased 1855
South Wales Pottery	Duty free	Ceased 1858
George Sparks	Duty free	Ceased 1854
Spode	Duty free	Succeeded by Messrs Copeland & Garrett, May 1833
Edward Walley	Duty free	Ceased 1856
Watcombe Pottery	Dutiable	Est. 1867
Wedgwood & Co. (of Tunstall)	Dutiable	Est. 1860

Josiah Wedgwood (& Sons)	From 1860 a system of impressed date-letters was introduced (see page 131)
Enoch Wood & Sons	Duty free Ceased 1846
(Royal) Worcester	System of accurate year dating added to standard printed mark

Many examples of English pottery and porcelain designed between 1842 and 1883 bear the diamond-shaped Patent Office registration device, from which the exact day, month and year of registration may be ascertained (see page 110). In general, a letter in the top angle of the diamond mark indicates a date of registration between 1842 and 1867, but if numerals appear instead the item was registered between 1868 and 1883.

The following general guides to dating marks will help to differentiate between duty-free and dutiable specimens:

'Limited', 'Ltd', etc., not added to firm's style before 1860.
'Trade mark' not incorporated in marks before 1862.
'Rd. No.' not used in or near marks before 1884 (see page 111).
'England' added to marks from c. 1891.
'Made in England', 'Bone China' or 'English Bone China' indicates a 20th-century date.

The foregoing deals with marks and marked specimens, but there are some classes of wares which are seldom marked and, in general, these are in the less expensive range.

Examples with suggestions for their treatment are given below:

Staffordshire Figures of the later flat-back variety on simple bases of narrow oval section. Examples with underglaze-blue decoration are duty free. In an effort to reduce costs this colour was omitted from later examples which should probably be regarded as dutiable unless there is evidence to the contrary. Dogs of the type shown in Plate 333 of the *Illustrated Encyclopaedia of British Pottery and Porcelain* are dutiable. For typical 'flat-back' figures, see Plates 520 and 523.

Parian Figures and Groups produced from the 1840's onwards. Many of the better examples will bear makers' names, dates of production or the firm's private date-marks (see page 95, etc.). Unless evidence in the form of the mark appears to the contrary, parian figures should be regarded as dutiable. See Plates 15, 49, 171, 175, 330, 407, 489 and 560 of the *Illustrated Encyclopaedia of British Pottery and Porcelain*.

Lustre. On the evidence of style and shape, 'silver', 'pink', 'purple' or 'platinum' lustre is duty free. Copper lustre was produced over a long period from c. 1810 and the shape or potting details (early pieces are

thinly turned) must be studied before a decision is reached. See Plates 28, 474, 610, 615 and 673 of the *Illustrated Encyclopaedia of British Pottery and Porcelain*.

Majolica. This colourful earthenware body was introduced by Mintons in 1850. Early pieces bear makers' marks and/or date devices (registration marks, etc.): in the absence of evidence to the contrary majolica wares are deemed to be dutiable.

Several specialist reference books have already been mentioned under the relevant factories in the main section of this book. The following general books give good background and often detailed information on the subjects suggested by their various titles. All these books should be available in a good reference library.

THE CERAMIC ART OF GREAT BRITAIN. L. Jewitt (1878; revised 1883).

THE ART OF THE OLD ENGLISH POTTER. M. L. Solon (1883).

A HISTORY AND DESCRIPTION OF ENGLISH PORCELAIN. W. Burton (1902).

ENGLISH EARTHENWARE AND STONEWARE. W. Burton (1904).

STAFFORDSHIRE POTS AND POTTERS. G. W. and F. A. Rhead (1906).

THE MAKERS OF BLACK BASALTES. M. H. Grant (1910).

ENGLISH EARTHENWARE. A. H. Church (1911).

THE A.B.C. OF NINETEENTH CENTURY POTTERY AND PORCELAIN. J. F. Blacker (c. 1911).

YORKSHIRE POTTERIES, POTS AND POTTERS. O. Grabham (1916).

THE A.B.C. OF ENGLISH SALTGLAZE STONEWARE. J. F. Blacker (1922).

GUIDE TO COLLECTORS OF POTTERY AND PORCELAIN. F. Litchfield (1925).

ENGLISH PORCELAIN FIGURES OF THE 18TH CENTURY. W. King (1925).

THE NEW KERAMIC GALLERY. W. Chaffers (edited by H. M. Cundall) (1926).

OLD ENGLISH PORCELAIN. W. B. Honey (1928; new edition 1948).

CATALOGUE OF THE SCHRIEBER COLLECTION, Vols. I and II (1929).

ENGLISH POTTERY AND PORCELAIN. W. B. Honey (1933; revised edition 1962).

ENGLISH POTTERY FIGURES 1660–1860. R. G. Haggar (1947).

ENGLISH DELFTWARE. F. H. Garner (1948).

ENGLISH COUNTRY POTTERY. R. G. Haggar (1950).

OLD ENGLISH LUSTRE POTTERY. W. D. John (1951).

NINETEENTH CENTURY ENGLISH POTTERY AND PORCELAIN. G. Bemrose (1952).

STAFFORDSHIRE CHIMNEY ORNAMENTS. R. G. Haggar (1955).

ENGLISH PORCELAIN AND BONE CHINA 1743–1850. G. and T. Hughes (1955).

THE CONCISE ENCYCLOPAEDIA OF ENGLISH POTTERY AND PORCELAIN. R. G. Haggar and W. Mankowitz (1957).

ENGLISH CREAM-COLOURED EARTHENWARE. D. Towner (1957).

STAFFORDSHIRE PORTRAIT FIGURES OF THE VICTORIAN AGE. T. Balston (1958).

VICTORIAN PORCELAIN. G. Godden (1961).

VICTORIAN POTTERY. H. Wakefield (1962).

ENGLISH BLUE AND WHITE PORCELAIN OF THE 18TH CENTURY. B. Watney (1963).

BRITISH POTTERY AND PORCELAIN 1780–1850. G. Godden (1963).

ENCYCLOPAEDIA OF BRITISH POTTERY AND PORCELAIN MARKS. G. Godden (1964).

ENGLISH PORCELAIN 1745–1850. Edited by R. J. Charleston (1965).

ENGLISH CERAMICS. S. W. Fisher (1966).

AN ILLUSTRATED ENCYCLOPAEDIA OF BRITISH POTTERY AND PORCELAIN. G. Godden (1966).

INDEX

Note. This index does not include the several hundred initial marks given in alphabetical order in Appendix I, nor does it include the hundreds of Potters listed in Appendix II, being extracts from Staffordshire Directories of 1786, 1818, 1830, 1850, 1875 and 1900.